MARINE PAINTING IN WATERCOLOR

MARINE PAINTING IN WATERCOLOR

BY EDMOND J. FITZGERALD

WATSON-GUPTILL PUBLICATIONS, NEW YORK

PITMAN PUBLISHING, LONDON

To Desmond and Ryder

Published in the U.S.A. and Canada by Watson-Guptill Publications,
a division of Billboard Publications, Inc.,
One Astor Plaza, New York, N.Y. 10036
ISBN 0-8230-3008-3
Library of Congress Catalog Card Number: 70-177379

Published in Great Britain by Sir Isaac Pitman & Sons Ltd.,
Pitman House, 39 Parker Street, Kingsway, London WC2B 5 PB
ISBN 0-273-31800-4

Manufactured in Singapore

First Printing, 1972
Second Printing, 1975

Acknowledgments

I wish to thank Professor Robert Farson, Mrs. Jean Bohne, and Mrs. Max Meerkerk for lending paintings from their collections for reproduction in this book. I also am most grateful to my wife, Mary Louise, for help in the preparation of the manuscript. Without the editorial expertise of Donald Holden, Watson-Guptill Editorial Director, Heather Meredith-Owens, and Adelia Rabine this book would not have been possible. For their advice and help I am deeply thankful, as well as for the expert photography of Geoffrey Clements and Paul Juley, and for the many painstaking details unstintingly provided by the Watson-Guptill organization.

Contents

Introduction

The music of water rippling over rocks, the "sea song" heard from a sailboat running before a fresh breeze, or the crescendo of breakers on an ocean beach — these are among the sweetest sounds known to man. The visual accompaniment to this orchestra is equally appealing.

Water covers more than three-quarters of the earth and is dominant in our lives in a thousand ways. What could be more natural than responding to this marvelous element artistically, and what better tool could we find than watercolor?

This book offers my "one-man show" search for an understanding of water in its various forms, from the Oregon mist to the roaring forties — 40°-50° south latitude known for its heavy weather — and the means of setting it down in watercolor. The study of water involves the shore, the sky, certain flora and fauna, and man-made things; and the following pages focus on discussions, demonstrations, and illustrations of water and its environment.

I have used only my own work to illustrate the many aspects of marine painting so that the step-by-step progression will be clear. Hopefully, this will stimulate the student to chart his own course.

You can get maximum use out of this book if you are also acquainted with the general literature on watercolor. (See *Bibliography.*) Experience in other media will also help, particularly if it involves the study of sea and waterway subject matter.

All art has fundamental roots in the study of nature. Your ability to draw and paint water, in its various aspects, is especially dependent on your understanding of natural phenomena.

For drawing and painting purposes, it is useful to consider many kinds and conditions of water separately in order to grasp the overall subject. Water, in all its variety, has many common characteristics: it is more or less transparent; it gets much of its apparent color from its mirrorlike ability to reflect; it can carry color-imparting substances in solution; it flows to seek a level; and its surface is readily disturbed. Nevertheless, within this framework of similarity is great diversity.

No one should pretend that understanding water or drawing and painting it is easy. There is a prevalence of misunderstanding and casual observation concerning water. For example, many people refer to reflections as "shadows." Actually, quiet areas of clear water may reflect colors and shapes with mirrorlike accuracy in accordance with the rules of perspective. If the clarity of water is altered by silt or algae, the colors reflected are modified. If the reflecting surface is disturbed, as by a flow of current or wave motion, the reflection is distorted or broken up. All such factors and many more must be observed and correctly interpreted for a successful rendering of water. Usually water is a restless model. Interpreting its moods and flashing action is a challenge.

Watercolor has been called the most difficult medium. It resembles a spirited horse that performs best under a skilled hand. It is sensitive, illusive, and capable of great power. It is merciless in recording any uncertainty and fumbling in its use. Like a fine animal, however, it has its own unique beauty. It might seem paradoxical that this demanding medium should be thought well-suited to capture the most illusive of subjects. But, paradox or not, the marriage works!

Transparent watercolor spilled upon paper has luminosity and freshness. When it can be controlled, its very transparency assists in expressing water. The characteristic speed it demands of the painter as it is spread makes watercolor compatible with the dancing sparkle of water. In fact, the beginning watercolorist often has more trouble with those things that sit rather patiently to be copied — rocks or trees, for example!

Watercolor has its gremlins and its pitfalls. Perhaps the Almighty never intended that any art should be easy. But even when we fail, an hour or two spent along a quiet lake or bubbling stream or within sight and sound of the sea is not all bad — and the experience leaves you more prepared for the next challenge.

There is no trophy in all the world more alluring than your *next* brilliant watercolor!

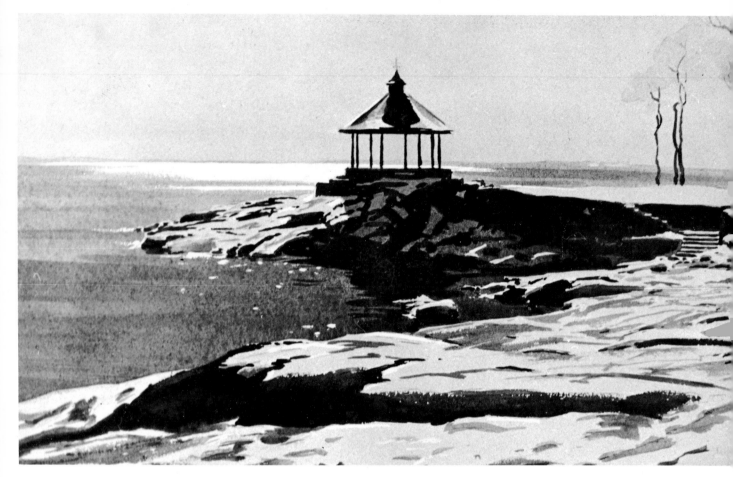

Summer House in Winter (Above), 15" x 22", 120 lb. stretched David Cox paper. Collection Mrs. Jean Bohne. I used a number 12 brush to carry a thick bead of the sky mixture across the top margin of the dry paper. Successive passes of the brush carried this bead down the area of the sky. I dipped the brush into the mix between each pass and made the mix warmer as the wash progressed. I was careful to leave the roof of the summer house unpainted but swept right across the area where the dark uprights were penciled. I reversed the paper to lay the basic wash for the water, starting at the near shoreline. The reversal caused the darkest part of the water to be in the foreground. For this wash I used a large mix, denser in pigment and warmer still than the sky mix. I left a few spots of unpainted paper for sunlight glitter in the foreground and a broader stretch for the glitter near the horizon. Then I added some water to lighten the wash and some cobalt blue as the wash approached the horizon. I painted the thin line of the far shore with pure color, right over the lower sky which had dried. To suggest texture in the water, I used a second wash of the basic mix, but intensified, to brush in horizontal bands over most of the water after it had dried. For the silhouette of the summer house, treetrunks, and the shadow areas of the rocky shore, I used a very dense wash, touching in the light patches of bare rock and the snow in the shadows separately. The bare paper served for the sunlit snow, highlighted here and there with Chinese white and warmed with cadmium yellow pale. I also used this combination for the glitter on the water

Use of Photography in Watercolor (Below). I took the snapshot on a bright January afternoon in Manor Park, Larchmont, and painted the picture Summer House in Winter, in the studio. It was too cold to paint on location, but I did make a slight pencil sketch in a 5" x 7" pad. The sketch established the horizontal composition and included steps and bare trees on the right, not included in the photo.

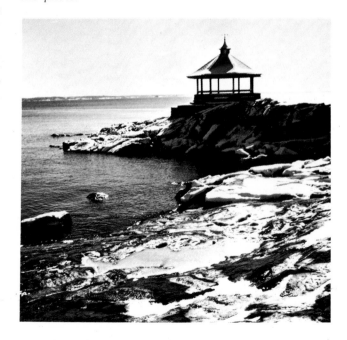

1

My sketching and watercolor kit

Almost every book on watercolor painting gives practical information about materials and equipment. Many ingenious ideas are revealed about lightweight sketching kits and a variety of brushes, paints, palettes, and so forth. But each of you will have to search for the tools that he prefers.

Water-Media Paints

I distinguish watercolor from the other water-media paints, which are usually identified by their individual names: tempera, casein, and acrylic. I do not use the term "aquarelle" very much as it seems to me just another word for watercolor. The term "gouache" refers more to method than to material and can be applied to all the water-media paints, including watercolor. It means opaque, as opposed to transparent, water-media painting. It is necessary to add opaque material — white pigment or paste — to transparent watercolor to obtain gouache. The other water-media paints are, more or less, gouache in their normal consistency; some can be given a transparent appearance by the addition of much water.

Simplicity

I have found that all media share a great deal of common ground, as do numerous esthetic schools of thought as well. I have distilled a few basic principles that I recommend to you in selecting materials and equipment.

One message that comes through loud and clear from all sources is that you can do fine work with limited equipment. Too much equipment can be confusing and burdensome, particularly for field-work. *Simplicity* is a cornerstone of art.

Permanence

As with anything else, painting and drawing form habits. When you get "hooked" on a questionable color, method, or material early in your career, you may find it hard to change later on. Use of good materials at the outset is a basic step in the direction of forming good habits.

There are a number of handbooks on the permanence of materials. (See *Bibliography*.) Most manufacturers of artist's materials provide information on this subject.

Quality

Quality of materials relates, of course, to permanence, but it also relates to performance. The best equipment will not guarantee good work, but it helps. Trying to stint in this area results in negligible savings.

Papers

My preference in watercolor paper is 300 lb. rough Arches. (Weight refers to weight per 500 sheet ream.) I frequently use the full sheet, 22" x 30", but most of my watercolors are of smaller size. Outdoors I seldom work larger than a quarter sheet (about 11" x 15"). Arches is not the whitest paper available. Usually I do not find this a drawback, but for some subjects I choose another paper, perhaps Crisbrook (Winsor & Newton), J. B. Green (Winsor & Newton), or the incomparable Whatman, no longer manufactured and hard to find.

Another favorite sheet of mine is 120 lb. David Cox paper. It is not white, but a warm gray or tan color. It lends itself to certain subjects and to certain treatments which I will discuss later on.

After "favorites," the list could get rather long. Part of the fun of painting in watercolor is in trying many papers. Heavyweight, handmade, all-rag paper is extremely durable; in fact, more durable than the linen of oil painting, which must be reinforced or replaced by restorers to preserve old paintings. Machine-made papers are not as long lasting, but many are attractive as watercolor pa-

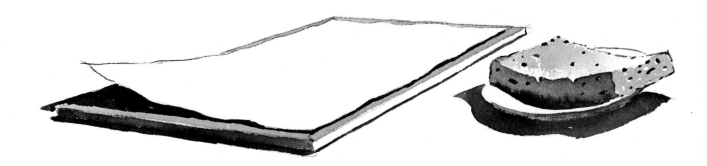

Stretching Paper: Step 1. *Wet the paper by soaking or sponging it with water. The wetness will cause the paper to expand slightly.*

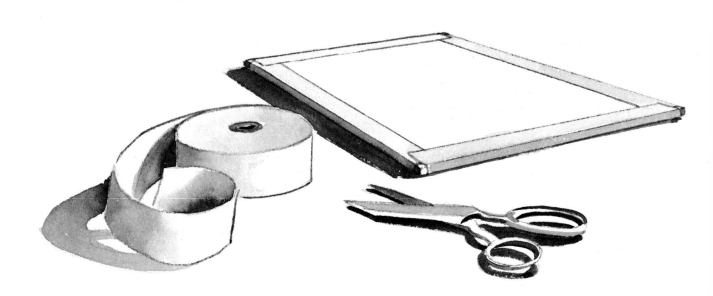

Stretching Paper: Step 2. *The edges of the paper must be firmly held in place while the paper dries. There are several methods of doing this. This illustration shows the use of gummed paper tape. The board backing must be rigid enough so that it will not warp during the drying and consequent shrinking of the paper. When the painting is finished, cut through the tape with a sharp knife. A straightedge can be used to guide the knife.*

per and are of sufficient permanence to satisfy some of the top watercolorists.

The David Cox paper, mentioned above, has an interesting history. The English landscape painter, David Cox (1783-1859) discovered the paper wrapped around a leg of mutton from the butcher shop! The paper had a watermark because all paper in those days was handmade. He wrote to the mill on the Clyde Bank in Scotland where the paper was made and ordered a ream (500 sheets), which he used for several years. It was a rather tweedy-looking, unbleached paper made from cast off sails from the ship repair yards along the Clyde. Some of Cox's friends raised eyebrows over the use of such "unrefined" paper, surely intended only for "vulgar" use. He was asked what he would do if one of the little specks, which appeared here and there in the paper, were to be found in his sky! "Why," said Cox, "I'd simply put wings on it."

That one ream was all that was ever available, as the mill went out of business. Many years after the noted artist's death, a mill specializing in fine papers decided to imitate the original paper and honor it with his name. (See *Rolling Surf*, p. 17.)

I find this paper suitable for subjects that are a little low-keyed but which have a few sparkling lights that appear lighter than the paper. These lights I plunk in with opaque color, usually as final touches, and get sensationally fine results — sometimes. The paper's surface is rather soft, and it will not take much punishment — like scrubbing, for example. It is somewhat absorbent and holds color in place, so that color changes can be readily incorporated in the washes.

Stretching Paper

David Cox paper, like other lightweight paper (under 300 lbs. per ream) should be stretched before use. To do the stretching, dampen the paper thoroughly and hold its edges firmly in place until it dries. You can do this on a board or canvas stretcher using tacks or glue, but I usually use gummed paper tape — the type used for parcels — not masking tape, which would not hold. When the watercolor is finished, you can cut it from the board with a sharp knife. A straight-edged ruler may be a valuable aid for cutting until your hand is steady. Stretching is done to minimize the tendency of paper to cockle or wrinkle up when water is freely applied.

Heavier paper, like 300 lb. Arches, gives little trouble in this regard — even without stretching — especially in smaller sheet sizes. I prefer it for field work because it is convenient, even though it is expensive compared to lighter paper.

Aging improves even the best paper. I once bought some sheets of 140 lb. Whatman watercolor paper in Bombay that were over 50 years old. The surface was deliciously sensitive, and I have never found a paper of equal quality.

Stretching lightweight papers tends to flatten out the texture of the paper. A rough-textured paper that has been stretched is slightly less rough than the same paper unstretched. A thorough soaking before stretching to soften the fibers of the paper flattens the surface even more.

If you are painting a subject which has much fine detail, this flattening is desirable. Rough texture can get in the way of a highly detailed drawing and rendering. Smoother papers also produce more brilliance of color than a rough surface because the rougher texture breaks up the light being reflected off the surface through the washes of color.

Cold-Pressed and Hot-Pressed Paper

I sometimes use cold-pressed paper. It is slightly smoother than rough paper, but it can be made still smoother by stretching. I have also used hot-pressed paper, which has an extremely smooth surface. The smoothness imparts a jewel-like brilliance to colors, but washes are very hard to control on its slippery surface. This quality limits its scope of expression.

Paper's Ability to Withstand Pressure

Strong, handmade, all-rag paper can stand a great deal of punishment. Large areas can be scrubbed out and repainted. Less rugged papers, like rice paper, are receptive to the charm and brilliance of watercolors but demand an application of color that requires a minimum of pressure with the brush to the paper. They therefore demand more directness and skill.

Toned Papers

I have not experimented extensively with non-white paper, other than David Cox, but I have used toned papers for pastels and graphic materials so I am aware of their possibilities, particularly for gouache or semitransparent, aqua-media methods. One of these days I will experiment more with them.

Pencils

Before I begin painting a watercolor, I often make trial sketches in pencil, and I also usually pencil in the composition carefully, before actually putting

brush to paper. Therefore, my studio is always well-stocked with a great variety of pencils and crayons — from hard graphite (about 6H), to 6B (soft and velvety). I also use both vine (which is more erasable) and artificial charcoal; carbon pencils of varying softness; Conté crayons, red and black; and colored pastel sticks, both hard and soft.

Colors

How do artists go about selecting the colors they use? This question would evoke surprising answers if posed to a cross section of people who paint. Your palette of colors undoubtedly originated with a teacher, either directly or indirectly: it was probably designed by an art instructor or was taken from a book that was written by an art instructor. I have noticed, though, that artists are an individualistic group, and nearly all soon expand upon the original selection with the addition of colors that appeal to them in one way or another. The trouble is that too often elimination is not also practiced, and the palette becomes expanded and confused. The principle of *simplicity* is apt to be disregarded, to say nothing of *permanence* or *quality*.

The various names of colors and adhesive materials can confuse the novice painter. The name of a pigment may be its place of origin, a chemical term, the name of the inventor, or something entirely different. The names of adhesive materials — oil, casein, acrylic, and gum arabic — used to bind the pigments together to make a paint, are not quite so confusing, once you get the hang of it. Then too, the many commercial, scientific, and decorative uses of color have their own special terminology, pertaining to dyes and inks. Of course the physicist's study of the color of light in the spectrum has only the most remote relationship to the use of colored pigments in painting because pigments mixed together do not act like the mixing of colored lights. Also the well-known color wheel, used to teach about color, has almost exhausted its usefulness once you discover that yellow and red make orange; blue and yellow make green; and blue and red make violet.

Manufacturers of artist's colors offer a wide selection for you to choose from, and they are helpful with information about their products. Also artist's handbooks offer an impartial source of such data. (See *Bibliography* at end of book.) Colors are not all equally permanent, even from the best manufacturers, and price has little to do with this. Some are poisonous; a fact to consider if you put your brush in your mouth — and many watercolorists do, as the lips are sensitive to the wetness and general feel of the brush. Within broad price categories, the products of leading manufacturers are fairly equal. Some manufacturers may dilute the colors a little more or reinforce standard pigments with dyes. The latter practice is usually reflected in a variant from the standard pigment name, e.g., "cobalt blue hue."

My Selection of Colors

After you inform yourself about the pigments you use, discard those that are questionable or that you do not really need, and add new ones to your palette with some deliberation. I believe that harmony of color and unity of composition are served by using a small number of colors. I have copied some of the great painters of the past — Rembrandt, Goya, Degas, Homer — using a very limited palette with good success. An artist's palette is as personal as his signature; it reflects his opinions and objectives — in short, his personality — and each individual will develop preferences as he paints. My watercolor palette is as follows:

cadmium red light	cadmium orange
alizarin crimson	viridian
Indian red	cobalt blue
burnt sienna	French ultramarine blue
burnt umber	ivory black
yellow ochre	Chinese white
cadmium yellow pale	

I use some colors much more than others; yellow ochre, viridian, and my blue pigments go the fastest. I like Winsor & Newton tube colors, but here again, this is largely habit. I think several other leading brands are comparable.

Tube watercolors are sometimes called "moist" watercolors. There are also "pan" colors and colors made in small, hard cakes, but these forms are less popular. Certain purists have declared a preference for pan colors, as containing fewer "adulterants." Most present-day painters, including myself, regard this as an unnecessary overrefinement. Tube colors are more convenient and meet generally accepted standards of permanence.

Using Opaque Colors

Pigments which are normally transparent can be made opaque by the addition of various amounts of inert pigment like precipitated chalk or blanc fixé. Flour paste and other materials have also been used to produce more or less opaque watercolors. Chinese white is naturally opaque, and I sometimes use it to produce opacity in other colors.

When I paint on David Cox paper, I often use a few touches of Chinese white, usually tinted with

color, to express those few areas of a composition that I feel should be lighter in value than the warm, gray tones of the paper. (See *Menhaden Fishermen*, p. 20.) When Chinese white is added to a color, it changes that color's characteristics considerably. Therefore, do a little experimenting on a separate paper before you add the mixture to your painting. All watercolors tend to change in appearance when dry, but with Chinese white added, the change upon drying is even greater.

Water Additives

Some watercolorists have recommended the use of only distilled water for watercolor painting because the various salts and other impurities present in ordinary water might affect the colors. This seems an overrefinement to me, as I have on occasion used swamp water or sea water with no apparent ill effects. Turner is said to have used spittle or urine when other water was not available.

I add a few drops of glycerin to water to slow the drying in very dry climates. However, exercise care as too much may prevent drying altogether. A little ox-gall or aerosol makes water "wetter" and helps overcome the resistance to water experienced with some papers.

Some alcohol added to water speeds up the drying in damp weather, and it will prevent freezing in very cold weather. In the latter case, a little alcohol taken internally might be helpful. Some recommend it in any weather.

Paintbox

For watercolor painting, a paintbox can be small or even eliminated. While oil painting tubes seem to exude a gummy substance and are generally messy, watercolors are tidy. They also are more compact, as watercolor goes much farther than oil paint. These are features that make watercolors easy to carry and attractive for field work.

Your studio may resemble a laboratory with numerous mixing trays and receptacles, but when you venture forth, a very compact version of this paraphernalia is all you need. Jack Pellew carries his tubes of color in a tobacco tin. A Canadian friend of mine, John Ensor, designed a handsome jacket with various pockets in which an entire watercolor outfit is carried. He usually carries a light board under his arm, but he can even fit that in a large zipper pocket on the back — at the risk of looking a little rigid.

Some people have a large canvas carryall, like a suitcase. This may be a mistake, as you are apt to stuff in more than you need, and the bag begins to look as though it should have wheels. Incidentally, I know a little elderly lady who always carries her painting outfit in a two-wheeled folding wire shopping cart; not bad, except for rough terrain.

My own watercolor kit for field work is not particularly ingenious, and it is partly sentimental, but it works. I have a waterproof canvas sack which just accommodates a 17" x 24" plywood board, a few half and quarter sheets of paper, and a sketchbook or two. I carry the sack under my arm, and in the fingers of the same hand, I carry a wooden box, 15" x 7" x 3" which holds my palette, tubes of color, brushes, pencils, and a few other odds and ends. My canteen came with a belt, but I often just carry it in the other hand. The canvas sack I have had since a 1930 Alaskan geological survey expedition I accompanied. We packed all of our provisions and equipment in these sacks for portability and protection from the elements. I have grown fond of it — or perhaps I am just used to it. It makes a fine ground cloth against the damp, when I don't take along a sketching stool.

Canteen and Palette

My one-quart canteen is a souvenir of war service. It has a canvas cover which also holds a one-pint aluminum cup. The cup has an L-shaped folding handle, which can be hooked over fences or anything handy. The canvas cover has a metal fitting, designed to hook into eyelets on a wide military belt made of heavy webbing. The belt is designed to also carry small canvas pouches for military equipment. These pouches are useful for certain art materials as well — little packets of cleaning tissue, for instance. You can purchase this type of canteen at Army and Navy surplus stores.

The watercolor palette for field work is a very important item. I am now talking, not about colors, but the thing on which you mix them — still another example of confusing nomenclature! There is room for improvement in every palette I have ever seen. In the studio the problem is less critical; you can improvise with saucers, enameled trays, or what-have-you. In the field, certain requirements must be met with a minimum of weight and size. I have a folding palette which fits neatly into the box, described above. It is satisfactory, but not perfect. One of its virtues is that it is inexpensive. It is made of molded white plastic, easily cleaned and light in weight. I am working on my third one, as the plastic hinge breaks after a time. Its principal virtue is that it has six 4" x 4" mixing-wells, separate from each other and about 1/2" deep. These wells have enough room to mix a large wash in isolation from other colors. Along the edges are 20 receptacles for

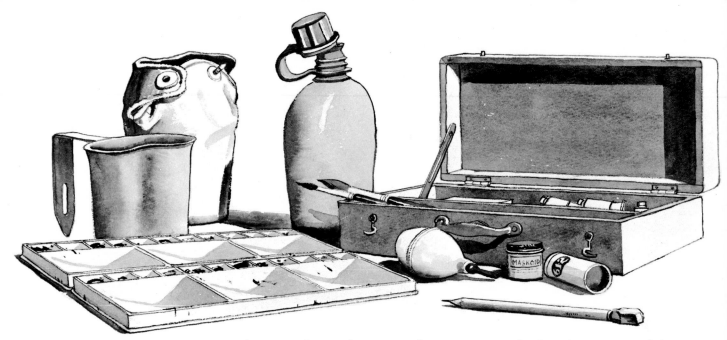

Palette, Paintbox, and Canteen. *This is my watercolor kit. The canteen and the cup nest in the canvas pouch. The pouch can be hooked to a belt (which I seldom use and have misplaced). The plastic palette folds and fits into the box.*

receiving color squeezed from the tubes. They are of proper size and depth to suit me very well. Now comes a drawback! When you close the palette, the moistened colors sometimes stick to each other and mix in an annoying way.

Brushes

I use a number 12 round sable brush for everything except smaller details. A number 8 and a number 1 complete my "necessary" brush inventory. There are a few spares and older brushes in my box; also one or two bristle brushes for scrubbing and similar corrective measures.

Good quality sable brushes of large size are expensive. Round, pointed brushes cost more than square-tipped, because they are harder to make. It requires more time and skill to set the natural hair ends of sable hair in the desired tapered shape for the pointed brush than for the square type.

Watercolor brushes last many years, so the overall expense is not so frightful. Since it is probably the most important part of your equipment, there is no satisfactory substitute in watercolor painting for the best red sable brush obtainable.

As I have pointed out, painting develops habits. I have used round brushes for watercolor for so many years that I have never adopted the flat, "wash" brushes popular with many of my fellow painters. These brushes have come into vogue more in recent years as watercolors have tended to become larger. I have tried them, but I have always returned to the rounds. There is an advantage to the flats — they are less expensive. I detect a disadvantage, however, that I consider important. There is a tendency in the wide, square-ended brush to induce a mannerism of painting that tempts the student to place too much importance on the appearance of cleverness. He may then look to art for his inspiration, instead of to nature.

The round, pointed brush provides a maximum reservoir for water and color and can deposit its contents on the paper in a great variety of ways, from thin to thick, at the will of the painter. However, the thin-thick stroke of the flat brush tends to become "automatic." This quality of stroke has contributed much to the beauty of lettering, and calligraphy certainly has a place in watercolor painting — just so it is not overdone. A calligraphic technique is often necessary for accents and texturing involved in finishing some parts of a watercolor, but this can be executed with a small, round or flat brush. A "rigger," which has a round ferrule and a square tip, is fine for this.

A word of caution here! Avoid the use of expensive sable brushes for acrylic and casein paints. Acrylic, particularly, dries very fast and is hard on brushes.

A number of years ago I lost a paintbox by carelessly leaving it in a taxi. In it was a number 12 sable I had had for more than 25 years. I was fond of that brush and like to think that it is still going strong somewhere. They last a long time. The point wears off after a while, but the main function, that of a resiliant reservoir for color and water, remains.

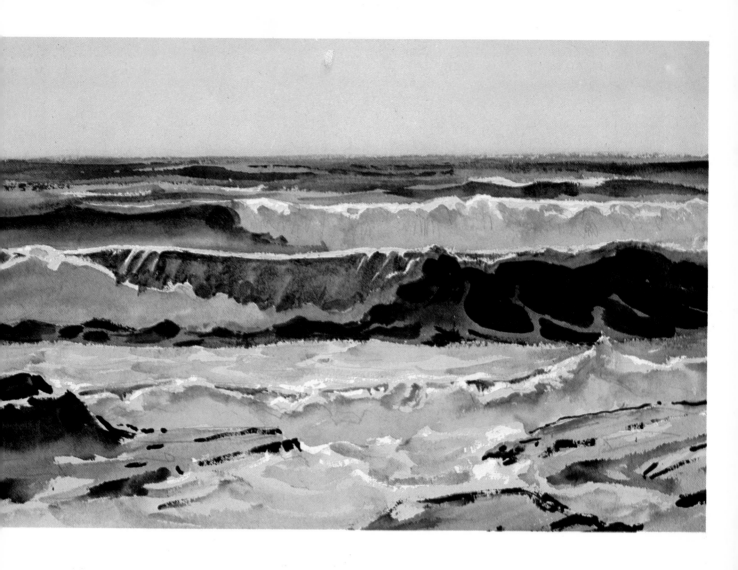

Rolling Surf, *14" x 22", 120 lb. stretched David Cox paper. I did this painting from a black and white charcoal study (reproduced in my book, Painting and Drawing in Charcoal and Oil, Reinhold, 1959). I have painted several versions of this subject, in both watercolor and oil. Color changes in the shadows on the white water were achieved by blending yellow ochre into washes started with cobalt blue at the upper edge. Such color changes are more feasible on David Cox than on harder, less absorbent papers. I added the brightest lights last with Chinese white warmed with cadmium yellow. The many strong color and value contrasts seen in aerated water are illustrated in this painting.*

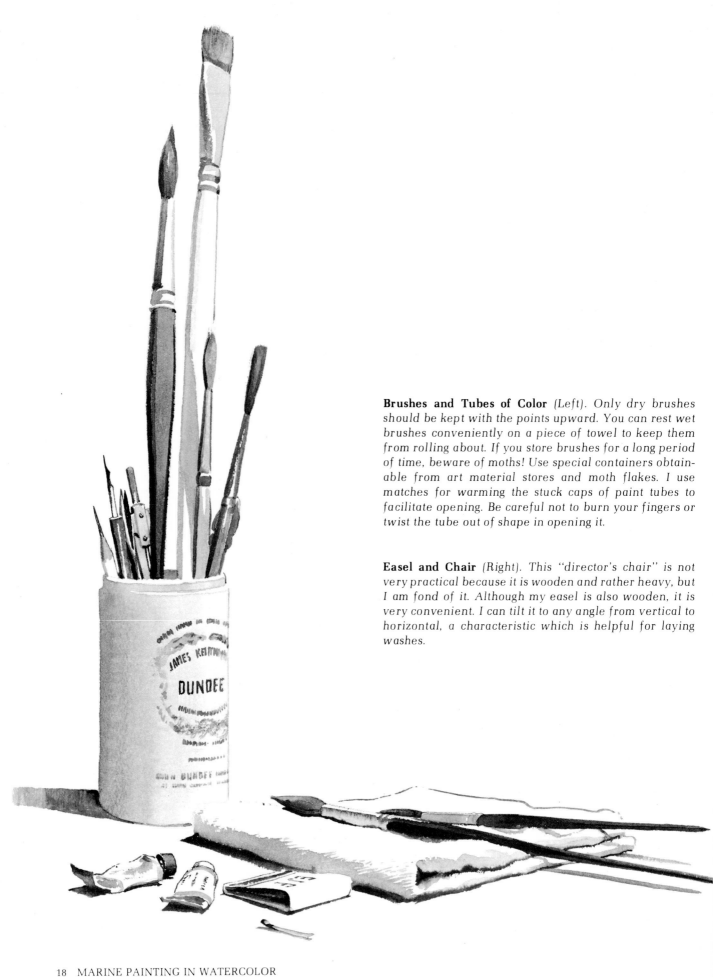

Brushes and Tubes of Color *(Left). Only dry brushes should be kept with the points upward. You can rest wet brushes conveniently on a piece of towel to keep them from rolling about. If you store brushes for a long period of time, beware of moths! Use special containers obtainable from art material stores and moth flakes. I use matches for warming the stuck caps of paint tubes to facilitate opening. Be careful not to burn your fingers or twist the tube out of shape in opening it.*

Easel and Chair *(Right). This "director's chair" is not very practical because it is wooden and rather heavy, but I am fond of it. Although my easel is also wooden, it is very convenient. I can tilt it to any angle from vertical to horizontal, a characteristic which is helpful for laying washes.*

Easel and Chair

The automobile is a convenient, mobile studio. I often paint right in my station wagon, particularly in bad weather. It is very pleasant to be able to turn on the heater or the radio while painting a rain-swept beach or an icy headland. However, it is not always possible to maneuver the car to the best vantage point so a few useful items to have in the car include an easel and folding chair.

I have a practical watercolor easel. It is actually an all-purpose easel, but I consider it a watercolor easel because it is capable of being tilted to a flat position — like a table. This is necessary in some watercolor procedures, such as laying large washes. However, it is made of wood and is a little heavy to carry. Perhaps an aluminum version would be an improvement.

Any lightweight folding chair will do. I don't carry a beach umbrella, but there are times when I think it would be a good idea, not only for comfort, but the hot glare of the sun often causes too rapid a drying of the washes, and natural shade is not always available.

Extras

In my paintbox are a few "extra" things worth mentioning. I have a 30" section of a folding carpenter's ruler that is useful in several drawing operations. I will discuss it more fully in Chapter 3.

A pocket knife and a small sponge also have many uses in watercolor work. I carry a little bottle of liquid frisket too for masking purposes, which I will discuss in later chapters. The final item is a tube of insect repellent. Mine resembles an oversize lipstick and is called "612." It provides a partial defense against various biting insects which will, no doubt, become Art Critics in future incarnations.

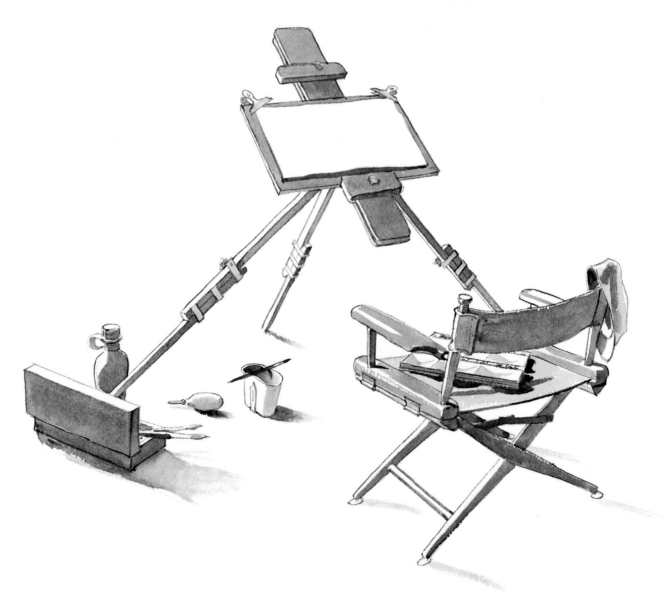

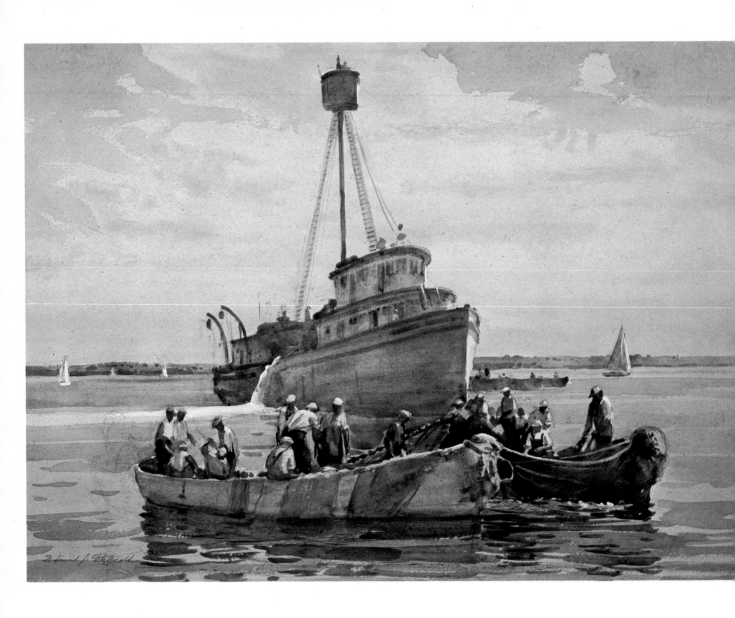

Menhaden Fishermen, *22" x 30", 120 lb. stretched David Cox paper. This full sheet was painted in the studio from photographs and sketches made while sailing on Long Island Sound. I observed the highly organized fishing operation for several hours. A spotter plane apparently locates schools of menhaden, a fish used for chemical and industrial purposes, but not human food. Then the processing boat — seen in the painting — and a number of large skiffs, filled with men who net the fish, move in. Ripples on the glassy water produced reflections in accordance with the principle that "the angle of incidence equals the angle of reflection." The fishermen and their work-battered boats supplied a rich spectrum of colors to be reflected. The warm tone of the paper influenced all the color values except the whites, which I put in last with Chinese white.*

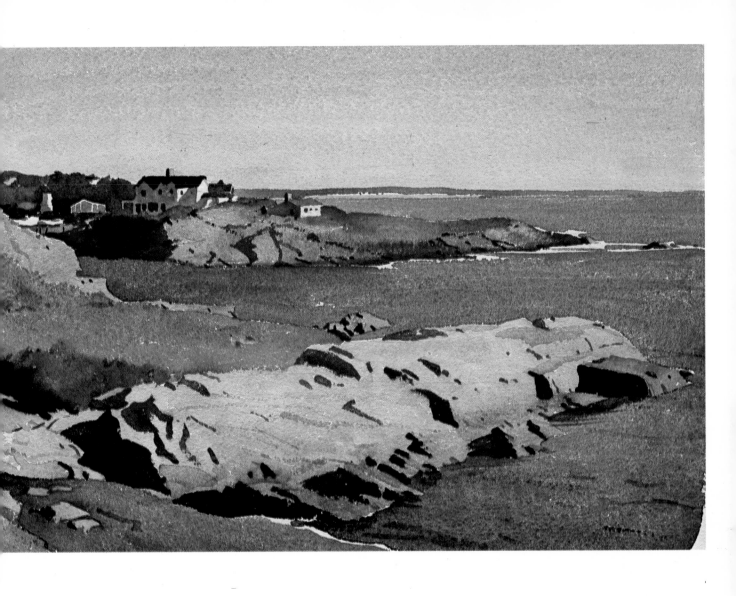

Jack's Cove, Morning, 11'' x 15'', 300 lb. rough Arches paper. I painted this watercolor at sunup. It shows the warm flood of light that bathes forms in position to receive the low angle of its rays. Shadows in the rocks are deep and cool, and the water, not yet fully illuminated, is also fairly dark. The clear, early morning sky is infused with warmth; I used plenty of yellow ochre near the horizon. The painting had to be rapid because of the changing light, but I regarded the perspective of the headlands and their placement with respect to the horizon as critical, and I was careful in my observations and drawing.

2

Basic watercolor techniques

Few materials used in the production of pictures have much beauty in themselves. To be sure, some mosaic tessera are gemlike, and fresh oil paint squeezed on the palette looks fresh, but by and large, the possibility of creating a thing of beauty lies in the assemblage of the materials, rather than in the materials themselves. Watercolor, however, is different.

Watercolor spreads rapidly over the paper with a gossamer tracery, at once delicate and strong like a butterfly's wing. The whiteness and texture of the paper shines through its transparency so that even the strongest colors lack harshness. Pale colors can be incredibly pure and clear, like tinted crystal, while darker colors and certain mixtures tend to dry with granular effects that add variety and texture to the washes. In watercolor, you get beautiful qualities for nothing.

Watercolor is sensitive though, and its dainty charm is easily deflowered. If it is overworked, it can turn quickly to mud. It seems to know *your* weak points too, and it can be an unconscionable tease. Faced with its delicate power, you are likely to become timid. The qualities it gives freely make it hard to handle. You can become dazzled by the charm of watercolor, accept that charm as your goal, and stop short of a fuller objective. The qualities that give watercolor its exquisiteness are apt to lead you into the conviction that too little is enough.

Laying Washes

A wash is any continuous area of watercolor that requires more than one brushstroke to apply. After you have made the first stroke, add water and color, or sometimes water only, to the wet edge of the stroke. Successive passes of the brush cause the color area to spread into a wash.

The edge of the wash should move quickly and smoothly over the paper, like the edge of a spent wave sliding over the beach. The chief problem in laying a wash is the limitation of time. Watercolor applied to paper dries or sinks in (or both) with remarkable speed once you commence a wash. Also, all paper does not receive watercolor in the same way. Some papers resist wetness like a duck's back. Stretching the paper or gently sponging it with clear water and drying it beforehand helps alleviate the "resistance" problem, but if paper is very absorbent, every stroke of the brush may show after the wash dries. You can reduce this by laying the wash as rapidly as possible and with as light a touch of brush to paper as you can manage.

You can control a dark wash best by holding the paper horizontally, or nearly so. Tilting the paper facilitates the speed of laying a wash as the wetness accumulates at the lower edge and is easily urged onward with the brush, but the wash tends to be lighter in tone than if applied horizontally. You can apply broad washes with the paper practically vertical, but you need considerable skill to prevent dribbles from running down the paper.

You can incorporate color changes and value changes in a wash while you are spreading it. (See *Rolling Surf*, p. 17.) The best place to accomplish such changes is at the "working edge," which you continue to advance like the incoming tide. You should plan such changes in advance, if possible, and have the requisite mixes ready on the palette. It is risky to add colors or otherwise disturb the main body of a drying wash by touching a brush to it while it is drying; not impossible, but risky.

If you want the wash to remain uniform in tone, pick up additional color with your brush from the mix on your palette before each pass. If you want the wash to change gradually to a lighter value of the same color, add some water to the mix before each successive pass. This can be done with a brush or syringe. With a little practice, you can rapidly achieve a graduated tone of great refinement in this way. Laying down a controlled wash

Laying a Wash. *Mix a quantity of color and water sufficient to cover a desired area on the palette in the necessary intensity of value. Fill the brush and paint a strip of color along one edge of the area, usually the uppermost. Refill the brush and paint a strip in the reverse direction, mating it with the first strip and advancing the wash. Repeat this process back and forth until the area is covered.*

Wet-Blend. *Paint an area of paper with clear water until it is evenly moistened. Then brush premixed color and water into the wet area. It will blend softly into the surrounding area in accordance with the amount of wetness on the paper and in the color mix. Different colors and values can be made to blend softly into each other by this method, but your control is limited.*

Fusing. *Quickly lay two premixed washes on dry paper, side by side, leaving a narrow strip of dry paper between. While the two washes are still wet, run a clean, damp brush along the dry strip, touching both washes at the same time. The washes will blend, and if they are about equally damp, they will not run into each other to any great extent. A slight lateral movement of the damp brush causes a more gradual blending of the two washes. Control is difficult — luck must be on your side!*

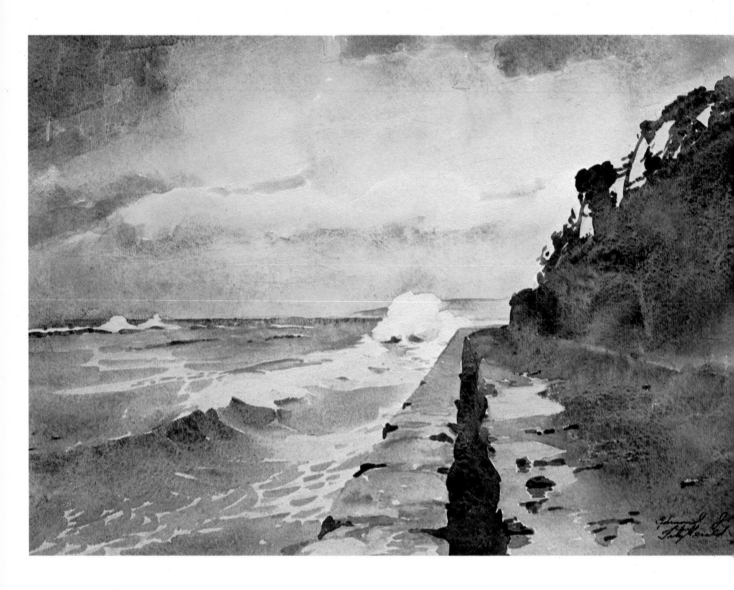

Puget Sound Storm, *11" x 15", 140 lb. cold-pressed, stretched Whatman paper. The drawing and painting for this one was done from the partial shelter of an ancient touring car, on the shore between Seattle and Tacoma. It illustrates the cool top-light present in stormy conditions and the unifying, misty effect of such weather. The blustery wind caused the surf to explode in sudden puffs of white. Ivory black, cobalt blue, yellow ochre, viridian, and a little burnt sienna were the only colors that I used. No wet-blending was used, except a little (inadvertently) from blown spray. However, I did a good deal of fusing of washes, implemented by the slow drying conditions. The sky reflections shown in puddles behind the sea wall are nearly identical in color to the reflection on the wet rocks.*

that becomes gradually darker is a little more difficult, but you can do it by intensifying the mix with more color before each pass.

Superimposing Washes

When your first wash has dried, you can lay a second wash over all or part of it. When you do this with conviction as a planned effect, all is well; but some of the freshness inherent in watercolor is sacrificed in the process. If you attempt the second wash with hesitancy, it usually shows. Watercolor has a way of "telling on you" for your shortcomings.

Sometimes a second wash causes the first wash to dissolve in places, producing muddy and undesirable effects. Some earth colors, particularly if the first wash uses a lot of color, dissolve more readily than others. You can avoid this unwanted result to a great extent if you apply the second wash with a rapid, light touch, flowing it on without heavy scrubbing with the brush. The second wash should, normally, be darker than the first. If you make it too light, you have not accomplished much, except possibly the unwanted effect of disturbing the first wash. However, there are exceptions where a light "glazing" — to produce a cool, dewy effect, for example — is worth the risk.

I have spoken of a first and second wash only; more are, of course, possible. Some excellent watercolors are constructed of many overlying washes. In my own work I definitely try to limit the number of superimposed washes, but all overlying washes should be applied along the same guidelines as a second wash.

Frequently, it is desirable to lay a cool wash over a wash of warm color, to produce a luminous effect on rocks or old walls, for example. The reverse, warm over cool, may also be effective. You should first lay such combinations on a separate paper to test for the desired final color value.

Painting Shadows on Sunlit Areas

The color of sunlit areas can occasionally be effectively painted as a large, first wash, including places where shadows appear. You can then superimpose the shadows as a second wash of darker, usually cooler color. In small outdoor watercolors, I often paint shadows, particularly large shadows, first and fill in the light areas between. Then I superimpose small shadows. This procedure helps me to quickly establish composition, particularly when shadows are large and therefore important to the pattern. It saves time and preserves freshness; also when I do it quickly, it permits fusing of light and shadow edges where necessary.

Wet-Blending

Beginners often ask, "Before putting on the colors, should I wet the paper first?" In my book of rules, the answer is, "Sometimes yes — but mostly no."

Painting on a wet or damp surface of paper enables you to produce an effect called "wet-blending." Colors fuse into one another in a way that is difficult to duplicate by any other method. You can express certain soft effects seen in nature in this way with great conviction. You can create an illusion of depth by contrasting the softly blended forms of objects which are some distance away with the sharp-edged forms of objects which are closer.

Like many good things, wet-blending is sometimes overdone and becomes a tiresome, manneristic cliché. The worst feature of the method is that it is difficult to control the drawing and values. As the brush with color and water touches the damp paper, the color flows softly away from the brush into the surrounding area. With luck and skill in judging the amount of dampness, you can exercise a certain degree of control, but at best it is approximate. This is no great problem if the effect is in a part of the painting where some latitude in rendering specific shapes is acceptable.

The values are just as hard to control as the shapes. A value is mixed on the palette by adding the correct amount of water to a color. When this is conveyed to the wet paper, the color leaving the brush is additionally diluted by the moisture on the paper, changing the value.

You can use the wet-blending technique on soaking-wet paper. The paper will lie flat on a smooth surface like glass or metal because of its wetness. You can maintain the wetness by occasionally lifting the paper and applying water to the back with a sponge. I prefer lighter weight papers for this method. The paper is softened and made absorbent by the wetness, and the colors tend to soak in. As the paper slowly dries, the colors retain their position to a greater degree than while it was very wet. When the paper is fully dried, you can apply crisp strokes or washes in the same manner as on the unsoaked paper.

You can use wet-blending on only a portion of the paper, the sky, for example, by carefully brushing clear water on an area delineated with pencil. Colors that you brush into this wet area fuse into each other according to the amount of wetness, absorbency of the paper, and staining power of the color. This technique is illustrated in *Northeast Harbor*, p. 78.

In my opinion, students should leave wet-blending alone until they have experimented considerably with direct washes.

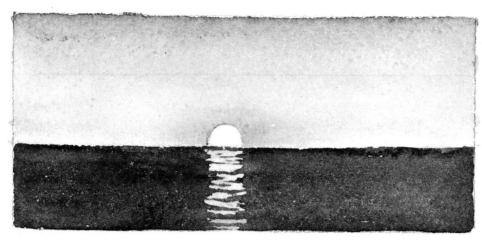

Masking. I first painted the sun and its path on the sea with a liquid masking material. (There are several brands on the market, but I usually use Maskoid.) After the sky and dark sea were painted, the masking was rubbed off, and I tinted the sun and its path with cadmium yellow pale.

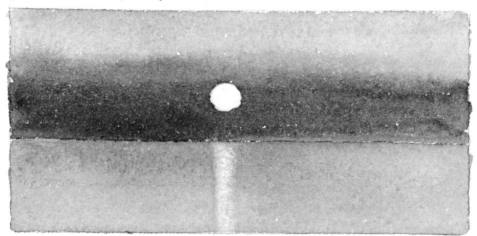

Wiping Out. Again I used Maskoid on the sun but this time not on its path. To make the soft sun path, I scrubbed the area with a bristle brush and lifted out the loosened color with a pad of tissue. When the masking was removed from the sun, I tinted it and the path with cadmium red.

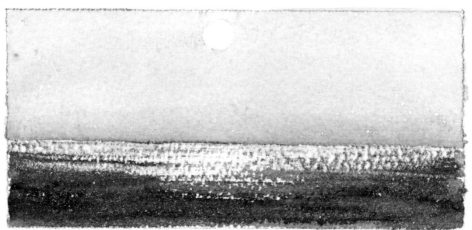

Scraping. This third sunrise shows the sun higher and brighter. Once more I used masking for the sun, but the broad glitter on the sea was achieved by scraping with a sharp blade. The sun and glitter were left white. Careful scraping with a dull point along a dampened line through a wash produces a dim line without tearing into the paper surface. You can then retint the line. I find this process useful in rendering twigs, ropes, and other narrow objects.

Fusing Adjacent Areas

Besides the wet-blend technique for creating soft, blended edges between colors, there is another way to create a blend where two strongly different colors or values come in contact. I refer to it simply as "fusing."

When a smoothly rounded form — the tower of a lighthouse for example — is about half in light and half in shadow, you must paint the light and shadow areas with entirely different colors. The sunlit part of the white tower might be painted with clean water tinted with a little cadmium yellow and a touch of alizarin crimson. The shadow part might be a fairly dark mixture of cobalt blue with touches of Indian red and yellow ochre. Because of the round form, the place where the light and shadow meet on the tower must be smoothly blended. Since this blend is at a definite place, the colors must be carefully controlled in the blending. To keep control, I prepare the color mixtures on separate parts of my palette. Then I quickly lay in the two washes — light and shadow — separately, leaving a narrow strip of dry paper between the two. The trick is to have both washes lying side by side on the paper about equally wet. Then I quickly run the tip of a damp (not too wet) brush down the narrow strip so that it touches both washes at the same time, and the two will fuse. With a little practice you can achieve a nice blend in this way, at the same time preserving the necessary contrast of value and color between light and shadow. This method works equally well on objects that are smoothly rounded and strongly lighted, but have irregular forms, such as the limbs of trees or sun bathers.

Masking

Masking is the method of covering an area of your watercolor paper with a waterproof material that can be removed after you have washed over it with broad, preliminary tones. Generally I use liquid frisket for this. (Maskoid is a popular brand name.) Frisket paper, strips of masking tape, or rubber cement can also be used. I find this method useful where I want to make large, complicated washes like skies behind light-colored, sharp-edged forms like the masts of boats.

Apply the masking to the places you want covered on your drawing. (If you use the liquid type, be sure to follow the directions on the bottle.) When the preliminary washes are dry, remove the masking. You can rub off the liquid frisket with your fingers, exposing clean paper for further work. You can also use masking over primary washes, while the second or third washes are being applied. Simply apply the masking where desired on the dry first wash and proceed. When you remove the masking material, the primary tone of the wash instead of original white paper will be exposed.

You can render complicated designs involving intricate tracery with the help of masking material. However, like many good things, it can be overdone or clumsily used. If its use in a painting is obvious, it is probably misused.

Wiping Out or Lifting Color

Early in this chapter I spoke about the delicate strength of watercolor. Paradoxically, it sometimes responds admirably to some rather rough treatment. Ogden Pleissner, N.A., A.W.S., one of the ablest of contemporary painters, told me that he has on occasion taken a stiff brush, industriously scrubbed out an entire foreground that did not please him, and then repainted it. Once I plunged a paper that I had worked on at length into a tub of water, thinking to re-stretch it and use the other side. As some of the colors began to dissolve, changes occurred that encouraged me to rescue it from a watery grave, go to work on it again, and bring it back to life.

Obviously, then, repairs can sometimes be made. You can scrub an area down with an old toothbrush and water to almost clean paper. Even soapy water can be used on strong rag paper. You can achieve a more delicate lifting of veils of color by dampening an area, pressing a piece of facial tissue over it, and peeling the tissue off along with some of the color. If you want to lift a little more of the color, substitute a blotter in place of the tissue. Repeat the entire process of removing layers of color several times, but be sure to allow the paper to dry thoroughly between each color lift.

Scraping

You can make a neat, pale line through a wash by dampening and scraping a line with a dull pointed tool. A sharp pointed tool may cut into the paper, causing a white scar, but even that is sometimes useful. The edge of a cosmetic emery board is fine for scraping thin white lines (to render ship rigging, for example).

Deeply scraped areas usually cannot be repainted because the roughened surface takes watercolor in an unpredictable way; however, you can burnish a scraped area smooth with something like the back of a spoon, and then try repainting it. Do the burnishing by repeated, firm rubbing with the smooth, hard surface of the spoon.

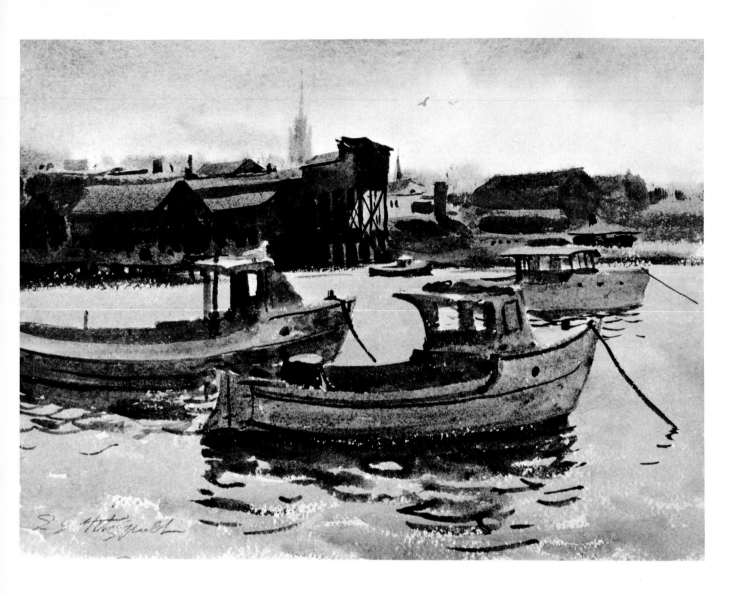

Newport Waterfront, *11" x 15", 300 lb. rough Arches paper. As the fog began to burn off, I pushed the pencil drawing as fast as possible in order to capture the effect before it changed completely. I wet the upper part of the drawing down to the shoreline with clean water, leaving the sea gull and the top of the boat cabin dry. I quickly brushed color into the wet area for the glowing, lower sky and spread a wash right across the top margin of the paper, brushing it down to fuse with the first wash. A strong mix served as the cool top-light on the building roofs. I lightened a spot with a tissue, near the center, and fused some color into it where a small church building glowed palely through the haze. By now the sky was almost dry; and with a couple of upward brush-strokes, I suggested the tall steeple. Then I covered all of the water with a diluted wash, avoiding only the pale top decks on the boats. As I neared the immediate fore-ground, I achieved a slight color and value change in the wash, and then I let my brushstrokes leave a few white "skips" to suggest glitter on the waves.*

Small Boat Moorage, Larchmont, *11'' x 15'', 300 lb. rough Arches paper. I painted the boats in Maskoid to protect the paper from the large wash I planned to lay over them. By the time the Maskoid was dry, I had planned the next steps, mixed the requisite washes, and wet the entire area of paper down to the shoreline with a sponge and clear water. This created the soft horizon line, and the feathery texture of the leaves of the little locust tree. It was a fast drying day so I had to hurry to lay washes for the sky, water, and locust leaves while the paper remained wet. Pre-mixing the three basic washes in the palette's separate divisions did the trick. I painted the sky and water in a continuous operation, simply changing to the pre-mixed darker wash for the water when I arrived at the horizon. When the sky and water were dry, I rubbed the Maskoid off the boats. I had painted sky and water right through the treetrunk, but I gently wiped a path for it.*

On the Oregon Coast, *11" x 15", 140 lb. rough, stretched Whatman paper. I climbed a rocky bluff to paint this watercolor. It shows the drawing problems which are important even in a slight painting. Once I had decided upon the placement of the high horizon, I determined the slant with respect to the horizon of the other major lines — the breaking surf, the edges of the beach, and the shape of the headland — by sighting with a carpenter's ruler. Observing the calibrations on the ruler, as I sighted past it toward the various parts of the headland, was helpful in determining the relative distances, vertical and horizontal, involved in placing the headland shape with respect to the horizon. For example, I determined that the distance from the horizon to the base of the headland (near the figures) was about one-third of the distance from the bluff on the right to the rocky point farthest to seaward. Also, this rocky point was about halfway between the base of the headland and the horizon. All such relationships must be carefully considered in order to retain perspective illusion. I left white paper for the gentle breakers. The tiny figures gave scale to the scene.*

3

Drawing outdoors

One of the dictionary definitions of drawing is "To draw, as water from a well." This is a good statement to have in mind when you think of drawing as a preliminary for watercolor painting. In other words, you want your sketch to draw out or select certain things for further use. This concept is particularly applicable to drawing outdoors. The changing light, shifting patterns in sky and water, and even the changing aspects of stationary things place a great demand and limitation on draughtsmanship. This limitation of time and the demand for quick decision in selection make drawing in the field different from studio work.

The special properties of field work can be very frustrating, but there are some fringe benefits. Your senses are quickened, and occasionally, in spite of human clumsiness, precious qualities of freshness, sincerity, and spontaneity creep into your drawing.

Selecting Subjects

What subject shall I choose? Everyone who has gone outdoors to sketch, even the student well-prepared by studio work, knows the problem of selecting a subject. Setting up a still life or posing a model is good basic training, but it is only partly helpful. You can't shift the sun around like a flood lamp, or move boats and buildings like lemons. Most advice seems negative or frustrating: "Don't paint the ordinary," and "Use your imagination to move things about." These are sound enough advice, but the question, "What subject shall I choose?" remains unanswered.

Part of the problem is solved for me because I am drawn to water like a mule in the desert. I seldom choose a subject which does not have at least a puddle in it. As this book is about marine painting, we are "on course."

Judging the Composition

A view finder can help you judge the composition of a picture. You can fashion one by cutting an opening, or "window," in a piece of paper. I prefer a folding carpenter's ruler. I shape three segments of the ruler into three sides of a square. With my thumb I hold a pencil or brush handle to make a fourth side to form a rectangle of suitable proportion. The rectangular shape can be varied by moving the pencil with my thumb. I use this like a window to study tentative subjects. The field of vision is varied by moving the "window" closer or farther from my eye. Scale — the size of objects seen in relation to the frame — varies, of course, at the same time. The view finder can be held in both horizontal and vertical positions to help you decide upon a composition.

The "Easy" Subject

I don't wait until I find the "perfect picture," but try to interest myself in the abundance that nature offers. With a little concentration, I see pictures everywhere, but the moment I think I have found an *easy* subject, I am on guard. I am certain that there is no such thing. Subjects that *seem* complex often give the least trouble. When beginners stop looking for easy subjects, they have better luck.

Michelangelo said, "Every rock contains a statue; you have only to chip some away." Some subjects require a little "chipping," or something added, like condiments in the stew, but in outdoor subjects I try to respond quite directly to the visual experience. I try to see my picture first and then transcribe it in terms of drawing or painting. With the view finder, I decide whether I should direct my attention more to the sky or more to the foreground. I half-close my eyes so that I can see the large patterns instead of a multitude of details. A great deal of selection and elimination takes

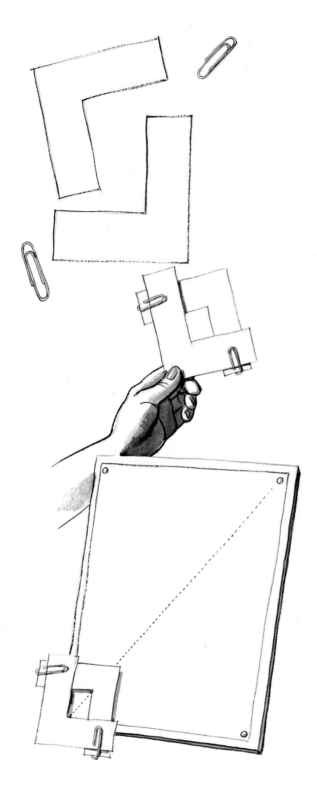

place, but I try to respond to the scene before me rather than to any preconceived need to rearrange it into a composition.

I can't say that the above procedure is foolproof, but it does help me make decisions and get on with the work. An urgency to get on with the work *must* be present, and with it, a recognition that time is of the essence.

Line

Drawing starts in the eye and in the mind, but it doesn't happen until the hand makes a dot, and as soon as the dot starts to go somewhere, a line. Degas said, "A line is like an acrobat; it risks its life every second."

There are thin forms in nature, twigs for example, that you can express by a single line, but in actuality lines are invented in the mind and do not exist in nature. They are a kind of shorthand, born of the draughtsman's will to say something. Before the pencil touches paper, four lines, the edges of the paper, already exist. However, they can be changed by setting down a new shape of different proportions. The first lines you conceive should begin a plan for a picture. The fundamental purpose of these lines, then, is planning.

Planning the Picture

Each line can say several things. The line of the sea horizon, for instance, also marks the edge of the sky. Lines may outline or detail objects, but their principal purpose is to plan the subdivisions and further steps in establishing the picture — the larger subdivisions first and then the smaller.

The subdivisions for a watercolor usually delineate the main washes of color that will be involved. A first wash may cover all, or nearly all, of the picture. Such planning should be thought about throughout the drawing preparation. Ask yourself what procedures you will need to establish the picture and try to make the pencil lines indicate the steps.

The time you have available is an important consideration. This might be determined by when you have to be home for dinner, but more importantly, it involves such things as the changing light. You may have time for very few pencil lines, or none at all, in attempting to capture some fleeting effect. For an outdoor watercolor, I often spend a good deal of the time available drawing in pencil lines, but if the occasion demands, I proceed directly to the brush without executing a pencil drawing at all.

View Finder. *Should the composition of your painting be square or rectangular? Vertical or horizontal? Questions like these can be explored with a view finder. To make one, cut an opening, "or window," in a piece of paper. Or you can make an adjustable one with two L-shaped pieces of cardboard held together with paper clips. To make the view finder reflect the proportion of the paper you are working with, adjust the two L-shaped pieces so that the diagonal of the shape they form coincides with the diagonal of your paper.*

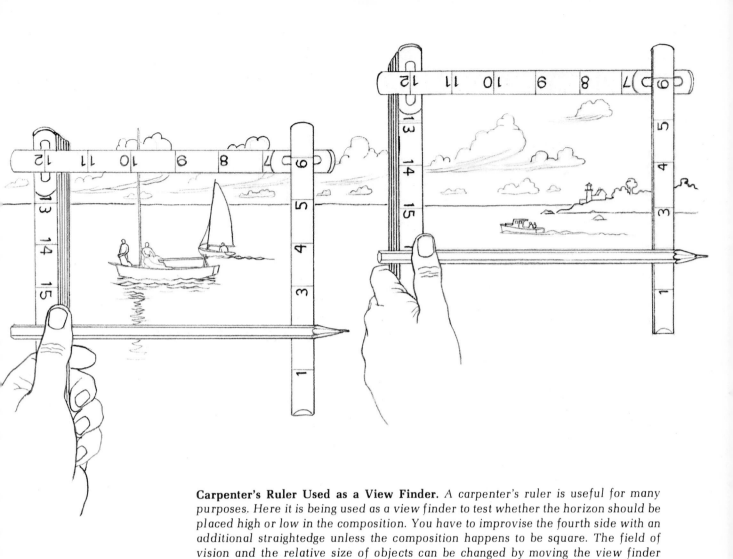

Carpenter's Ruler Used as a View Finder. *A carpenter's ruler is useful for many purposes. Here it is being used as a view finder to test whether the horizon should be placed high or low in the composition. You have to improvise the fourth side with an additional straightedge unless the composition happens to be square. The field of vision and the relative size of objects can be changed by moving the view finder closer or further from your eye.*

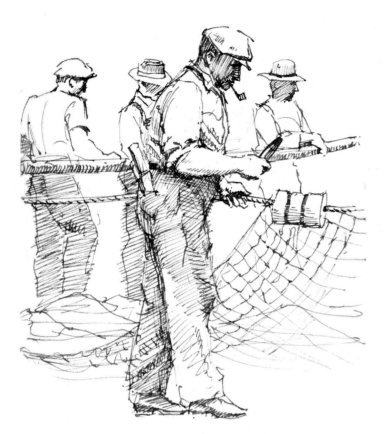

Lines. *Lines can express a great many things. If two sets of parallel lines are placed across one another (a technique called crosshatching) or if the lines are simply grouped together, they can express tone values.*

Value

The same tool used to draw lines — charcoal, pencil, crayon, or perhaps pen or brush — can also establish tone values, usually called "values." Values refer to the range of tone from white to black. Values can be drawn with an assemblage of lines such as crosshatching. They may also be rapidly stated with a smudge, a broad stroke of the side of a charcoal stick or crayon.

Just as lines are the plan or the bones of a painting, values give it pattern and are the flesh. Learning to judge the values in their relationships is no easy matter, but watercolor is admirably suited to setting down values rapidly because of the speed with which water and pigment can be applied. Every color is also a value, and a single pigment of any dark color and water can be used to express a range of values. Lighter values are achieved by adding water to the dark pigment, thinning the paint mixture.

Color Temperature in Drawing

It should be apparent that, while we are discussing drawing with lines and values, we are already in the province of painting, because we are talking about stating the values with a brushful of color and water — albeit only a single dark color instead of a pencil.

If we go a step further into the transitional area between drawing and painting, we engage a fundamental concept of color, the color temperature. Temperature refers to the warmth or coolness of values in their relation to one another.

To illustrate this concept, consider two pigments for drawing broad value patterns with the brush — cobalt blue (cool) for sky and sea and burnt sienna (warm) for beach and sun on the rocks. You can mix these two to form a considerable variety of values for shadows and intermediate tones, with varying degrees of warmth and coolness. You can follow the same experiment using other color combinations — warm and cool. This use of color adds temperature range to values.

Dry pigments, as well as watercolors, serve well in this kind of drawing. Sanguine (red) Conté crayon and artificial charcoal (Siberian charcoal) are a good combination. Gray values of the charcoal look cool in juxtaposition to the red Conté. You can mix the two to produce values of varying temperatures. You can also use a warm-toned paper (brown wrapping paper will do) in combination with black (charcoal) and white (chalk) to achieve a color temperature relationship within a value range.

Relationship of Temperature and Value

The temperature range is related to the value range, but it should be considered independently. Successful use of the two, value and temperature, must be based on a good sense of values and a sensitivity to the warm-cool relationships in nature. Warmth is related to light and coolness to shadow, but these relationships become complicated by reflected lights. Reflected light produces warm tones in some shadows and cool passages in some lights. The orchestration of these two opposing forces — warmth and coolness — within the framework of line and values tells us much about the use of color to represent nature. (See *Jack's Cove, Morning*, p. 21.)

Perspective

Perspective is an involved subject, and no attempt can be made to give it a comprehensive treatment within the scope of this book. (See *Bibliography*.) Most texts on the subject concentrate on the architectural aspects of perspective, where the problems can be most clearly visualized. A good grounding in these aspects is helpful. A simple mechanical aid and a critical eye can also help with perspective problems. The mechanical aid is, again, the folding carpenter's ruler.

Lines that are parallel to each other do not usually *look* parallel. For example, the lines of the floor, ceiling, streets, fences, and roofs all seem to slant. The lines of a flagpole, the horizon of a large body of water, or the corner of most buildings, however, are either straight up-and-down or horizontal. The chief problem, when drawing the apparently slanting lines, is placing the direction of their slant with respect to vertical or horizontal lines. With the carpenter's ruler you can measure this slant, apply the information to your drawing, and check your freehand estimate of the slant.

Carpenter's Ruler

The carpenter's ruler comes in six 1/2" folding sections, so that if you open it, like a jackknife, it remains at whatever angle you leave it. If you hold a section of the ruler before your eyes and line it up with something you feel sure about — the vertical corner of a building, for instance — then, with the other hand, move the next section until it lines up with, say, the line of the roof, you can place the ruler on the drawing and check the angle of your freehand sketch of the lines. This process can be repeated, checking the angle one line makes with another, as many times as necessary on the drawing.

Values. *Values (variations in tone, including white and black and all shades in between) can be expressed with anything that makes a mark on paper. They are of primary importance to painting in any medium because every color is also a value. In this study, I used pencils of three degrees of softness: 3H for the light values, HB for medium values, and 4B for the darkest values. The blacks are practically smudges of graphite made with the soft pencil.*

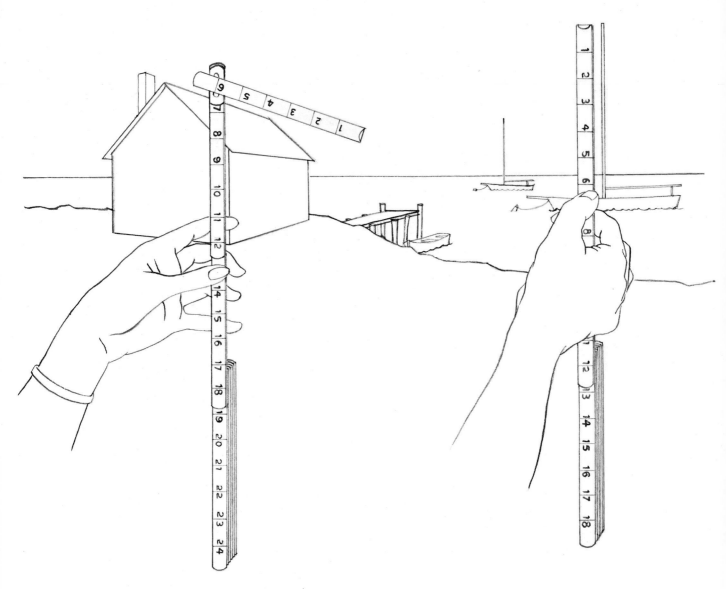

Perspective. The folding carpenter's ruler is a helpful mechanical aid for solving problems of perspective and scale. It can check the angle between a vertical line (the corner of the building) and a slanting line (the ridge of the roof). You can also use the calibrations on the ruler to check the difference in the apparent height of the masts of the two sailboats, which are at different distances from the sketcher. At the same time, you can check the distance below the horizon of the two boats. The calibration measurements are applied to your drawing in a relative way.

More subtle lines, the way a beach slants off toward the horizon, for example, can be checked in the same manner, using the horizon as the line you feel surest about. The lines of all kinds of structures — piers, boats, etc. — can be checked; also lines of waves, clouds, and anything that might look wrong if its perspective goes too far astray.

Scale

The calibrations on the ruler can also be used to help with the tricky problem of scale. If you hold the ruler up and observe that a sailboat moored a short way off measures 3" in length (visually) and another sailboat of the same type moored farther off measures 1", you can use this information in a relative way to check your drawing. In other words, you would not necessarily draw boat number one 3" long (it could be any length, depending on the scale of your drawing), but you would make sure that it was drawn three times larger than boat number two.

The problem of vertical scale, a common area of error in shoreside sketching, can also be checked. How far below the horizon should a point of distant shore be placed, relative to a point closer at hand? With the ruler held vertically and the calibrations observed as you look past it to the points, you can get an idea of the relationships needed.

Plumb Bob

Still another use for the carpenter's ruler is as a plumb bob. If you open out several sections of the ruler in a straight line and hold it lightly at the top between the thumb and forefinger, it will hang in a vertical line perpendicular to the horizon. By making observations past it, you can get an estimation of how things in the background line up with things in the foreground — another area that leads to frequent errors in drawing.

Rapid Sketching Methods

The entire concept of outdoor drawing must be based on quickness. Let's return to the most elementary and yet most eloquent expression of drawing, the line. You can get bogged down by trying to make each line too exact in the early stages of a drawing. The eraser, a great friend at times, can also be a time-consumer. Avoid erasing at all if possible. State "blocking in" lines lightly. Then if they are not right, it usually does not matter. Such lines are present in many great drawings by Raphael, Rembrandt, Tintoretto, and Ingres.

The early stages of a drawing should be used to roughly establish the big shapes. My method is to draw light lines, blocking in the biggest shapes of sky, sea, land forms, and structures in the simplest possible way. These lines are not outlines, but lines of *direction* and *distance*. For the most part these lines are straight, since the simplest way to express a general direction and a distance is by a straight line. The entire picture space is divided up in this way to help me visualize the succeeding stages. If the drawing is in preparation for a watercolor, I try to think in terms of watercolor washes right from the start. In this way, the lines become a guide for these washes, as well as being statements of form. Avoid erasing; instead, make your corrections by second or third statements of the lines. As your confidence in the correctness of a line increases, it becomes more firmly stated in successive restatements.

As the drawing progresses, I swing in curving lines and detail edges for the washes. If areas of light and shadow are sharply visible, their shapes are also firmly drawn. (The pattern of shadows may be more germane to the composition than the forms that cast them.) However, I leave many texturing effects that involve intricate, small shadows or brushstrokes for final work with the brush. Such decisions are usually determined by the time available. On rare occasions when under pressure of time, I eliminate all of the above and go to work on a quarter sheet directly with the brush, in effect, doing my "drawing" mentally without a pencil line at all.

I always keep a small 4" x 6" or 5" x 7" sketchbook handy to set down notes in either line or color. I often interrupt work on a larger sheet to make notes. If time permits, I make a thumbnail sketch in the notebook beforehand to test the composition or to plan an effect.

Use of Pastels

A quick sketching medium that I like for outdoor work, particularly for surf, is pastel. I select a colored paper that will serve for one of the values, for example, the cool shadow pattern in the white water of cresting waves. I then use three or four pastel sticks for quick color notes. One of the sticks might be a warm white for the sunlit part of the white water. The second, a pale green for the trailing wake, and perhaps two more in shades of blue, for the non-aerated water. Such pastel drawings can provide fresh color notes for further work in any medium in the field or back in the studio.

Photography as a Drawing Aid

Many painters are also photographers and make use of this craft as a drawing aid, even for record-

Preliminary Drawing: Step 1. This drawing was the beginning of the watercolor, Junks at Danang. The first line established was the slanting line of the beach. The large shapes of the sails were the next order of business, and I located them by first determining the position of the masts. Then with the location of the horizon line I had established the major abstract subdivisions of the painting.

Preliminary Drawing: Step 2. I blocked in the shape of the sails and boat hulls next. Note that the lines drawn tend to be straight and are primarily lines of direction and distance. Such lines effectively locate the shapes of large color areas of washes and permit you to decide whether or not your picture is developing in composition to your satisfaction before you become involved in the time consuming problem of drawing smaller details. Restatement, and if necessary, erasure of "blocking-in" lines is less troublesome than changing carefully copied outlines.

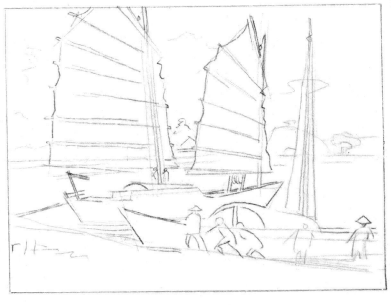

Preliminary Drawing: Step 3. When the blocking-in lines seemed satisfactory, I drew the additional lines needed to guide the brush. Among the first of these lines drawn in were the figures, as they were still beaching the junk and I knew they would soon be gone. Before I had finished the drawing, the sails were in different positions, so some of the drawing — and much of the painting — had to be done from memory.

ing color. The Polaroid camera makes it possible to produce instant photographs.

I use photography at times in studio work and have come to some conclusions about it. The camera has done much to contribute to the ease of picture-making, but it has contributed little to the art of picture-making. Perhaps, in terms of disciplined training, it has taken away more than it has given.

Pietro Annigoni, the great contemporary Florentine painter says of the camera, "...it can produce only feebly the appearances of nature and life. For this reason it does not interest me even as a means. A hasty sketch set down under the impulse of a spontaneous emotion of my own is for me a thousand times more vital and evocative."

To make use of photographs for drawing or painting, you must recognize that you are imposing a mechanical device between your eyes and nature. The eye focuses on only one point at a time,

and thousands of impulses are triggered in the complex computer of the mind in the process of seeing. Your two eyes, with their stereoscopic effect, complicate the process still more. The camera "sees" impartially everything within its field and focal depth, and only the skilled and clever photographer can impart a modicum of personality to the result.

I see nothing wrong in using photography if it can help produce a better painting. The great difficulty is to transcend its dominating influence. Paradoxically, if you have enough knowledge of nature to fully avoid the dominance of photography, you probably have no need for it. The best source of this knowledge is nature itself. The camera is a mechanical aid, but then, so is the brush! If you use all mechanical aids within the terms of their limitations and go directly to nature for your main source of information and inspiration, you cannot get very far off the beam.

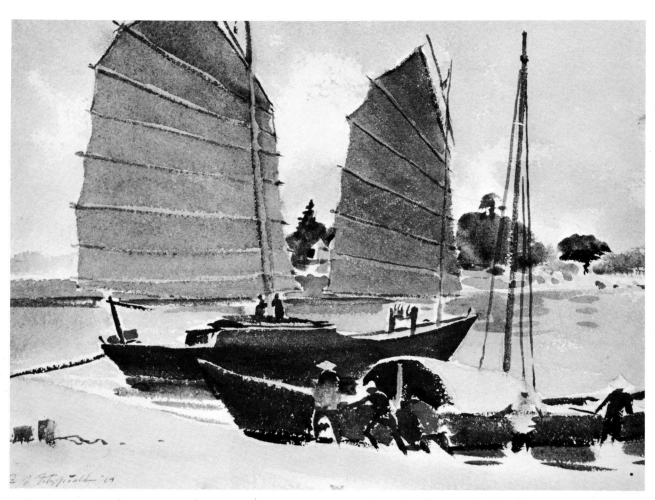

Junks at Danang, *11" x 15", 300 lb. rough Arches paper. I used about 45 minutes for drawing and painting this scene. It was blistering hot. I painted the sails first. The mix on my palette became concentrated by evaporation so I immediately applied a second coat of the slightly* *more intense color over the dried first coat. I applied the second coat in bands, leaving the first coat exposed at places to show the slim battens in the sails and the masts against the sails. Later I accented these details with still darker touches. I left white paper for the clouds.*

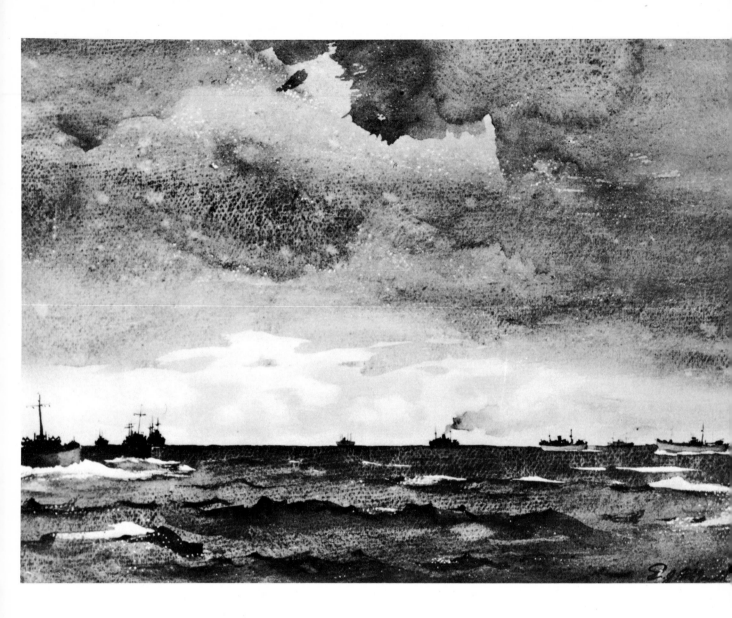

Convoy, 10" x 13", 72 lb. rough, stretched Whatman paper. This painting is a souvenir of World War II, done from the bridge of LST 175. (I was her skipper.) We were making a passage from the Mediterranean to England in January, 1944. LST's were on the flanks of the convoy to shield the merchant ships, of which several can be seen to the left in the painting. Enemy planes and submarines pestered us all the way, but the dreariest enemy was the weather. That patch of light in the sky at the horizon was the most promising thing we had seen, and it prompted me to get out my paints. The break in the clouds only lasted half an hour. A few pale spots appear in the sky where spray was blown onto the wash. I stood under shelter, but there were few really dry places on board. I can still feel the cold. The nearby waves appeared in bold relief because sleet was spattering the troughs beyond.

4

Watercolor outdoors

"On-the-job training" is a household phrase nowadays and it is applied to many varied activities. I must say that the "learn by doing" idea appeals to me as the best way to tackle watercolor painting. Watercolors done in the field present numerous problems, but I will try to show that the problems, in spite of the hazards they present, contribute to their own best solutions.

In my own career I have done little in the way of practicing brushstrokes or laying down perfect washes as a kind of exercise to learn watercolor technique. I would therefore be less than sincere if I were to urge such practices on you. I do not insist that the approach of doing exercises is wrong — for everyone — but I propose in this chapter to chart a different course and present some reasons for following it.

Selecting Subjects

My approach to painting is to look for pictures in the world around me and try to set them down in line and color. This "on-the-spot" practice includes the world of sky, water, and earth — in short, landscape. My emphasis is on the waters of the earth, but you can apply the attitude of this approach indoors to still life and figure and interior studies — all of which I often try.

The knack of seeing pictures around me may be an acquired thing, like a taste for olives. It has been with me for so long that I cannot recall when it started — but then I cannot remember my first olive either. I believe the knack springs from my conviction that the raw material of pictures is not in objects but in their aspect, the way light falls over forms and reveals them to our sight. Light itself becomes the principal raw material.

Time of Day

Outdoors, light involves time; the time of day affects the light's intensity, color, and direction.

The way light falls on objects is usually more important to the picture seen in nature than any other factor. A scene that suggests a picture under a certain light presents an entirely different picture under a different light, or it may not appeal as a picture at all. When a picture suggests itself to you, it is important that you estimate the time that will be available for sketching, the time that the light will remain fairly constant. The position of the sun and its probable position in an hour or two hence are important considerations in making this estimate. Probable cloud movements are another consideration.

Overcast Day

An overcast day with no direct sunlight remains fairly constant for a longer period than most other light conditions. The diffused light that prevails on such a day does not appeal to everyone, but I often find it to my liking. A cool top-light falls over everything, and local colors often seem more intense. (Local color is the actual color of an object, uninfluenced by reflected light or color.) The strongest source of light on such a day is still the sky overhead, but not from a single point as when the sun is out. The shadows are muted and soft-edged, rather than intense and sharp-edged as in sunlight.

Bright Sunlight

Bright sunlight bathes things in warm-colored light, but it produces such a powerful contrast with its strong, cool shadows that the range of values when you draw or paint is strained toward its "black and white" limits. Local colors tend to be overpowered by the value range.

Diffused Light

In diffused light, since the light is less intense and less warm than in direct sunlight, shadows are also

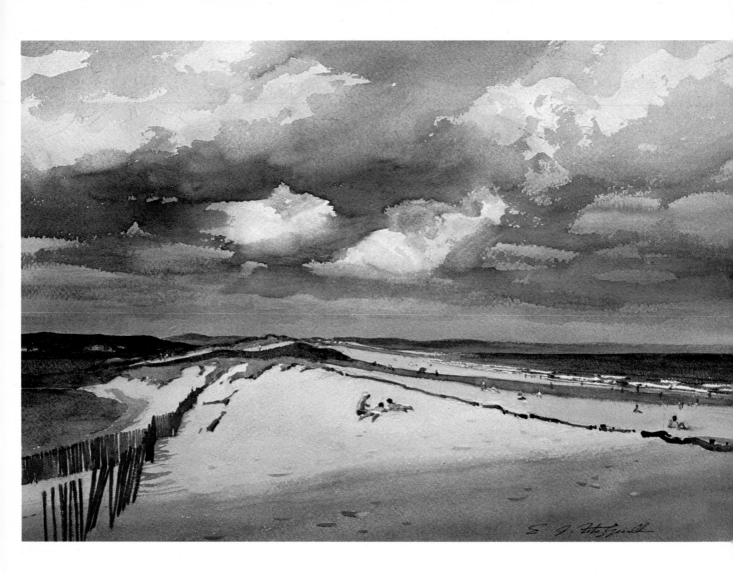

Shower over Cape Porpoise, *13" x 19", 140 lb. rough, stretched Arches paper. I painted this watercolor in the studio from a small 10" x 18" oil done quickly on location. (Obviously the oil was of different proportions; it had only the lower third of the sky which is shown in the watercolor.) I improvised the cloud forms of the upper sky from those in the oil. I drew the upper sky as a perspective extension of the dark cumulus clouds near the horizon. They seem to move on an invisible ceiling, and their illuminated tops are seen occasionally through holes in the ceiling. Transitory effects, such as the moving cloud shadows and figures on the beach, were gleaned from the oil and also from memory. The darkness of the approaching shower clouds brings out the light on the dunes and whitecaps and soon sent the sunbathers (and me) scurrying for shelter.*

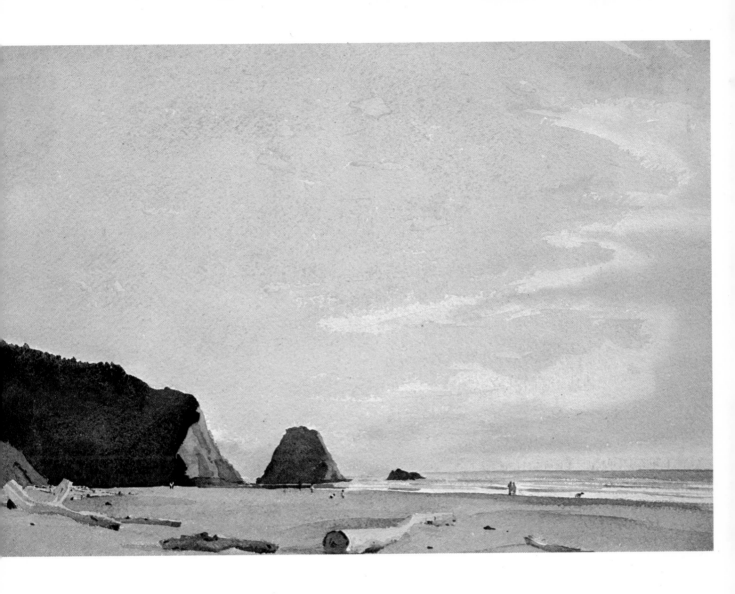

Beach at Arch Cape, *10" x 14", 140 lb. rough, stretched Whatman paper. This quarter sheet, painted late in the afternoon, was the basis for Arch Cape at Evening. (See Demonstrations section.) The very low horizon and small figures of this composition agree with the traditional English school of watercolor. I changed the demonstration painting considerably in composition, but it still retains a similar mood. The vast sky, which gives an effect of limitless space, was done in two washes. The first wash was yellow ochre for the light on the clouds, with warm gray shadows wet-blended. The second wash was pale cobalt blue.*

Midday. *Detail of* Lobsterman's House, Cape Neddick, *p. 101. When you paint in the bright, vertical light of midday, remember that distinct shadows fall directly under objects like this boat.*

Overcast Day. *Detail of* Winter Morning, Weymouth, *p. 140. On an overcast day the light is gray and diffused, and the tonal contrasts are reduced by the overall grayness.*

Transitory Effects. *Detail of* Bronx Marshland, *p. 111. A fleeting effect, like these windblown trees, must be caught quickly as you paint, or at least captured by your memory, perhaps with the aid of a rapid sketch.*

less intense. Cast shadows are practically nonexistent, and local colors have a better chance to assert themselves. Light from the overcast sky is a cool blue-gray, and it will mostly influence upper surfaces. Warm colors on other surfaces become more apparent. The mist or rain that often accompanies such light is not desirable when it falls on your work, but working from shelter is sometimes possible. More than once I have worked on a watercolor, holding an umbrella with my left hand — sometimes to the accompaniment of chattering teeth. (See *Puget Sound Storm*, p. 24.)

Midday

The middle of a sunny day from about 10:00 A.M. to 2:00 P.M. is usually the least interesting time to look for subjects. Strong sunlight from nearly overhead appeals to few landscape painters. The many small shadows which then appear directly beneath forms produce a confused, broken up effect. It is also a time when radical changes in the light on vertical forms occur. A wall that may one moment appear in shadow may soon be flooded in light as the sun overhead moves a short way, and the picture concept is changed completely. Midday is a fine time for a siesta.

Sunlight near noon is usually hottest, but the heat is not directly related to the color temperature. The low-slanting light of early morning or late afternoon produces the warmest glow of color on sunlit forms. The shadows are larger then, and the contrast between light and shadow is more dramatic.

Transitory Effects

Some light effects that are extremely dramatic are of short duration, and you cannot always anticipate them. A burst of sunlight breaking through clouds or cloud shadows racing over land or water remain only a few seconds. Rapid sketching, a good memory, or photography help you capture such effects. (See *Shower Over Cape Porpoise*, p. 42.)

The transient sun is not the only time-limiting factor. The rise and fall of the tide sometimes produces radical changes in the appearance of salt water subjects. Also, moored boats that you start to sketch have a tendency to get underway, and trucks often park in the foreground. Tide tables and knowledge of local conditions can be as useful to the artist as they are to fishermen or sailors.

You can expect some of the moving elements in nature, waves or clouds for instance, to repeat themselves to some degree. Clouds are not too reliable in this respect, but cresting waves sometimes consent to "pose" more than once, however briefly. Other times you must rely on memory.

Personal Discomfort

Your main problem with field work may be physical discomfort, even painful experiences. Weather conditions can turn unexpectedly grim in a short time. Violent gusts, sudden showers, radical temperature changes — all are familiar to the outdoor artist. Rising tide and blown spray can suddenly soak you and your watercolor. Savage creatures, ranging from gnats to snorting cattle, may pester or terrify you. Natives, friendly or not, may annoy.

Sir John Millais (1829 - 1896) described a typical encounter he had while making sketches for the painting *Chill October*, now in the National Gallery, London. He was working in a field along the Scottish border when a local resident happened by and stopped for a chat. "Did you ever try photography?" asked the Scot, as a friendly opener. After a long pause Sir John answered, "Can't say I have." Presently the local tried again, "It's a deal quicker." After a very long pause, Millais said, "I dare say it is." The Scot, stung by the laconic response, went on his way with a parting shot, "Aye, and it's a muckle sight mair like the place too."

The Pitfalls of Watercolor

As if the difficulties of timing and physical hazards were not enough, the watercolor medium provides its own special frustrations. It can be spread over the paper with speed and freshness of color, but it dries, especially in wind and sun, with sometimes aggravating swiftness. (See "Water Additives," Chapter 2.) You may be allowed scant time to carry the edges of a wash into the pattern you have penciled for it. On other occasions a wash may be annoyingly slow to dry, or sometimes a part of a wash dries quickly, leaving a puddle that breaks out and runs where it is not wanted.

When a wash dries, it does not look the same as when it is wet and glistening on the paper. It will be much lighter when dry. All pigments are not exactly the same in this regard; some dry slightly lighter than others. When washes are heavy and dense with pigment, they may dry opaque instead of transparent; no problem — if it meets your intent. (See *Arch Cape at Evening* in *Demonstrations* section.) The tendency to opacity or transparency varies a good deal with different pigments, but it is usually not apparent except in dark passages. While manufacturers' lists give some indication of the characteristics of various pigments, experiment with colors to learn how they react.

Experience as Preparation

When you go out to sketch, you can hardly be expected to run through a complete check-off list of the many possible hazards you may meet or to make contingency plans for all of them. As experience accumulates, you will, however, almost automatically appraise most of the circumstances outlined in this chapter.

There are many different ways to tailor your work to fit some of the limitations that circumstances may impose, particularly the limitation of time. If you decide that you have only half an hour to seize an effect that appears transient, you will surely proceed in a different way than if you planned on two or three hours.

The Limitation of Time

Your estimate of the situation, with regard to the time available, can be a catalyst. You set goals for yourself and know that you must accomplish various phases of your painting within the limits of your timetable. This deepens your concentration and intensifies your effort. The marvels of nature are there before you, and your desire to translate them into form and color will help you invent the means to do so as your work progresses and your picture grows. You become so engrossed in your work that your mind shuts out everything else in the urgency of the task you have set for yourself.

Consistency of Treatment

The pleasant discovery, after half an hour, that you have a lot more time may not be advantageous. When a watercolor is conceived with a direct, one-wash-per-area approach, it may throw everything off to attempt to change to a slower, more studied treatment, after the picture is well started. For example, you may have forced yourself under pressure of time to set down an effect in a single wash of color, although two washes, one superimposed over the other, would have been a better way to accomplish the particular effect. However, when you discover that you have more time, it may be too late to revert to the two-wash approach because wash number one was not put down with that in mind. The single wash would probably be darker in value than a first wash would be if you planned to superimpose a second over it. Also, the rest of the watercolor would be conceived in terms of the same "premier coup" treatment.

There are occasions when the reverse is also true. That is, when you commence the work with a more pedestrian treatment in mind, it may not be possible to successfully introduce a more rapid treatment to part of it.

I do not mean that you must be inflexibly wedded to every course of action you decide upon, that you can never change horses in mid-stream. I am only

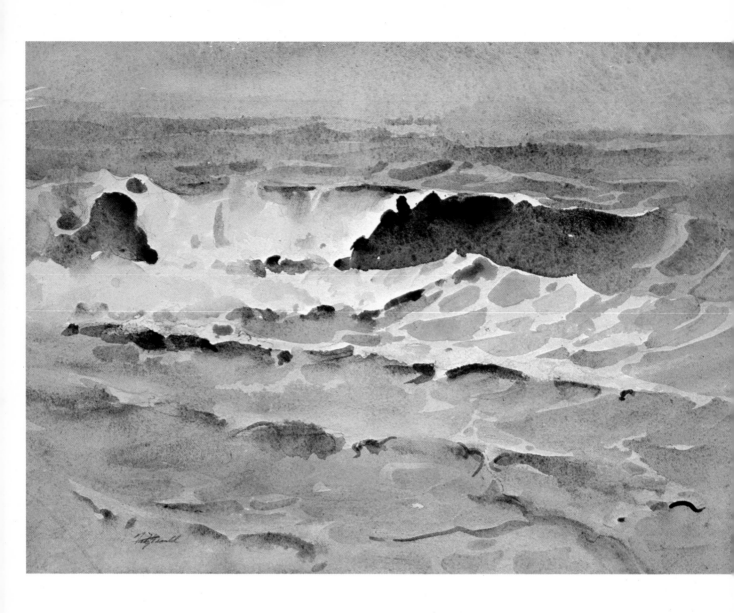

Surf, *10'' x 14'', 140 lb. cold-pressed, stretched Whatman paper. This watercolor was painted in the studio from a pencil drawing done while I was studying surf from the window of a beach cottage in Oregon on a rainy day. I used a pair of binoculars to project myself close to the surf and made notes of the colors observed. I used a very simple palette for the painting: yellow ochre, viridian, and ivory black. I left white paper in a few places for the highest light on the aerated water, but there is a faint wash over most of it. The jade-colored pattern in the foamy water being lifted into a wave is clearly illustrated.*

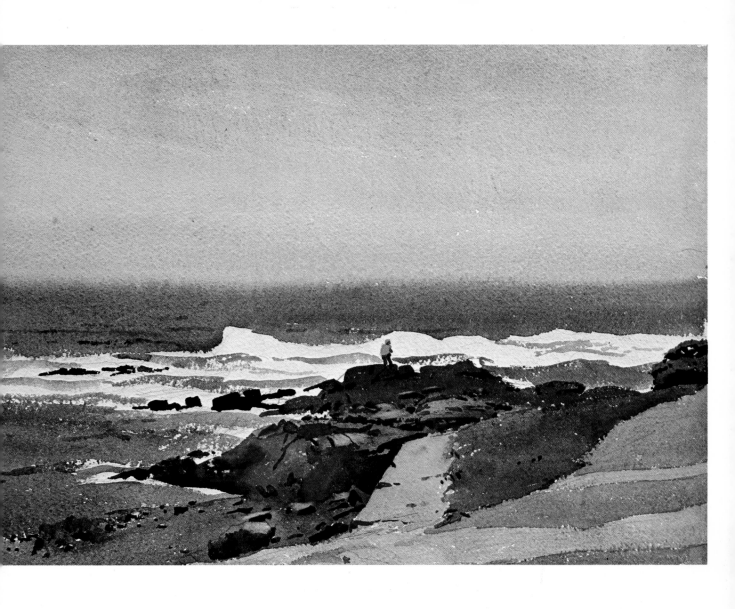

Marginal Way, 11" x 15", 300 lb. rough Arches paper. This is a rainy day watercolor done from my car at a place where I parked close to the "Marginal Way" footpath at Ogunquit, Maine. A silvery coolness pervades the painting. The strong reds, yellows, and greens, which can be seen in the damp atmosphere, would be overwhelmed by the powerful blues that would dominate such a view in sunlight. I painted the sky and sea, down to the white surf, as a continuous wash in order to achieve the soft line at the horizon. The surf is white paper. I used a good deal of warm color, yellow ochre and Indian red, in the mix for the rainy sky.

emphasizing my belief that an important part of watercolor is planning various steps and carrying them through with confidence.

Spontaneity and Nature

Amidst all the difficulties of time and overcoming the discomforts and frustrations of outdoor work, there are rewards. The substance of creative experience is born of the struggle to confront nature and to seek out the essence of visual response and distill it in terms of drawing and painting. This is true of all media, but watercolor with its fluidity and sparkle produces its own heightening of the experience.

A blob of watercolor spilled upon paper has a unique, luminous charm. It is a dividend you get throughout your watercolor work. The rapid drying of watercolor also imposes a discipline which quickens the senses and makes you perform — sometimes better than you think you can. Benjamin Franklin said, "There is nothing that concentrates a man's mind so much as the knowledge that he's to be hanged in the morning."

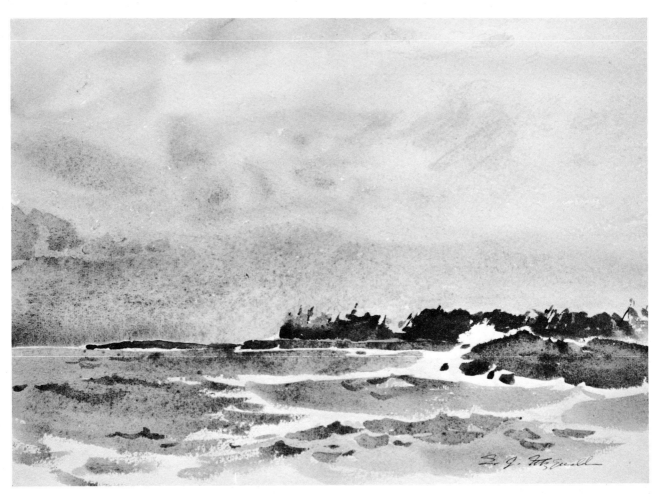

Stormy Day, Annette Island, *11" x 15" Whatman board (watercolor paper mounted on heavy cardboard — no longer manufactured). I found partial shelter in the lee of an overhanging bluff one blustery day on this island near Ketchikan, Alaska. One rain squall after another came sweeping in from the west, and I had scant time to try to set down the transitory effects. I penciled in the low horizon composition, with due regard for the relative proportions of the few shapes involved. I mixed a large puddle of pigment and started the sky at the horizon on the extreme left. I carried the wash across and upward with my number 12 brush, lightening it as it progressed,* with the wind trying its best to blow the brush from my hand. It was a devilish job to try to keep the paper protected from flying spray and puffs of rain, and the washes seemed to take forever to dry. By leaving thin areas of dry paper between still-wet washes, I proceeded with the water area. The white water is just plain white paper. By the time I painted the timber, the sky just above it had finally dried. I filled in the white space I had left between the trees and rocky bluff on the far shore with the point of a small brush. A few accents were added to the sky and water when they were dry, but the rest was left in its sketchy state.*

5

Studio drawing

Winslow Homer is alleged to have said to a young student seeking an art career, "Draw the figure — rocks are easy."

In his cryptic way the great painter seems to be advising a classical approach to art training, although he pursued art in his own inimitable way and not in the "classic" manner. He was mostly self-taught, and since he was never communicative about his early years, we must speculate about his methods. He obviously did draw the figure a great deal, but he also drew the sky, waves, rocks — everything. I don't think he meant that rocks were really easy. (There is no such thing as an "easy" subject.) Perhaps he meant that by diligently studying the figure, you could learn to draw anything. The same principle would probably apply in reverse. If you draw rocks or anything in nature, you learn methods that can be applied to everything. The difference is that you are more aware of your errors when drawing a person and are therefore more critical. You are most demanding of your results, so it *seems* more difficult.

In like manner, studio work imposes its own special demands. The hazards and limitations of field work produce stimulation and excitement that is not so characteristic of studio work. The thrill and spontaneity of field work must be generated intellectually in studio work, but there is more time to think things out and plan the steps to produce your picture. You can undertake larger, more ambitious paintings that have a greater dramatic impact. The difficulty is to infuse studio work with the verve and spirit that gets into outdoor work almost automatically.

It is said that Homer often carried his large studio pictures back to the locale of the subject to put in finishing touches under the stimulus of wind and spray, in order to get the spontaneity of outdoor sketching into his painting.

Drawing from a model or still life in the studio is similar to field work in that it is also a direct study of nature, but how do you create *outdoor* paintings in the relative comfort and convenience of the studio? (See *Shower Over Cape Porpoise*, p. 42.)

Source Materials

Your source material is your memory; drawings, sketches, and paintings done in the field; or photographs you have taken. Photographs published in periodicals may also be used, or that vast source known by the studio term "scrap." Scrap usually refers to published work by other artists and illustrators, clipped from publications and filed under various subject headings for easy reference.

The use of scrap or published photographs is thought by many to be a form of stealing and poses knotty ethical problems. Copyright laws do not give much protection to the artists robbed in this way, because a slight change from the stolen work makes it hard to prove theft. There are many examples in the history of art that appear to be "borrowings" from earlier artists. Rembrandt's etching *Christ Driving Money Changers from the Temple* is strikingly like a woodcut by Dürer. Gaughin's painting *We Shall Not Go to Market Today* is very like an Egyptian frieze in the British Museum. The painting *Old Battersea Bridge* by Whistler looks a lot like a certain color woodcut by Hiroshige. Such similarities could be mere coincidence or gleanings from subconscious memory. It is generally agreed that the difference between research and plagiarism is a rather fine line.

Advertising artists, rushed to meet deadlines, often make use of scrap or "swipes," a synonymous, less euphemisitc term. Among painters it is generally considered non-creative and a pretty sneaky practice. When work that has any hint of theft appears before juries of acceptance for major exhibitions, it gets a quick "thumbs down." Borrowing ideas or minor details from the work of others often goes undetected, but professional art-

ists who serve on juries are remarkably sharp-eyed and have long memories. It does not pay to attempt to deceive them into thinking you are more talented than you really are. In any case, each of us must decide, according to our own conscience, where justifiable eclecticism and plagiarism meet.

Copying from originals or reproductions, as a means of training or commercial assignment, is another matter. I have made copies for both purposes, but I always identify them as copies in the signature area.

Working Drawings

There are many ways to develop paintings from your source material. Very often you will wish to incorporate information from more than one source into a composition. Also you may wish to enlarge or otherwise change an on-the-spot study.

My method is to make a working drawing on semitransparent bond or tracing paper. I can simplify a complicated drawing by tracing it and eliminating details or strengthening weak areas. Then I add details by drawing them on small bits of paper and placing them under or over the master drawing. I usually do working drawings in line only with pencil or pen, though I may add minor shading or even spots of color to help me visualize succeeding steps. My working drawings are similar to drawings done in the field; that is, they are the planning stage for further work. As preparation for a watercolor, the lines in a working drawing are a plan for the washes of color. I may interrupt work on the drawing from time to time to make small watercolor sketches to test out ideas of design or color. Since the pressure of field work is not present, some of the stimuli to spontaneity are missing. However, the creative process generates a compensating stimulus that enlivens your work in a different way. What studio work loses in immediacy of response to nature, it often gains in strength of design and convincing power.

Transferring the Drawing

When the working drawing is done, I fasten it over the watercolor paper with thumbtacks or masking tape and transfer it to the clean surface. I usually use sheets of graphite carbon paper under the working drawing for transferring, but you can do it just as well by rubbing the back of the working drawing with a 5 or 6B graphite pencil to create a carbon paper substitute. To transfer, I simply go over the lines of the drawing with a sharp pencil, and I have a clear, clean drawing ready for watercolors. Use of a colored pencil or ball-point pen for the transferring helps prevent going over the same

lines twice. I vary the pressure in transferring so that stronger or lighter lines result in different places. This can serve several purposes; for example, I might indicate clouds in the sky with light lines, while I could show the mast of a boat seen against the sky with heavier lines. Sometimes I transfer only part of the drawing before commencing in watercolor. I fold back the working drawing, but keep it firmly fastened so it will not get out of register. When the preliminary washes are dry, I return the working drawing to position and continue the transferring.

Saving the Drawings

Working drawings can be kept on file in case you want to duplicate or try another version of the same subject later on. Occasionally I get orders for a repeat of the same subject. I once did *nine* duplicates of the same painting to be installed in club cars for a major railroad. I felt nonplussed about this "production line" approach until I recalled that Rubens and Velasquez often produced several duplicates of paintings for patrons. Once I got a request through a gallery for the original of a watercolor of mine that had been reproduced 20 years before in the *Lamp*, published by the Standard Oil Company. A man in Peekskill had kept the magazine all those years because he liked the painting, a view of the Hudson Valley. The original was long gone, but I did have a near duplicate and made the sale.

Drawing from Memory

When you develop a working drawing of a marine or landscape in the studio from various sketches or other material, you invariably find that part of your information comes from your memory. You dig deeply into your store of knowledge to recall how light falls over certain forms or how the action of clouds, waves, or figures takes place. Someone said that drawing is like a bank account and that, when you draw from memory, you are making withdrawals. You can only take out as much as you have put in!

Even when you are drawing directly from nature, your memory and imagination enter into and influence your work. Perhaps this use of the mind is the most intimate and creative part of the whole business. This logically might strongly urge drawing entirely from the imagination. However, individuals vary greatly in the capacity and desire for this kind of "drawing without the model." In this, as in so many things, each must find his own way. Suffice it to say, it is great fun and excellent training.

Working Drawing. *(Right) You can prevent wear and tear on watercolor paper by working out drawing problems on tracing paper first. Transferring is then done by the carbon methods described in the text.*

Overlay. *The working drawing is held in place at its top edge with thumbtacks or masking tape during transferring. You can then fold it back out of the way and return it to position if necessary during rendering of the watercolor.*

Studio Setup. *The convenience of working conditions in the studio permits you to use larger washes of color with greater control than in the field. Larger watercolors are feasible, and you may rework or further develop field sketches or other material. You can tell when a wash is dry by holding your work near eye level and slanted toward a strong light source. The gleam of dampness shows that it is not dry.*

6

Studio watercolor

In Chapter 5 you were figuratively brought in from the great outdoors, tanned and refreshed by the sea breezes and ready to work up your accumulated raw material into studio paintings. Now we will delve into some of the problems of creating watercolors when you are far removed from sparkling pools and crashing surf.

Using Your Imagination

The studio work of some artists is not easy to distinguish from their field work. Perhaps they make a conscious (or subconscious) effort to retain so much of the spirit of outdoor work, with its multiple hazards, that the results are similar. Imagination is a powerful tool; under its spell such artists can retain the urgency of field work and sustain it over the more leisurely time span of studio painting. My old friend, Chauncy F. Ryder, was such a painter. His studio pictures were usually larger in size than his field work, but they retained the same freshness, economy, breadth of stroke, and nervous energy. The great John Constable was similar. He brought the damp English sky into his studio, both in his mind and in the form of brilliant small sketches, and carried the outdoor quality into his large works. On the other hand, J. M. W. Turner put his myriad studies of boats, water, mountains, buildings, and skies through the alembic of his mind, and in a prodigious output of paintings, recreated a world of his own in his famous studio at Petworth. His studies of reality and his imaginative paintings appear as two parallel but distrinct avenues of expression.

Advantages of Extra Time

In my studio work I attempt to recall the mood of my response to visual experience while sketching in the open, but I use the advantage of the additional time to plan the design and execution of the work more carefully than would usually be possible in the field.

Additional time makes it feasible to undertake larger washes of color having greater intensity of value. Large washes are difficult to control at any time, but you can manage them more successfully under the conditions of the studio where larger receptacles for mixing are available as well as plenty of clean water. The more intense the value of a large wash, the more difficult it is to execute, because of the greater concentration of pigment in relation to the amount of water. A wash of light value (less pigment to the quantity of water) is more manageable. When a light wash has dried, it can be intensified by laying a second wash over it. However, large washes which are either bright or dark take time both for execution and drying, so they work better in the studio than in the field. These large washes are necessary for larger paintings.

One of the great advantages of time is to be able to pause, light a pipe, and cogitate over each successive step in the painting. It is very important to have a clear idea of what you are going to do in the steps ahead. Success often depends on how well you have done your planning. It is also advisable to have an alternate plan or two up your sleeve in case of varying developments and to remain on constant alert.

Preparing Washes

The question of mixing "enough" for a large wash beforehand can not be overemphasized. Perhaps "more than enough" would be a good rule. John Pike suggests using a cup for this purpose. Nothing is more frustrating than to arrive halfway through a large wash and find that you have not mixed enough color. In your frantic haste you are sure to tip over the water jar, and about then the phone will ring!

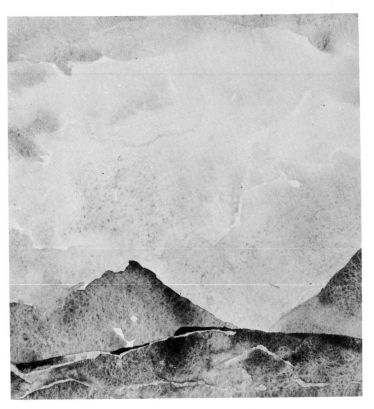

Curtain. *Detail of* Tikchik Lake, *p. 70. The ragged shape just above the center is an accidental "curtain." In this instance it integrates nicely with the turbulent sky.*

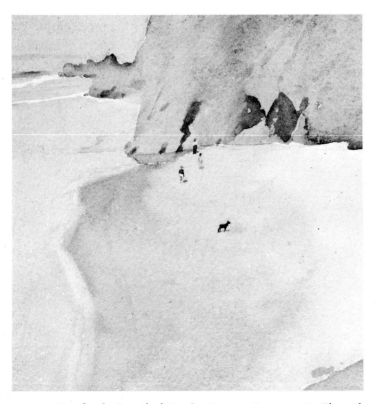

Run-back. *Detail of* On the Oregon Coast, *p. 30. The soft but distinct transition from light to shadow on the beach is a run-back, that is, a pale, liquid color that has eaten away at a darker wash.*

In the studio you can guard against many mishaps by good preparation. Make sure your research is complete, your materials are all on hand, your thoughts organized, and your motor revved up. Hang out the "Do Not Disturb" sign, and it might be a good idea to put the telephone on "answering service."

Problems with Washes

Things happen fast in watercolor. The water and pigment spreads and dries quickly. If a planned wash of color has a complicated shape, you will be kept very busy trying to get the wash spread into all those nooks and corners without losing control. If an edge dries prematurely in one part of a wash while you are busy in another part, you may be in trouble. Be sure you have mixed enough for your wash and keep alert to the drying. If you touch a fully loaded, wet brush to the edge of a wash that is almost dry, an excess of water and color is apt to run into the wash causing "run-backs" or "curtains" that you may not want. Run-backs resemble those annoying watermarks that sometimes occur when you try to remove a spot from a garment. They inevitably happen from time to time in watercolor washes, usually near the edge. Do not panic if you see one forming and go poking into the wash with a brush; you will only make it worse. A careful "bleeding" away of a puddle remaining at the edge of a drying wash with a blotter, tissue, or piece of cotton is sometimes helpful. Judicious application of warm air with a hand-held hair drier may also help. After a run-back dries, its effect can be lessened by rubbing the area with an eraser, but often the best thing to do is ignore it! If the colors and values of your total watercolor work out well, a few run-backs in washes are of little consequence.

Equipment

Set up your working space and equipment with care. You should have everything you would need in the field — water, for instance — in greater abundance. One large container of water should be used only for rinsing your brushes. Mixing water should be separate, clean, and plentiful. A rubber syringe is useful for moving water rapidly from the container to your palette. A hand-held electric hair drier is a big help for drying and controlling the washes. Facial tissue is handy for picking up excess color, and wiping brushes.

I have an aversion to standing wet watercolor brushes in a container with the points up. Apart from the fact that water dribbles down the handle, I have a feeling that it is soaking into the ferrule and weakening the brush. I place my wet brushes

in a flat position, ready at hand. They rest on a piece of towel so they will not roll about.

Lighting

Adequate lighting is important. For transparent watercolor work it is far easier to solve this problem than for oil painting, principally because there is no thickness to watercolor to cast shadows, as there is to oil paint. The traditional, unobstructed north light is fine but not necessary, except that it is superior for lighting subjects like portraits or still lifes. Natural light is preferable for lighting your working surface when painting in oils, because artificial light, traveling a short distance, lights the heavy "impasto" strokes in the wrong way. This principle could also apply to water-media paints that can be used like thickly painted oils.

Working only by artificial light poses no serious problem to most watercolorists as long as they give a little thought to the *color* of the light. It should resemble average daylight in color, not too warm and not too cool. This is fairly easy to control with the various fluorescent lights available. One *cool white* and one *warm white* tube in the same fixture make a satisfactory combination.

A lighting consideration that I find helpful is to arrange at least one source of light, such as a lamp or nearby window, coming from a fairly low angle. When you are waiting for a wash to dry, it is sometimes hard to tell whether a portion of it is still damp. By positioning your work between your eye and the light source, on a plane coinciding with the direction of the light, you can see the gleam of dampness. This is preferable to testing with your fingertip, which will mess up a drying wash, but believe it or not, I have seen students do it!

Comfort

What a great life an artist has! His studio is an ivory tower invulnerable to the cares of the humdrum world. At the close of a day of creative work, he meditates peacefully in the fading light. An old retainer fetches a cool drink and freshens the fire on the hearth. A lovely model lounges nearby, listening to the hi-fi; while through the rain on the window, the artist contemplates the tired commuters trudging homeward. Patrons are waiting in the anteroom to purchase his latest work.

Well — it is something like that. I don't have a fireplace in my studio, but I do have a potbellied stove in which I can burn paint rags and ruined watercolor paper. Unfortunately, the retainers seem to have all retired to condominiums in Florida, and at current prices models are a rare luxury. My record player is neither hi nor fi, and if there is

a knock at the door, it is likely to be only my landlord inquiring about the rent.

Still, the humblest studio seems very cozy when you return from the field and remember the deer flies and biting wind. When the washes go well on your enlargement of one of the sketches, the old studio becomes a "marble hall," and a tinny radio sounds great. The most remarkable thing of all is that people *do* buy some of those pieces of handsome paper stained with colors!

Enlarging Field Work

Although I like to make a working drawing, you can enlarge a picture directly on watercolor paper, particularly if you do not contemplate any radical changes in design from the smaller picture. There are many mechanical aids to enlarging, such as the pantograph, camera lucida, projectors of both opaque and transparent types, and photostatic processes, but I usually enlarge freehand because I like to draw.

Freehand enlarging can be greatly assisted by the traditional "squaring-up" method. The sketch to be enlarged and the proportionally larger sheet are each divided into the same number of rectangular divisions. (I find that sixteen divisions is adequate for most watercolor work. In other words, all four margins are divided into four equal parts, and lines are drawn lightly across.) Rather than draw lines on the small watercolor, I use a clear acetate overlay with pen lines. Sometimes I merely mark the margins with a dot and visualize the connecting lines. You can also use a proportional divider. It is a drafting instrument that can be adjusted to proportions in the two different scales you wish to compare.

Enlarging Watercolors

In enlarging watercolors some strange and interesting things happen. The larger picture becomes something other than a mere enlargement. It goes through a metamorphosis and takes on a new life — not always for the better, unfortunately. A color area that looks right in a smaller scale may now appear inflated, flat, and uninteresting. Additional texturing will sometimes put it right, but not always. Values and colors do not look the same when enlarged; even though they may look *good*, they look *different*. Your enlargement is a *new* picture with new problems of relationships. This is, of course, all part of the fun.

Reducing from a large to a smaller size, while done less often, is equally fascinating. A work of art is not necessarily better because it is larger. There is, no doubt, a "correct" size for everything.

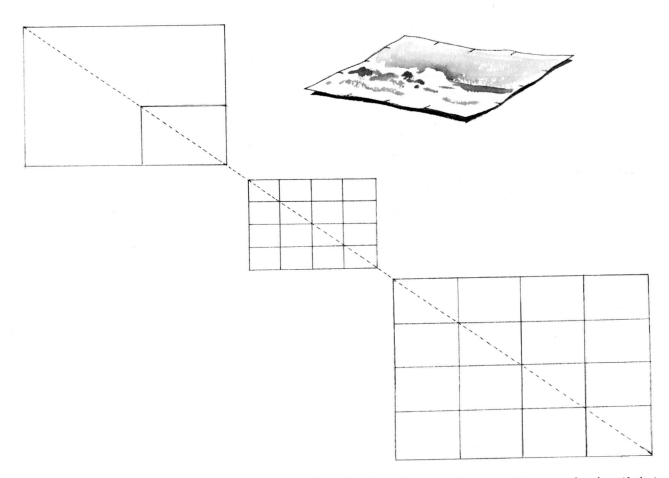

Squaring-up. *Rectangles of various sizes are in proportion to each other if their diagonals coincide. All of the rectangles shown here are, therefore, in proportion. If two sheets of paper are in proportion, they can be divided into an equal number of subdivisions to facilitate enlarging. Rather than rule the lines directly on a sketch, ink them in on a sheet of clear acetate or tracing paper and place this over the sketch. I sometimes simply mark the edge of a sketch with pencil which can be erased later. Then I either visualize the connecting lines or place a straight edge across the paper to line things up.*

Proportional Divider. *This drafting instrument is helpful in enlarging pictures from one size to another. Although it is adjustable, it is somewhat limited as to size. I have improvised a serviceable proportional divider for large work with two thin strips of wood and a tack, but it takes a little calculation, or trial and error, to figure out where to put the tack!*

The *art* is in deciding what that is.

Subtle things happen in watercolor that can never be copied exactly. In fact, in redoing a watercolor, it is practically axiomatic that you must not *try* to copy exactly. The very effort of doing so can put the "kiss of death" on the second attempt. The successful redoing of a watercolor is more in the nature of paraphrasing than copying.

Watercolors from Other Media

Traditionally, watercolor has been used as a sketching medium by oil painters because of its convenience and speed of execution. This makes good sense, but there is no reason why the reverse should not work just as well. My good friend, Tore Asplund, N.A., A.W.S., likes to do field sketches of small size in oils. He often translates these into watercolors in the studio, usually in a larger size, with splendid results. I have also worked from some of my large oils in watercolor, usually in smaller size, with equally good results. (See *East Wind* in *Demonstrations* section.)

Combining Watercolors with Other Media

It is also effective to combine washes or touches of watercolor with various graphic media or pastels. Charming examples of such combinations are being explored by contemporary artists, but these methods have plenty of tradition as well: Rodin, Gericault, Tiepolo, and so on. I have not explored such combinations extensively in my own work so I do not have examples, but I recommend that you remain alert for them in the work of others.

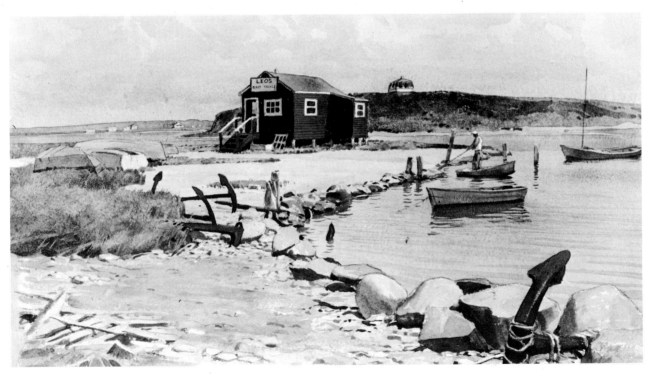

Bait House, *14" x 25", 300 lb. rough Arches paper. This is primarily a landscape, though in painting it I became aware that the foreground had the characteristics of a still life. This is in the category of "found" rather than arranged still life. However, I recall that I did some rearranging of the old anchors, not physically, but in the drawing. (I have often wondered if those rusty cannon on the beach in Winslow Homer's great watercolor Nassau were actually there — so absolutely right!)*

Northeaster, Provincetown Harbor, 11" x 15", 300 lb. rough A.W.S. paper. (This handmade paper was made in England although it was distributed by the American Watercolor Society. It is no longer produced, but it is similar to other English watercolor papers, such as R.W.S. or J. Green.) I painted this watercolor from the cabin of the ketch Flood Tide. The storm kept us in Provincetown Harbor for a day or two along with the fishing boats in the painting. Light and weather were fairly constant (lousy!) so I had ample time. Wind and tide kept the boats swinging at anchor a good bit, and the choppy waves produced less than ideal "studio" condi-

tions. The cool, wet atmosphere made washes dry slowly. The granular appearance of this painting is, at least partly, the result of the conditions under which it was painted. Movement during drying of a wash, such as a rocking boat, promotes granulations, as does slow drying. Some pigment combinations also cause this effect, particularly when lots of water is used. Like many "accidental" effects in watercolor, granular washes are sometimes welcome dividends. I did not use masking in this painting. Instead, I painted around the white mast, cabin, and sheer line of the nearest boat with the basic sky wash, and then used a thin second wash in the upper sky.

7

Water as a veil

"Turner," said one of his contemporaries, "paints pictures of nothing, and very like." Turner was evidently as intrigued by the enveloping mists and vapors as by the solid substances in nature. Impressionists, like Boudin, Pissaro, and Sisley, have also shown us the beauties of shimmering light which makes air, haze, and — yes — smog as palpable and substantive as the objects seen dimly through those colorful veils.

Fog

When fog is dense enough, it obscures everything except objects close by. Even these are seen only as dim shapes whose colors are subdued in intensity, with the dark and light areas brought into close relationship. The reduced visibility in a fog causes things to fade rapidly into the distance. Therefore, the presence of fog supplies an exaggerated demonstration of aerial perspective. (Aerial perspective is a term referring to the fact that color and value diminish in accordance with distance.)

Fog varies in density, of course, and it is of more interest to the artist when he can see at least a little farther than "the hand in front of the face." It also varies in thickness, that is, in the amount above your head between you and blue sky. I once crossed the Mediterranean in a peculiar fog that was dense enough so that you could not see ahead more than a few yards, but all the while blue sky was evident overhead and occasionally gleams of sunlight shone on the masthead. Such a fog has a dazzling whiteness. Light penetrates it and seems to scatter and intensify it.

Fog that hangs in valleys or around the base of hills and mountains creates some marvelous "watercolor" effects.

The Color of Fog

What is the color of fog? The layman would quickly answer white or light gray, but that would not satisfy the artist. He has to know the precise tint of white or gray in order to mix it on the palette. Fog is readily colored by its environment. You have only to recall the appearance of neon signs on a foggy night to confirm that. Probably the best answer is that fog comes in many colors.

For purposes of painting, consider clouds of dust, smoke, or smog that surround us in the same general category as fog. The main difference would be the color.

The chief characteristic of fog in a painting, as in nature, is that it tends to unify all colors. (See *Puget Sound Storm*, p. 24.) It may tend toward yellow, pink, or blue — you name it. As a matter of fact, if you stare steadily into fog, you can see it in almost any color you wish.

Sea Smoke

Another way in which water acts as a veil is when certain atmospheric conditions at sea produce a phenomenon known as "sea smoke," a smokelike vapor of fog that hangs close to the water. It is concentrated in the troughs of the waves like the fog in mountain valleys, producing an enchanting and mysterious effect. Such vapors are associated with frosty mornings when there is a marked difference between the temperature of air and water. The condition is transitory and does not "pose" long to be painted.

Similar low-lying fogs often drift near the surface on quiet lakes in early morning or in swampy fens and marshes. The ancients considered these fogs unwholesome and deadly, and the fear still lingers in the minds of most of us. The movie industry has machines that can pump out volumes of the stuff, and many a Hitchcock "chiller" has thrilled us with phoney fog. Perhaps some of it still lingers in the smog of southern California.

Ships were equipped with fog generators in World War II, and if an anchorage area was threatened with attack, the signal, "Make smoke!"

Aerial Perspective, *(Right) Detail of Rock-strewn Beach, p. 102. As objects recede, they become progressively paler and less detailed with less distinct contrasts.*

Sea Smoke. *(Below) On frosty mornings a white vapor resembling smoke sometimes appears to cling to the surface of the water. This makes any nearby wave stand out in bold relief. A similar appearance on the water's surface may accompany a downpour of rain when the splashing of heavy raindrops creates a mistlike vapor.*

would be broadcast, and soon a comforting "pea-soup" concealed the area.

Mist and Rain

The appearance of objects in rain or mist is similar to that in thin fog; that is, shapes are generalized and details obscured. Large masses of trees, buildings, or rocks become silhouettes. This simplification is great for the artist, and particularly for the watercolorist. It permits full play for broad washes of transparent color.

In Whistler's famous "Ten O'Clock Lecture," he speaks of an artist's response to those conditions in nature that obscure the view but enhance the vision, "And when the evening mist clothes the riverside with poetry, as with a veil, and the poor buildings lose themselves in the dim sky, and the tall chimneys become campanili, and the warehouses are palaces in the night, [Nature] sings her exquisite song to the artist alone...."

The Color of Rain

The color of rain, like the color of fog, is illusive. The general feeling on a rainy day is the slight chill of coolness — except in the tropics, where a suffocating steaminess may accompany rain. When you observe a rainy day closely, however, you discover that the colors are rather warm and deep-toned. Shadows are no longer blue-black, as they might be in sunlight, but are rich and somber. Dark browns and reds creep in. Greens that might be "sharp" on a bright day become an olive shade when seen through mist. Your mixture for a sunlit sea would probably be strong in cobalt blue or ultramarine blue, but on a rainy day you would need burnt sienna and ochre or umber to modify the blue to gray. As in a foggy atmosphere, your painting turns out to be surprisingly strong in colors from the warm side of your palette. (See *Marginal Way*, p. 47.)

Heavy Rain

A sudden shower, with its furious splashing and diminished light, is a far cry from the gentle drizzle or "Oregon mist" that can fall for days in the Pacific Northwest. At sea you notice the difference even more than on land. A heavy downpour quickly softens the sharp facets of choppy waves, while the hissing splashes of the rain produce a condition

similar to sea smoke. The troughs and crests of the waves are sometimes etched into stronger contrast with one another than in other weathers. Distance is, of course, obliterated in a heavy shower, while in a gentle rain the sea would not look different than it does under an overcast with no precipitation.

Painting Rain

Most of my rainy-day paintings do not show the rain itself. It has always seemed to me a contravention of scale to try to depict falling rain, although I have rendered the appearance of a veil of rain, falling from a distant cloud. I have used the wetness, the spouting gutters, the "color" of rain, but usually not the raindrops. You can depict rain as slanting dark lines, or as thin scrapings when rain is seen against something dark in value, but usually this seems to me too much a convention or symbol to be consistent with my own way of working. Nevertheless, I did use this technique in *Rain at Go Cong*, p. 62.

Shelter for the Painter

I have painted many times in rainy weather, usually from a car or boat cabin. Some kind of shelter is necessary, particularly for watercolor work. Crouching under a damp bridge or archway is possible, though not much fun. The worst is trying to paint with an umbrella clutched in one shivering hand.

Properties of a Wet Surface

Water acts as a reflective veil on all surfaces that are not absorbent, making them appear to be freshly varnished when wet. Even absorbent surfaces retain the shiny quality of wetness until the water is absorbed. The hard-packed sand of a gently sloping beach, for example, retains the gleam of water on its surface for a time, to indicate where the tide or a receding wave has recently been. (See *Wyngersheek Beach*, p. 74.) On a relatively flat surface like pavement or a wet beach, this wetness produces reflections in the manner of a still pond. All things — the sky, for instance — that are at the correct angle to your eye will appear as reflections. The color of the wet area is a modification of the color of whatever is reflected. Therefore you should determine what is being reflected in a given spot, in order to assess its color characteristic.

Hard, less absorbent surfaces retain wetness on the surface for a considerable time and so they have a high reflective capability. A smoothly pol-

Dry vs Wet Surface. *As the surface becomes wet, the reflective capacity of the pavement increases.*

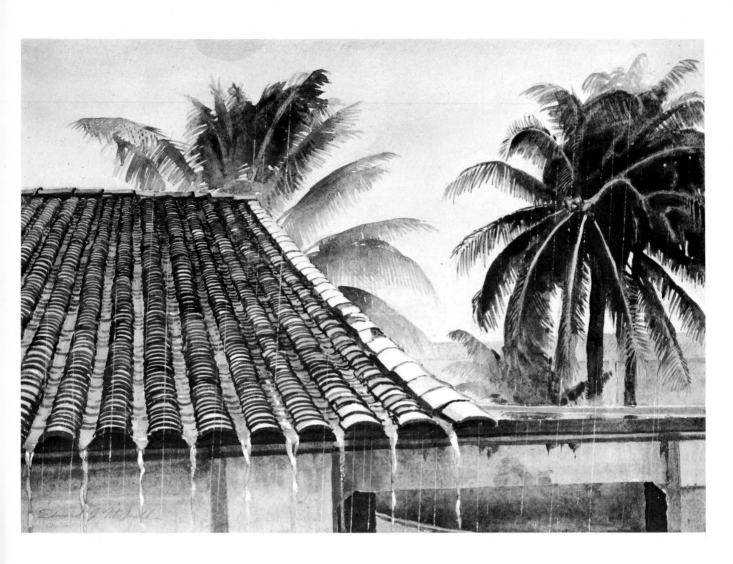

Rain at Go Cong (Above), 15'' x 22'', 120 lb. stretched David Cox paper. I painted this watercolor from a window during a tropical downpour in the Mekong Delta town of Go Cong, South Viet Nam. It is one of the few paintings of mine that actually shows the rain drops. Warm-toned David Cox paper was suited to the subject and helped to create the underlying glow apparent in the tropical steaminess. I superimposed the palms over a gray-gold sky. I used a few touches of Chinese white to express the flashing highlights on the twisting "ropes" of water pouring off the titles. The rain was added last by running the point of a knife along the edge of a ruler placed on the picture after the paint dried.

Foggy Morning, Larchmont (Right), 10'' x 14'', 300 lb. rough Arches paper. This painting is surprisingly warm in color, even though it expresses the somber stillness of a foggy morning. I painted it looking from the sea wall of the Larchmont Yacht Club. Shapes were simplified and details lost in the reduced light. I was mindful that the fog might soon lift and change the mood so I did the drawing quickly. Sky and water were painted as a continuous wash, starting at the top and moving downward. I painted around the figure and the decking (top plane) of the three nearest boats. I gradually added ultramarine blue to the wash as I approached the foreground to make the water appear cooler than the foggy sky. I superimposed the distant boats on the fog as delicate gray silhouettes. The nearer boats were painted in fog-dulled versions of their local color values. I painted the rocky foreground in washes so dense that they are practically opaque.

ished surface has this look, even when dry.

An irregular, shiny surface reflects colors to your eye, in accordance with the angle that each part of its surface presents to your eye. (More about this in the next chapter.)

Color and Value Change on Wet Surfaces

Wetness on a surface changes the color and value of that surface considerably. Most surfaces look much darker when wet; their colors are muted, as though by the addition of a dark pigment. Some light, bright colors are intensified by wetness, so that their colors, while not lighter in value than when dry, look more intense.

Since wetness on a surface imparts reflective capability to that surface, a major part of a wet object's change of color is caused by colors other than its own color being reflected to your eye. Again, you should determine just where this reflected color originates in order to have a better understanding of the object's apparent color when it is wet. Understanding the source of a reflected color helps you to see the color. (See Chapter 8.)

The Bright Gleam of Wet Objects

The characteristic bright gleam of wetness, on rocks for instance, is the reflection of a bright source of light, usually the sky. That reflected gleam comes from a point on the rock that is at just the right angle to the light source and your eye to flash the bright reflected light in your direction. The principle of the heliograph is based on this idea. A heliograph is an apparatus for signaling, using a mirror to flash reflections of the sun. Nearly every child has improvised one with a hand mirror or the lid of a can, often to the annoyance of the person having the bright light flashed into his eye.

All reflective surfaces act like mirrors, more or less dull, according to their reflective capacity.

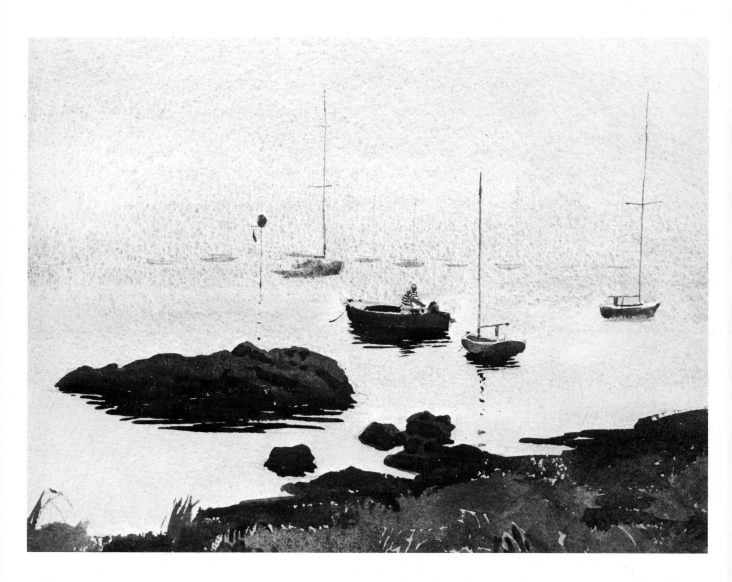

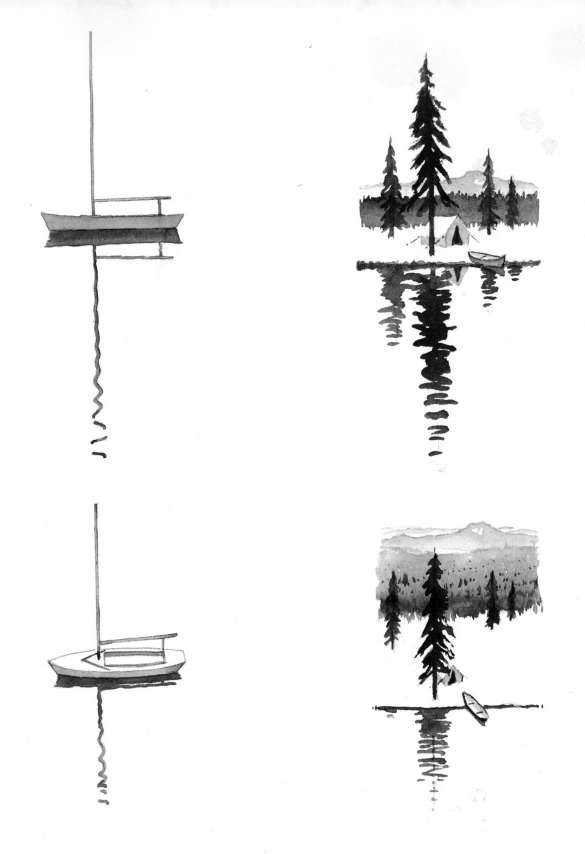

Perspective of Reflections: Sailboat. *A reflection in still water, seen from a point near the water's surface, nearly duplicates the size and shape of the thing reflected. When seen from a point above the water's surface, the reflection is foreshortened.*

Perspective of Reflections: Trees. *When seen from a point near the surface of the water, trees near the bank are duplicated by their reflections in still water, but only the upper parts of things farther back from the shore are reflected. Seen from a higher point, reflections are foreshortened and objects back from the shore do not reflect at all.*

8

Still water

Everyone is familiar with photographic picture postcards of mountains and trees reflected so clearly in a mountain lake that the picture looks almost the same upside down as it does rightside up. Such pictures are pretty dull artistically, but consideration of variations on this theme provides for an understanding of reflections.

Reflection, refraction, and perspective are closely related. All three can be considered from a mathematical and diagrammatic point of view. Such an approach is helpful and interesting but leads rather far afield from the direct, "sketcher's" approach. Full treatment would require a separate book; however, you can develop a useful "sense" of these subjects without delving far into their scientific basis.

Reflection and Refraction

Reflection refers to that mirrorlike ability to bounce back shapes and colors. Refraction, as I use the term here, refers to the fact that light rays bend as they pass from one element (water) to another (air).

Foreshortening of Reflections

Another way of describing the relationship of reflections to objects reflected is demonstrated in the accompanying diagram showing the principle of reflection: *the angle of incidence always equals the angle of reflection.*

If you sit close to the shore of a still body of water and observe a sailboat moored a few yards away, you will see an image of the boat and mast repeated, upside down, directly beneath the boat. If you climb up a nearby pier and look down at the boat, the reflection will appear much shorter. The higher you climb above the water level, the shorter the reflection will appear to be. This foreshortening of the reflection can be worked out

precisely by applying the principles of perspective, but it is unnecessary. You have only to recognize that the process is taking place to do a suitable job of sketching the boat and its reflection. (See *Schooners, Seattle* in *Demonstrations* section.)

Similarly, if you look across a small body of water at a field on the opposite shore that has a scattering of trees, you will see that trees near the shore are reflected in their entirety in the water. The reflection of each tree is directly beneath the tree, and if you are near the level of perfectly still water, the reflection is the same height and width as the trees themselves. However, only the upper parts of the trees farther back from the shore are reflected. If you remain standing at the same place but imagine the level of the water extending back to the base of the farther trees, a measurement from that point to the top of each tree will be equal to a measurement from the same point to the lower end of its reflection. Houses, hills, or any other objects reflected follow the same rule. If you climb up to a point well above the level of the water, you will observe that the reflections have grown shorter in relation to the things reflected, just as the reflected mast of the boat was foreshortened in the previous example. The reflections of the upper parts of farther trees may have disappeared altogether, because of your higher point of view.

Things hidden from view, the underside of a nearby pier, for instance, are sometimes visible in their reflected image.

Reflections on Moving Water

Water is seldom still enough for reflections to be undisturbed. Gentle ripples cause the reflection of a thin, vertical shape like the mast of a boat to writhe like a snake. The reflection breaks and rejoins, going through a continuous ballet. This movement causes the reflection to appear longer than the actual shape, as various facets of the

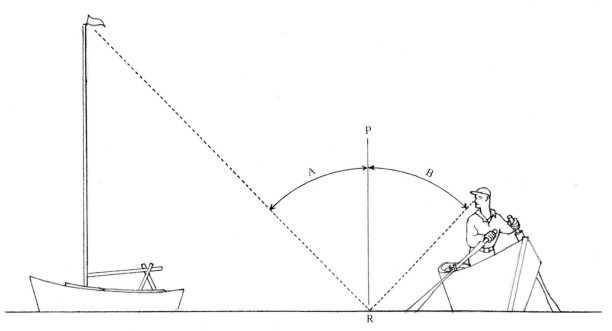

Angle of Incidence Equals the Angle of Reflection. *Point R in the diagram marks the spot on the water where the oarsman in the dory sees the reflection of the pennant on the mast of the sailboat. The line PR is a perpendicular to the point of reflection. The angle at A is called the angle of incidence. The angle at B is the angle of reflection. These angles are equal in every reflecting situation. The need for the perpendicular PR in describing this rule is apparent when you consider some reflecting surfaces that are not level. (See "Reflections on Horizontal and Sloping Objects" in Chapter 9.)*

Refraction. *When seen from above, a stick thrust into water at an oblique angle appears bent. However, if the stick is perpendicular to the water's surface, it does not appear bent but does appear to be shortened. This is because the rays of light travel more slowly through the medium of water than through the less dense medium of air. This process of refraction causes colors and values seen through water to appear darker. Also, when the bottom is visible, water appears more shallow than it actually is because of refraction.*

restless mirror of the water fall momentarily into a position where a temporary extension of the reflection is produced.

Reflected Light on Objects

A situation involving reflections that most of us have observed is the dancing pattern of light, which resembles waves, reflected on the smooth hull of a boat moored nearby. In this case it is the boat hull, rather than the water, that is acting as a mirror. The curving shape of the hull is reflecting light from nearby waves. Your attempts to paint such an effect must be done with restraint, as with all secondary, reflected lighting, to avoid a condition called "overmodeling." Overmodeling results from exaggerating reflected lights appearing in the shadow areas, and it produces a stiff and unreal quality in the drawing.

Refraction of Images

Refraction is an entirely different phenomenon. When light rays pass from air into the denser water, their velocity or rate of travel slows down. Unless the rays enter perpendicular to the water's surface, the change in velocity causes them to bend. This means that if you stand on the shore and look into the water, objects appear to be at one place in the water while they are actually somewhere else. That is why the bottom in clear water appears more shallow than it really is. In the same manner, if a stick is thrust into the water obliquely, it appears to be bent. However, if the stick is perpendicular to the water's surface, its image is not bent, but it does appear shortened.

Refraction is not as important to the marine painter as reflection, but you should be able to distinguish between the two phenomena as they become involved with each other in your study of clear water, either calm or in violent action.

Small Bodies of Water

Small bodies of water are a microcosm of the great oceans. Since they are more apt to be still, they provide a good opportunity to study reflections.

They are important elements in all landscapes. A puddle in the foreground of a John Pike or Ted Kautzky watercolor is like a jewel in its setting.

Small catches of water, and especially puddles, have always been a source of fascination for children. Is there anyone who can not remember going out of his way to splash through a puddle on the way home from school, or gazing into one after a summer shower to ponder the reflected sky and the apparent infinite depth suggested by the water.

Lakes

Lakes are not necessarily small bodies of water. The appearance of large lakes is not markedly different from the ocean in mild weather, but the distance between crests of large breakers, even on the Great Lakes, is usually shorter than on an ocean shore because the waves do not have such a long run. Also, the shore itself is different because of the absence of a rise and fall of the tide, and there is a marked difference in vegetation and rock formation. Sand beaches may look similar, but structures along the shore are not the same, and the general atmosphere and *feel*, which inevitably finds its way into paintings, is different. Not better or worse, but different.

Nevertheless, in my book of rules, any body of water from the smallest trickle to the roaring forties is "grist for the mill" of the marine painter.

Reflection of Water on Objects. *Detail of Newport Waterfront, p. 28. The hull of the boat picks up reflected light from the water, and the reflection in the water appears darker than the boat itself*

Currents. *Detail of Channel to Perkins' Cove, p. 107. Currents become visible when they break up the patterns of reflection, as shown in this detail.*

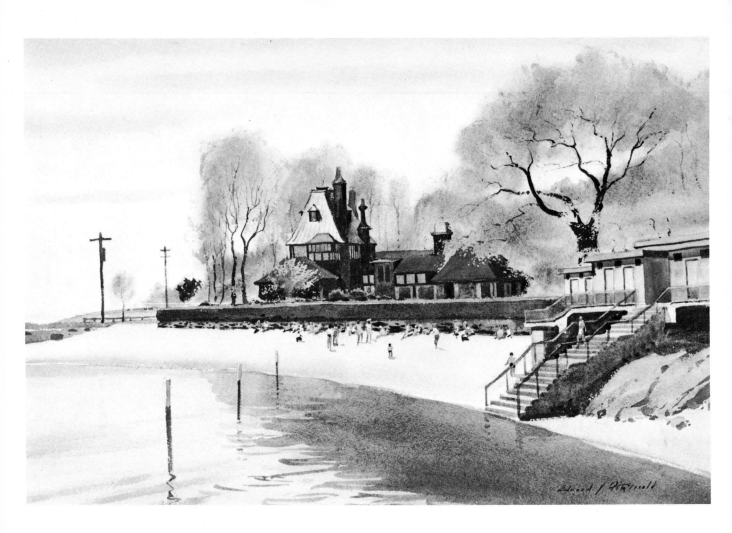

Manor Beach, Larchmont, *14" x 21", 140 lb. rough, stretched Arches paper. This painting was enlarged from an 11" x 15" watercolor. I used the wet-blending technique to achieve the desired soft transition between the sky and the delicate spring foliage. When the working drawing had been transferred, I brushed a wash of clear water over the sky, carefully stopping at the horizon on the left and the top of the hedge and then following along the roofline of the buildings. I quickly flooded a pre-mixed wash of color for the dainty spring leaves into the lower margin of this wet area and then fused it into a pale, warm basic wash for the sky. When dry, this produced a sharp outline for the buildings and a soft outline for the trees against the sky. The treetrunks and architectural details were worked out after this warm wash had dried. Most of the architecture is too far back from the water to be reflected to my high point of view. The reflection in the water is dominantly the color of the massed foliage; the edge of the reflection is disturbed by ripples on the water.*

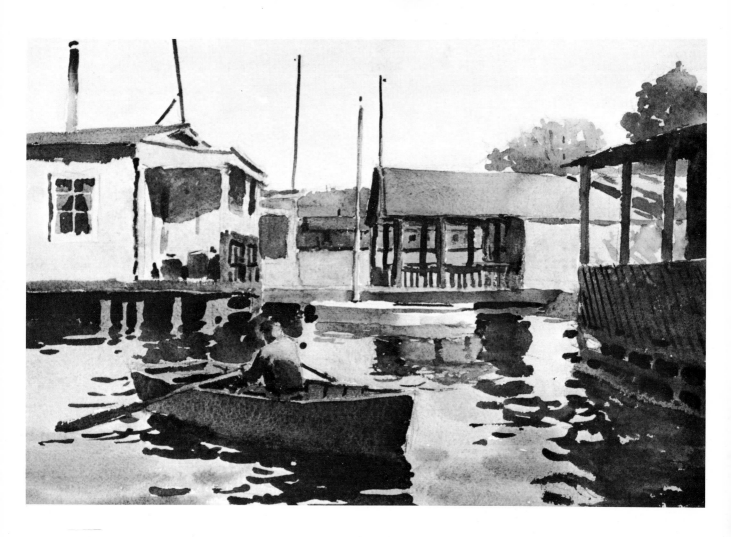

Lake Union Shore, 11" x 15", Whatman board (watercolor paper mounted on heavy cardboard; no longer made). When I lived in Seattle, this shore crowded with floating dwellings was a favorite sketching area. I talked one of my students into sitting in the nearby skiff briefly while I sketched him. The painting illustrates the appearance of reflections in water disturbed by a complex of small ripples made more by the gentle movement of floating things than by wind or current. Perspective problems were carefully studied during the drawing stage, which occupied about half the two hours available. I did the painting with direct, simple washes and a minimum of superimposing. Value relationships are always important, but they are particularly critical in this type of composition involving close-up, large shapes of strongly contrasting values.

Tikchik Lake (Above), 10'' x 15'', 90 lb. cold-pressed, stretched Whatman paper. This painting was done on the shore of a remote Alaskan lake as a sudden squall, locally known as a "Williwaw," came roaring out of the mountains. Perhaps you can tell from the painting that it is a fresh water lake rather than a body of salt water. Under similar wind conditions, waves rise more quickly on fresh water than on salt because the surface tension is less. Waves on fresh water tend to be closer together, and for that reason, more menacing to the small boatman. Naturally, the oceans produce bigger waves because of the greater expanses of open water; also, ocean tides and currents contribute their effects. The "feel" of a fresh water lake, even a large one, is different from a part of the salt sea. Salt water lakes, such as Great Salt Lake, Utah, are different still, mainly because of a lack of tidal rise and fall.

Jockey Cap Rock (Left), 10'' x 14'', 120 lb. stretched David Cox paper. This painting shows surf patterns as seen from above. Contrary to many of my watercolors on David Cox paper, I used no opaque white in this one. The day was overcast and misty, so I did most of the work in my car, parked on U.S. 101 on the side of Neahkanie Mountain on the Oregon coast. The lightest part of the lacy surf is the unpainted, tannish gray paper.

9

Water in motion

Water is very paintable when it is still or nearly so, but it is even more fascinating when it is in motion. With a camera you can "freeze" things in motion to study them at leisure. But if you understand something about the character of the motion, you can get more of the feel of the action into your paintings than by even the most painstaking copying of a photograph. To consider water in motion, we will start with some of the gentler motions and advance to the more spectacular.

Dribbles and Rivulets

A thin dribble of water running off a rock displays the same characteristics as a flat sheet of water; it reflects light and the colors that happen to be in that magic angle of incidence. Reflecting light is not a different process from reflecting anything else, but the fact that light, usually from the sky, is so much brighter in value than other things sets it apart from other reflections. Such a reflected light source gives off a bright gleam of wetness.

Refraction, on the other hand, is essentially the impeding of light, slowing it down. It often makes wet surfaces look darker than when dry, i.e., the color beneath the film of wetness has a hard time getting through to your eye. You have to be able to see *through* the water to some degree for refraction to take place. When the trickle of water is reflecting a bright high light, the brightness nullifies refraction at that spot.

Since the irregularly shaped, constantly moving dribble of water is not flat and still, its reflections of darks and lights keep changing position. It helps, though, to recognize that the processes taking place are the same as those on a quiet pond. Each bright gleam and dark accent has a very specific source like the reflections on still water. If you remember this, you can paint the effect with more conviction. (See *Rain at Go Cong*, p. 62.)

Currents

Currents in large bodies of water are not very visible in calm weather. However, when the wind blows — especially if it is contrary to the direction of the current — you will see a marked effect on the surface of the water. This is a condition known as "tide-rip." Short, choppy, irregular waves are set in motion, and these present an agitated, confused appearance quite different from ordinary waves. The turbulent waves in some of Turner's more theatrical marines resemble tide-rips. Tide-rips are not enjoyable if you are riding in a small boat, but they are very paintable because of their dramatic irregularity.

In confined channels or in rivers and streams, currents are quite visible even in calm weather. You can see the movement of the water from close by, but in addition, the reflections are affected by the current. Reflections of trees on a river bank are broken into patterns following the direction of the current. Effects like a gentle boiling will surface and change the angle of incidence momentarily. If the current is swift, the surface is irregular, and a confusion of reflections becomes involved. Aerated or "white" water may also be present. You must sort out the visible effects and analyze them for painting purposes in terms of the principles of reflection.

Cat's-Paws

Another interesting visual effect on large bodies of water is the phenomenon known as "cat's-paws." Perhaps you are sailing on Long Island Sound in midsummer and become becalmed. The water around you gets glassy smooth, the sails hang limp, and the sun beats down. You search longingly for a cat's-paw, a slightly ruffled, darker patch on the water disturbed by a gentle zephyr of breeze.

Such areas on the water create delightful hori-

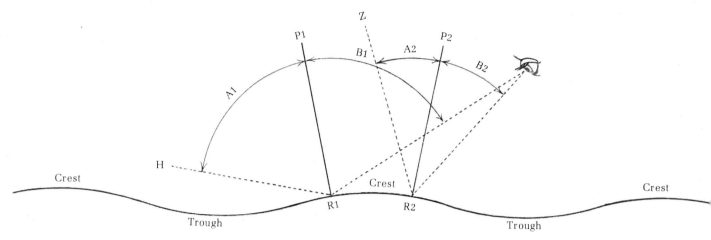

Wave Forms and Reflections from Waves. *The curving line represents the profile of a wave, showing the crests and troughs. The eye is receiving reflected light from points R1 and R2. To determine where the reflected light is coming from, draw perpendicular lines at R1 and R2 (P1 R1 and P2 R2). These form the angles of reflection (B1 and B2) and because the angle of incidence equals the angle of reflection, you can then draw the angles of incidence (A1 and A2), therefore discovering that the reflecting light is coming from H (the lower sky near the horizon) and Z (the upper sky, or zenith). As the eye moves over a reflecting surface, it sees an infinite number of reflecting points (R).*

Reflections on a Slanting Surface. *A sloping roof, made reflective by wetness on a rainy day, reflects images to your eyes just like water. However, because the roof is not horizontal but sloping, the reflection is not vertical but at an angle. The reflection of the chimney might easily be mistaken for a cast shadow. However, if the sun breaks out while the roof is still wet, the shadow might be cast in an entirely different direction, but the reflection would remain where it is. Occasionally reflections and shadows are present at the same time. In the enlarged diagram of the chimney, the line PR, drawn from the reflecting roof's surface at point R within the reflection of the chimney, is perpendicular to the slope of the roof.*

zontal patterns on the surface for the watercolorist.

Cat's-paws and their opposite — clear, glassy streaks on slightly ruffled water — are useful effects to give interest and add perspective depth to broad expanses of water in your painting.

Waves

When you drop a stone into still water, visible waves spread in circles from the point of impact. Waves have a crest (the high point), and a trough (the low point), and a wave length (the distance between crests). They also have frequency and velocity, and they are subject to interference, like being bounced back from an obstacle. They can also be "diffracted," that is, they can spread around the corners of something, like a rock, in their path. Also they can crisscross each other and set up a rather confused image.

Your painting of the sea will become overcrowded if you show too many waves. Winslow Homer's dictum, "three is enough," is a pretty good rule of thumb.

Reflection on Waves

Waves on water are visible because they reflect values and colors from their mirrorlike surface. The patterns of reflection and shadow reveal the shape of the wave to us.

Imagine a large mirror securely glued to heavy canvas, placed face upward on the ground, and shattered into tiny bits, and the canvas then shaped to resemble waves. You would have a rough semblance of the mirrorlike characteristics of waves on water. Each small facet of mirror secured to the wavy canvas would reflect a slightly different image to your eye because each would have a different angle of reflection with respect to your eye. Groups of facets adjacent to each other would reflect similarly, but as your eye moved over the undulations of the wavy surface, a great many different angles of reflection would present themselves, as is the case with waves on water. Those facets on the near slope of a wave are so tilted that they reflect the deep blue zenith of the sky, while facets on the far slope of a wave and the trough

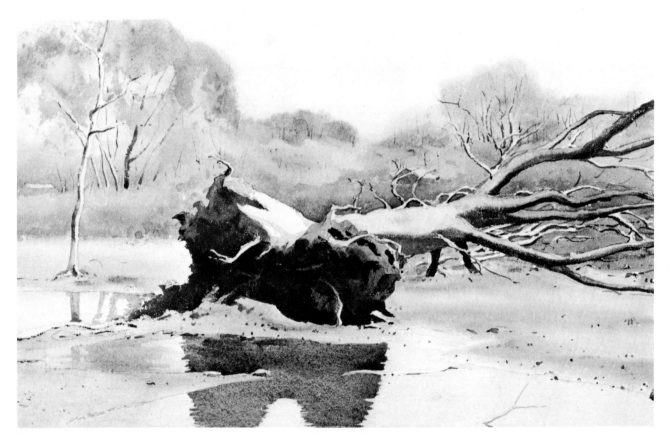

Storm Victim, 13" x 20", 300 lb. rough Arches paper. I found this fallen tree in early spring in a marshy area just a few yards from the Boston Post Road, in Larchmont. I used some Maskoid on the light-toned, thin branches. Then I applied a basic wash for the sky and background in a wet-blend treatment. I painted the ground around the puddle with warm colors; while I painted the puddle in a slightly darker version of the sky. When the puddle area had dried, I superimposed the reflections of the stump and the other objects. The reflected version of the earth on the roots was painted in a warm olive tone, a good deal lighter than the color reflected. The other reflections were also modifications in color value of the color of the objects reflected.

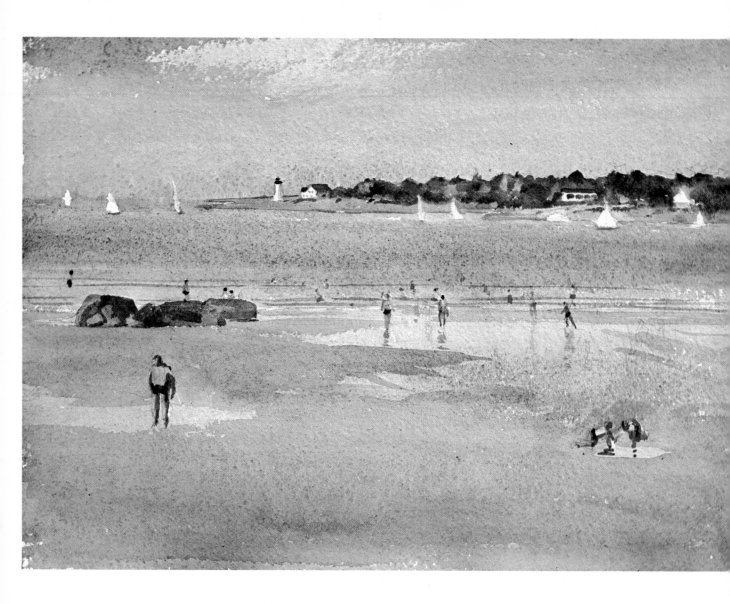

Wyngersheek Beach, *11" x 15", 300 lb. rough Arches paper. This little beach on Cape Anne, east of Boston, has attracted almost as many artists as it has swimmers and sailors. At low tide the firm, rather dark sand is full of color and reflected gleams. Puddles and damp areas reflect sky, figures, and whatever happens to be in position to be reflected. I painted the sky in two washes, the blue part being the second. I mixed cobalt blue, viridian, and yellow ochre for the water. It was a difficult wash to lay because I left white for the sails, the warm light on the rocks, and the light-colored figures. Masking could have been used, but it might have caused a stiff effect, and in any case, I was in a hurry to seize an impression. The water wash, diluted a little, was continued down the beach area, but I avoided the figures. I superimposed the patterns of darker sand. Finally, the landscape and figures were filled in as penciled.*

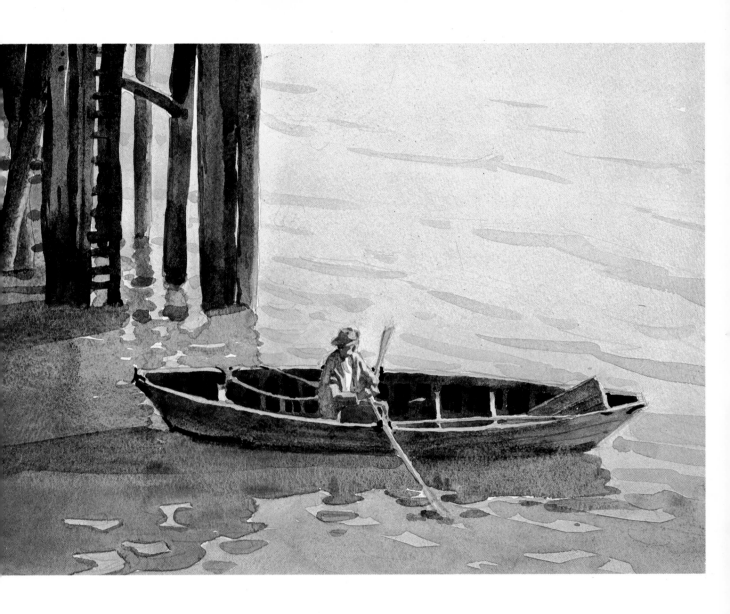

Doryman, *9'' x 15'', 140 lb. cold-pressed, stretched What-man paper. The doryman tied his boat to the ladder on the piles supporting the pier so I had a little time to study the boat construction. Nevertheless, I worked rapidly to capture the effect I had observed as he eased the dory in. I had penciled the action almost as it occurred. I was especially intrigued by the mix of reflections and cast shadows present on the semiopaque harbor water. The irregular pattern of the forest of piles also appealed to me. The ripples in the sunlit harbor were superimposed, as were the blue shadows cast on the water by the piling and the dory. Most of the other color areas were washed in "alla prima."*

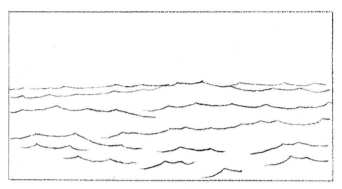

Waves and Ripples: Step 1. *Here is a wash drawing exercise for studying the relationship between waves and their building blocks, ripples. Draw a series of pencil lines to represent successive ridges of waves.*

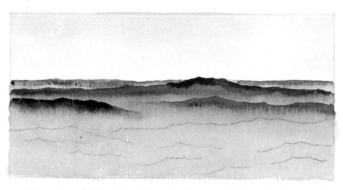

Waves and Ripples: Step 2. *Using any fairly dark color such as ultramarine blue or ivory black, wash in a pale tint for the sky. When that dries, brush a strong tone along the upper line, the horizon, to begin rendering the ocean. While this tone is still wet, fill the brush with water and carry a dilution of the tone to the bottom margin. When dry, brush a strong tone along the second line of wave, and also wash it down to the margin, after diluting it with water.*

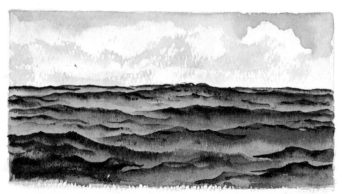

Waves and Ripples: Step 3. *Let each wash dry; then proceed with the next line of wave in the same way until all the waves have been done. You now have a series of wave crests and lighter troughs represented in simplified form. Go back over the separate larger waves with the same treatment on a smaller scale to texture the large waves with ripples. You can create the effect of clouds by passing a light second wash over part of the sky.*

reflect the lighter colored, lower part of the sky.

You can carry out a similar experiment by holding a small mirror, face upward, in your hand and making it move like a gently rocking boat. It will reflect constantly changing areas to your eye, again, as do waves on water. Bodies of water seek a level, horizontal plane because of surface tension and gravity. Therefore reflections on water, like trees and ships' masts, generally have a vertical relationship with the object reflected.

However, other reflecting surfaces are not horizontal. A wet, shiny roof that is sloping at an oblique angle to your eye might reflect a vertical chimney, but because the roof is slanting, the reflection of the chimney bends off at an angle from the base of the chimney, and you can easily mistake it for a cast shadow. Reflections on the slanting, wet deck of a rolling ship behave in the same manner. Waves not only have slanting sides, but they curve in and out. These undulations on the water's surface give reflections that hula-hula movement.

Aeration of Water

As water is hurried along in a turbulent stream or pushed into a wave by wind, it is apt to overrun itself and burst the bonds of surface tension. It captures millions of tiny bubbles of air as it bursts, producing a whitecap, a wave whose crest has broken into white foam. The bubbles are packed tightly together, and since they reflect all of the light, they appear opaque like snow. In open water the massed bubbles, thrust forward by momentum, dance along on top of the water they have overrun. Many bubbles are left behind, like sparks from a rocket, and are dispersed into the clear water. As they disperse, they create a semiopaque, pale-green color effect in the water. Some of the bubbles surface and linger briefly as patterns of foam on the surface. Soon the momentum is expended, all of the bubbles disperse, and the lovely jade color fades like a dying candle. The repetition of this phenomenon on a breezy day creates a superb ballet of patterns. (See *Surf*, p. 46.)

Waves and Ripples

The major difference between waves and ripples is one of scale. Larger waves carry smaller waves and ever-active ripples on their backs. For drawing purposes, consider ripples and wavelets as the building blocks of large waves similar to the texture or the individual threads on the folds of coarse cloth. The reflective characteristics, previously dis-

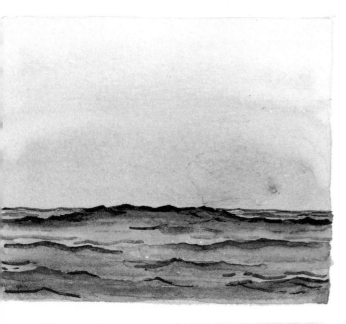

Cresting Wave: Stage 1. *The oncoming wave is about to break and overrun the water ahead. The line above is a schematic drawing of the wave crest as it would appear from above.*

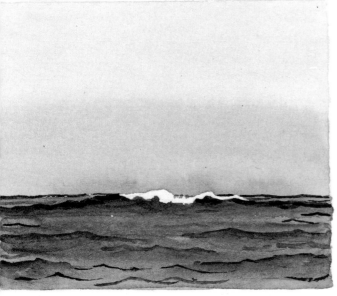

Cresting Wave: Stage 2. *The surface tension has broken and the water, charged with bubbles of air, produces a whitecap. A churning vortex at each end of the whitecap adds more bubbles, and the whitecap broadens. A wake of aerated water trails behind, as the schematic drawing shows.*

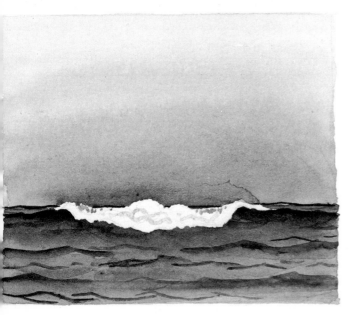

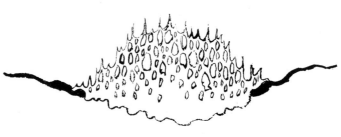

Cresting Wave: Stage 3. *As the energy that caused the wave to build up and crest is expended, the white water is absorbed as the air bubbles disperse. The whitecap then fades away.*

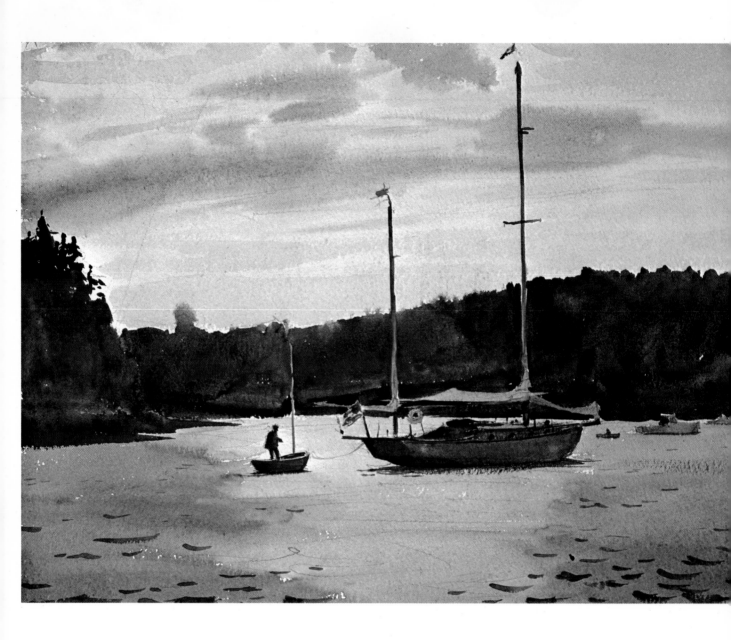

Northeast Harbor, *11" x 15", 300 lb. rough Arches paper. Sunlight breaking through the clouds late on a summer afternoon turned the mass of Mt. Desert Island and nearby boats into handsome but transitory silhouettes. I penciled the shapes rapidly and splashed on the color like mad to capture the mood. I wanted the feeling of a snug harbor at evening and the camaraderie among boatmen to come through in this watercolor. The first wash on the sky was a wet-blend of yellow ochre and patches of gray-violet (ultramarine blue and Indian red). When this was dry, I superimposed streaks of pale blue. The glitter on the water was achieved by fusing the warm sun-path with washes of gray on each side while all three areas were wet. The next problem was to keep the silhouette shapes dark enough in value, yet transparent and atmospheric. I used a dense mix of ultramarine blue with a little Indian red and yellow ochre for this dark value. I avoided masts and sails, as I planned to fill them in last.*

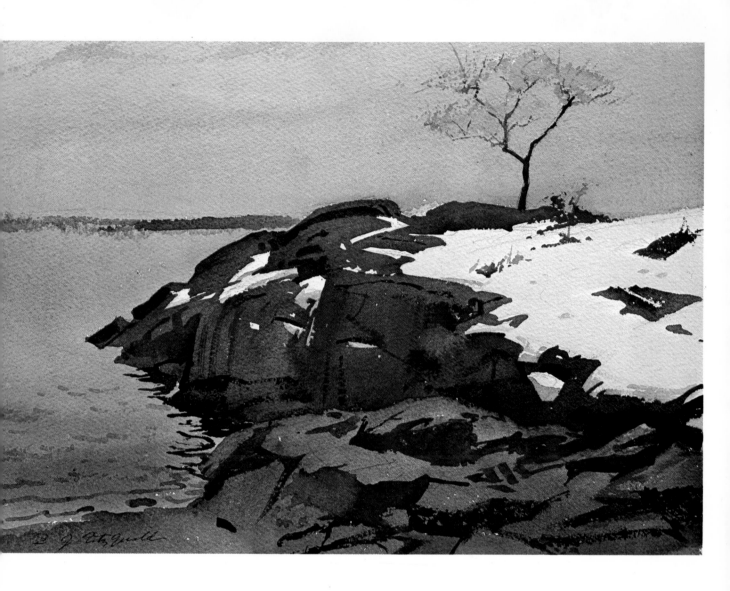

Manor Park, Winter, *11" x 15", 300 lb. rough Arches paper. Painting outdoors in winter presents obvious problems. In addition to personal discomfort, washes can freeze on the paper, producing unpredictable results upon drying. Or, more likely, they will freeze on the brush and palette, making painting impossible. I have successfully overcome the latter drawback by adding an ounce of whiskey to a pint of water. An even better solution is maneuvering your car into position and working inside with the heater and radio on. This was not possible in Manor Park, but actually the day was fairly mild. I was interested in the brilliant snow pattern which made everything else, including the sky, low-key by contrast. I was also interested in the somber but subtle colors in the rocks. I painted them with a basic wash and superimposed accents.*

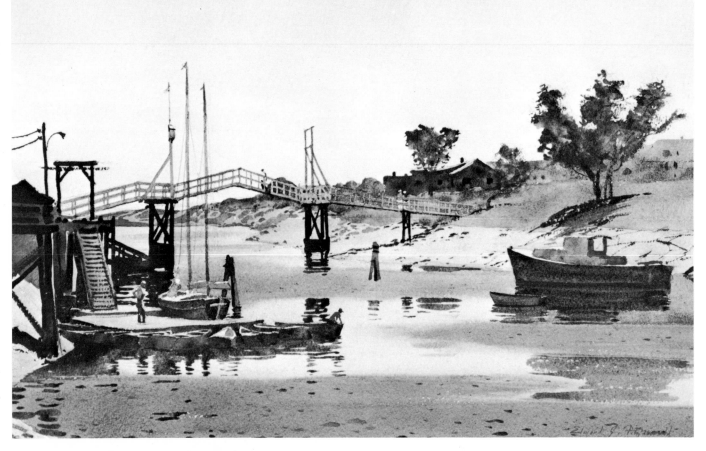

Perkins' Cove *(Above), 14'' x 20'', 140 lb. rough, stretched Arches paper. This watercolor illustrates "cat's-paws," those gentle puffs of wind that ruffle the water surface in places on a calm day. At times while I was painting, the water in the cove was completely calm and the reflections undisturbed. Occasionally the dark, ruffled areas created patterns breaking through the reflections. They would subside, then reappear, in varied patterns. I penciled in a pattern that suited me. I then pre-mixed a wash for the light pattern in the water, which was a reflection of the warm color of the lower sky, and a second wash for the cat's-paws, colored by the reflecting darker zenith of the sky plus the darkening of many tiny wavelets. I applied the two washes separately and fused them at their edges. When these washes had dried, the dark reflections of piling, boats, and trees were superimposed on the unruffled areas of water.*

Whitehorse Rapids *(Right), 11'' x 15'', 140 lb. rough, stretched Whatman paper. This watercolor of rapids in the upper Yukon River shows fresh water churned into white, similar to surf on the ocean shore. The "waves" appear to be breaking upstream. This is like the action of breakers on an ocean beach where a large part of the force involved is from backwash. That is, the incoming wave is largely formed by the receding previous wave. I spent about an hour and a quarter on this painting, half of which was devoted to drawing the patterns of washes and white paper in pencil. Later I erased most of the pencil lines from the white areas.*

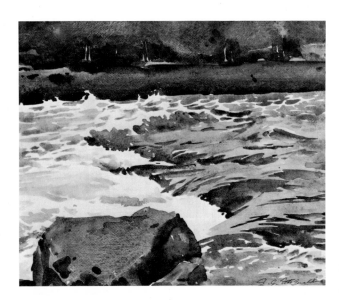

cussed (and you have not heard the last of this), are the chief source of values and colors in drawing waves.

I hasten to point out that you should not reduce the texturing of waves to a formula, as there are probably more variables here than there are different textures and patterns in cloth. All manner of crisscrossing ripples, cat's-paws, miniature whitecaps, and trails of foam can be intermingled on the slopes of one "gray-back," (an old sailors' term for big waves). The whimsical vagaries of wind instantly affect the water surface.

Breakers

Waves break on beaches, reefs, or other obstacles in their path, but the most common cause of breaking waves is simply their hurry to go somewhere, causing them to overrun the water ahead. (See "Aeration of Water," in this chapter.) If you have flown high over the ocean, you recall the sight of waves below rolling lazily along like ripples on a pond and occasionally breaking into a white crescent with a trailing wake. What appears as ripples from 20,000 feet may look menacing from a small boat or even from an ocean liner — such is the deception of scale. Deception is not always as convincing in the opposite direction, however; movies of sea stories are sometimes obviously made with toy ships and waves that have that "splash-in-the-bathtub" look.

In drawing breaking waves on open water, remember the crescent appearance of whitecaps when seen from above. It is often a fairly flat crescent, but nonetheless a portion near the center is usually ahead, racing the rest. It rapidly loses its pep as it tumbles forward. Sometimes two crescents nearly touch at their tips and actually join. The point of joining hurries the water ahead, forming a longer crescent, but this is more characteristic of breakers on a beach than of the open sea.

If the wave action is violent, you will see a spectacular vortex at each end of the whitecap. It looks like an angry whirlpool on its side, advancing along the wave front as the crescent widens. The vortex sometimes looks like the entrance to a long tunnel, but it is funnel-shaped and usually only inches in depth.

Certain stylized waves in art, the well-known "Greek wave" or the huge wave in Hokusai's woodblock print, *Mt. Fuji from Kanagawa*, represent a section through the vortex area and may be misleading if you are studying the characteristics of waves. The white, aerated leading edge of a breaker does not hang over the front of the wave except for a short distance at the vortex. Most of the white

mass of foam tumbles down the front slope of the wave, bouncing along and losing its bubbles into the wake behind the wave as it goes.

Surf and Backwash

Waves breaking over a ledge or on a beach display characteristics similar to a breaker at sea. The difference is that the wave's front slope is likely to be steeper, because the water ahead is impeded in its forward progress or may even be running back to meet the oncoming wave. This backwash effect can be very violent, particularly if the water is thrown back from a steep rock or other obstacle. It often becomes a wave itself, going in the opposite direction and a powerful collision occurs when it meets the following wave. (See *East Wind* in *Demonstrations* section.)

On a sloping beach, the leading edge of a spent wave runs up the slope until it is above the general level of the water and is forced by gravity to run back. Successive spent wave edges carried forward by momentum overrun those ahead and overlap each other in roughly crescent-shaped patterns. Numerous minor collisions occur, where the spent waves overlap and intermingle. The broad, flat wakes of these spent waves carry patterns of foam on their surface through which patches of partly aerated water appear. These patches have the characteristic jade color of partial aeration, usually modified to a warmer tone by strong infusions of churned-up sand.

Storm Effects

When violent winds rage over the water, aeration of the surface water increases. Clean-cut whitecaps on blue water produced by a moderate breeze become lost in a general smother of spume and spindrift. The wind literally "blows the top off the water." Knives of wind slice the water surface, slapping it into darts of spray like a string of machine gun bullets. Waves are menacing and powerful, but they usually attain maximum size on the fringes of a storm or as the wind force begins to moderate. Violent storms are often accompanied by heavy overcast and diminished light. Little blue appears in the water, which tends toward gray, green, and white. When sunlight and blue sky are present, along with gale winds, color contrasts are heightened. The whites become warmer, the greens sharper, and strong blues turn the tracery of foam into lace. (See *Puget Sound Storm*, p. 24.)

In a storm an enormous expenditure of energy is expressed along the shore. Great waves collide with obstacles and backwash and explode like

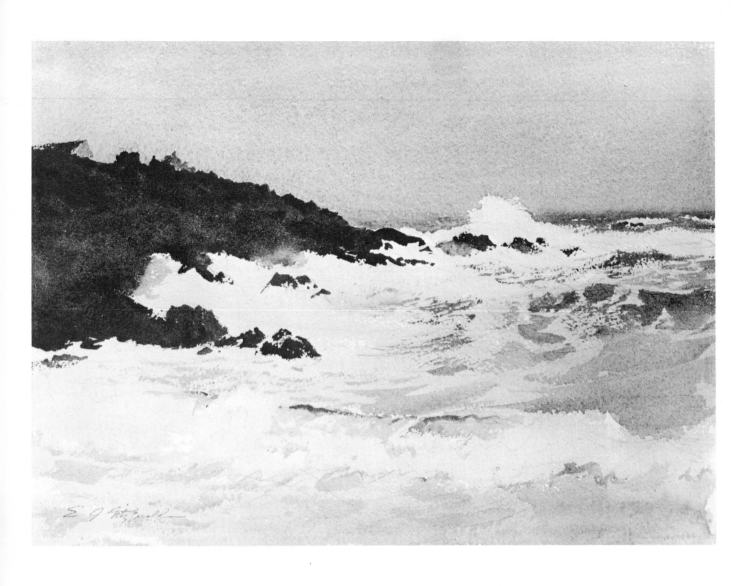

Storm Surf, Oarweed Cove (Above), 11" x 15", 300 lb. rough Arches paper. Collection Mrs. Max Meerkerk. This painting was done from my car during a rip-roaring late summer storm. After I had penciled in the main compositional elements, I mixed a large pale wash. This served as the tone of the white water. I spread this wash over practically the whole paper, but I fused in some darker undertones along the right side and foreground of the ocean. I painted the menacing sky and distant water as a continuous wash, although I added some darker value to the sea at the horizon. This 11" x 15" inspired the 22" x 30" studio painting East Wind. (See Demonstrations section.)

American Falls, Niagara (Right), 22" x 30", 140 lb. rough, stretched Arches paper. This painting was done in the studio from sketches and photographs made on a family outing. It shows the power of water. I painted the rubble-strewn area in the foreground with a basic wash of warm tone. When this was dry, I applied liquid frisket (Maskoid) over it for each of the scattered rocks that appear lighter in tone than their surroundings. Then I applied a second wash, slightly cooler and darker. When I rubbed off the Maskoid, it exposed the warm basic wash. Darker accents brought these light spots out as scattered rocks.

huge puffs of smoke from ancient cannon. Erosion is accelerated and entire beaches can be swept away. Even heavy boulders may be moved, and man-made structures reduced to rubbish. "White" water, much in evidence, is usually not very white. Churned-up sand and other debris warms the white to a yellow tint. If sunlight breaks through, the color effects are dazzling. One color seems to heighten another. The violence of expended energy, your emotional reactions, and the brilliant colors all seem to nourish each other with a kind of kinetic energy.

Waterfalls

In a breaking wave, the crest pouring over the vortex and summit of the wave is a miniature waterfall. Water pouring over boulders in a rapids or the great cliffs of Niagara becomes an enlargement of the same phenomenon. You can see the process of aeration when the water first starts

its fall. Aeration quickly fills all of the forward and downward rushing water, turning it to opaque white. The white cloud of foam at the base of a waterfall and the leading edge of a large whitecap are similar. The difference is chiefly one of scale and the degree of violence of action. The greater the distance of fall, the greater the impact and the more explosive the reaction.

Power of Water

The flow of a great river or the conflict of sea against shore, even the trickle of a small stream, are expressions of tremendous power. The sculpturing of land forms, like mountains, rolling hills, canyons, caves, and alluvial plains is largely the result of the action of water. Water also conveys sustenance to growing things and is a major source of life on the planet. A sense of this awesome power makes understanding and painting this delightful element a source of deep inner reward.

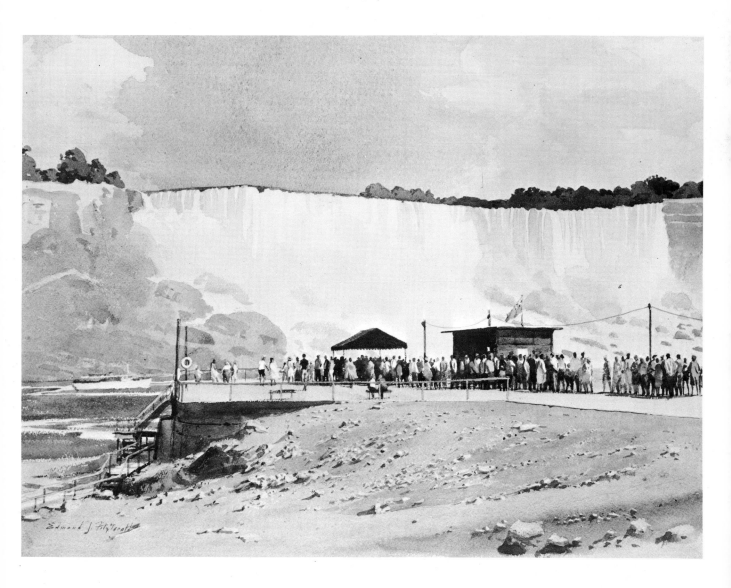

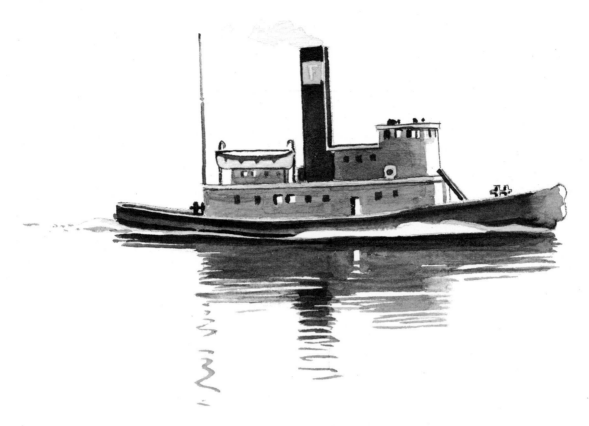

Reflections in Clear Water. *When the water is fairly clear, the reflections of the tugboat are close in value to the tug itself.*

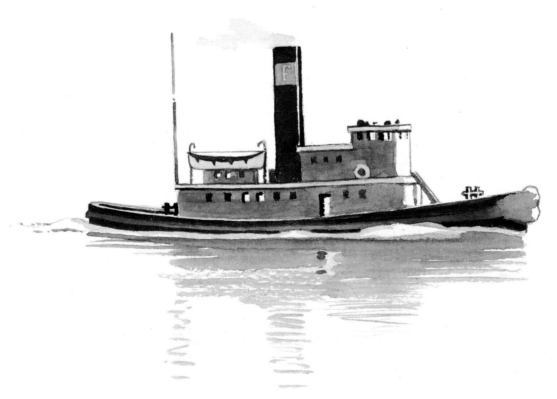

Reflections in Muddy Water. *When the water is opaque with silt or algae, the reflections are much lighter.*

10
Color of water

Water comes in a variety of colors, from the crystal clarity of mountain lakes to the muddy "café au lait" of the mighty Mississippi, whose outpouring is visible far into the Gulf of Mexico. Many rivers, ponds, and lakes have characteristic coloring from animal, vegetable, or mineral sources. Iron oxide, for example, produces a rusty red. A "red tide" appears in Long Island Sound and other salt water estuaries at certain seasons, said to be caused by iodine from seaweed. At the Cape of Good Hope, you can clearly see the line of demarcation where the waters of the Atlantic meet the waters of the Indian Ocean because there is a difference in color. Maps are dotted with bodies of water called Blue Lake and Green Lake. There are the Blue Danube, the Yellow River, the Red River; the list is endless. Pollutants are also busily coloring the waters in the more "civilized" areas of the world.

The actual color of water varies considerably, but this variation is minor in comparison with variations in the *apparent* color of water. Apparent color is what we see around us, as opposed to a test tube sample, and it is of paramount concern to the artist.

Influence of Reflections

Under most conditions the apparent color of water is influenced more by colors reflected from its surface than by its actual color.

The relative clear water of mid-ocean varies from vaporous turquoise on a calm morning to leaden gray under lowering clouds, or even blue-black at the horizon in the teeth of a driving wind. The time of day is an important factor; for example, at dawn or sunset the sea may be tinged with gold or crimson.

The direction of your gaze with respect to the direction of light is also signficant. A white glitter meets your eye looking toward a high-riding sun. An opposite view may seem deep cobalt blue.

Obviously, the principal source of reflected color in these last conditions is the sky itself. The sky is so large that it is always there to get into the act, and at times it dominates the scene completely. It is the source of reflected colors when nothing else is there to be reflected. Also, when the reflections of other things — trees or boats, for instance — are broken up by waves or other surface disturbance, the reflected sky color fills these breaks.

Often on a breezy day, the water is so choppy and reflections so broken up that you can only discern sky color, even though large and colorful shapes are in position to be reflected. As the breeze dies down, the other reflections return to the area invaded by reflected sky color.

Clear Water

Many years ago in a remote part of Alaska, I was struck by the mirrorlike quality of clear, still water. I was a passenger in a light airplane equipped with pontoon floats for landing on a lake nestled among high mountains. When we arrived over the lake, there wasn't a breath of air stirring and the lake was as smooth and clear as a perfect mirror. It looked as if the sky were directly beneath us. Fleecy clouds seemed to float in the reflected blue sky. The pilot actually had difficulty determining just where the water surface was. He maneuvered fairly close to shore so that, as he brought the plane down cautiously, he could watch the shoreline and thus estimate his height above the surface. With the jolt of our pontoons hitting the water, the pristine surface broke into foam and glassy waves.

Such clarity is not usual of course; nor is it particularly desirable in a painting. A disturbed reflection is more fun to paint. But even when a reflection is disturbed, the *colors* are more accurately reflected in clear water. Water that is not clear may reflect a shape accurately, but it modifies reflected color.

Silt and Algae

Under rare conditions, reflected shapes and colors duplicate the things reflected very closely, duplicate them closely enough to confuse the skilled perception of a bush pilot. Usually, however, the color of a reflection is modified to some degree by the amount of actual color the water possesses.

Silt, algae, or other coloring matter in water influence the reflections of colors. In such water, dark colors are reflected lighter, and the actual color of the water is a strong influence on the color of the reflection. On the other hand, lighter colors — the sky or a white boat, for example — are reflected darker, but the water coloration is less apparent in the reflection of the lighter color.

Shallows and Deeps

Another important influence on the apparent color of water is the color of the bottom in shallows or the darkness of the depths in deep water. A light sand bottom produces a pale effect on the surface of shallow water while deep water looks much darker. Both of these effects are most apparent when you look down into water from a high point, or when you look into an area of water that is reflecting a dark color, like the dark side of a boat.

Similarly, your eye can perceive bottom color or the darkness of the depths through the sides of waves that slope toward you. The side of a wave or ripple sloping away from you usually reflects the brightness of the sky and does not permit you to see into the depths.

A glassy sheet of water on a wet pavement surface or sliding over boulders in a tidal pool or rocky stream is influenced in its apparent color by the color of the substance over which it flows. This influence appears as a darkened version of the rock or pavement since surfaces appear darker when wet than when dry. However, portions of these wet surfaces inevitably reflect something bright, whether it be sky or artificial light, thus producing a gleam of wetness. Underlying colors do not show through this gleam.

The Difference Between Reflections and Shadows

Cast shadows, sometimes confused with reflections, can be seen through clear water which is shallow. You can see the shadow cast on the bottom through the thin covering of water. When much actual color is present, in muddy water for example, the water surface may have enough opacity to receive a shadow, like a shadow falling on a solid substance. In such a situation, the shadow is intermingled with reflections; you must observe the difference and sort out the various effects for proper rendering. (See *Dorymen,* p. 75.)

Direction of Light

Reflected light is spectacularly illustrated in the vast glitter that appears on the sea as you look toward the light when the sun is riding high. Painting this effect is difficult in any medium because your control of values is strained to the limit. White paper, the whitest white available to the watercolorist, is scarcely adequate to represent the brilliance.

Light tones of pure color, tinting the sun-struck areas, can make the white paper seem actually brighter. But you must exercise care to keep brushes, colors, and mixing water as clean as possible. (See *Northeast Harbor,* p. 78.)

Brilliant light effects also appear in a less intense form on broad expanses of water when you look a little to the left or to the right of the brilliant area for the direction of your composition. Values here are less extreme, and consequently you will be able to use stronger color.

Sunrise and Sunset

Lovely, fleeting effects of reflected light occur near sunrise or sundown, particularly when the sun is partly obscured by haze or by bands of cloud and specifically when the water surface appears *lighter* than the sky at or near the horizon. You will not find this condition often, as it requires special circumstances of light, atmosphere, and sea. Luminous, opalescent colors follow one another over the water surface like the sweep of a brush, and

Reflected Light on the Sea. *Detail of* Summer House in Winter, *p. 10. The surface of the sea in the distance mirrors the light falling on it from above.*

watercolor is really in its element. The effects change quickly as more or less light breaks through; the light colors and is colored by varying bands of mist and cloud. (See *Lobsterman's Morning* in *Demonstrations* section.)

When the sun sets or when it is fully obscured by cloud, the tone of the water deepens and is no longer lighter than the sky. The color of the sky, however, has a dominant effect on the color of the water. The brilliant colors of the afterglow reflect in the water, though now they are deeper in value.

Weather Influence

Weather has potent effects on the apparent color of water. Even when the sky color remains the same,

varying wind conditions change the appearance of a body of water.

The zenith of the sky dominates the color that is reflected from the sides of waves or ripples that slope *toward* you. The sides of waves that slope *away* from you reflect the lighter, lower portion of the sky, but this can only be observed relatively close at hand. The far sides of small waves are more visible than those of large waves.

The collective effect of the waves produces a gradual darkening of the water surface as your eye moves from the foreground toward the horizon. The lighter back slopes of the waves are hidden from your view, while the darker front slopes massed together cause an apparent darkening near the horizon.

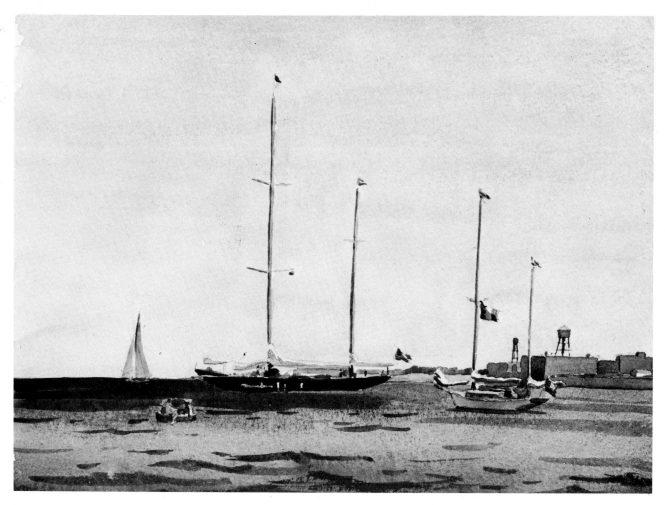

Sailboats, Newport, *11" x 15", 300 lb. rough Arches paper. A clear sky and a brisk southwest wind were the dominant characteristics of the afternoon at Newport when I painted this watercolor. When I looked toward the direction of wind, the horizon appeared as a sharp line against the sky, almost as dark as the beautiful, black hull of the big ketch riding at anchor. I used the flapping bunting and the close-hauled boat under sail to indicate wind direction and freshness. I did not use Maskoid in*

this painting, but it would have been a suitable treatment on the masts and flags. I painted the sky in one wash. The wash was made gradually lighter by adding water as I carried it across and downward, avoiding the masts and flags. In addition to graduating the tone, I also incorporated color changes in the wash, complicating the mixing in the palette between each application to the paper. Behind the upper part of the masts I made the sky cooler, but toward the horizon, it became warmer.

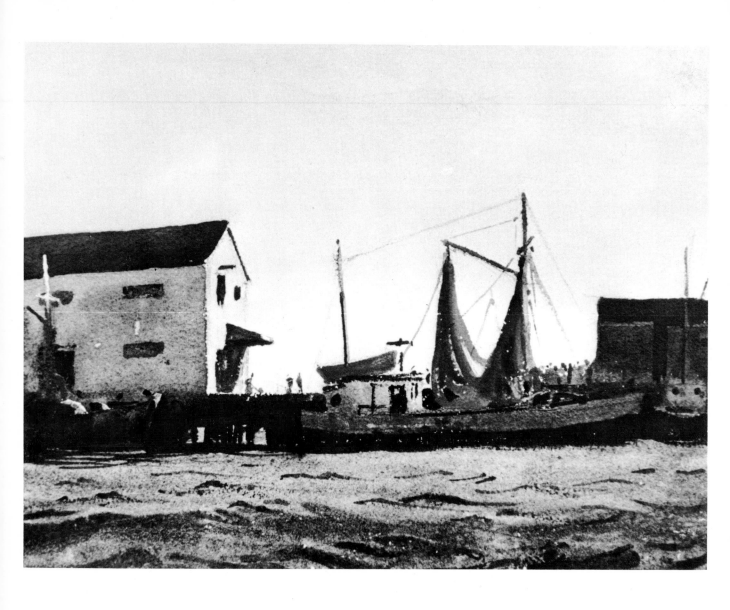

Provincetown Pier, *11" x 15", 300 lb. rough Arches paper. This watercolor shows a harbor with water which is so active that even strong colors and large shapes are not visibly reflected from its surface to your eye. I painted the hanging nets in strong strokes of pure color, yet there is no reflection in the choppy water. Neither is there a reflection of the large, dark shapes of buildings, boats, and docks or of the warm, pale lower sky.*

Mississippi Shore, *11" x 15", 300 lb. rough Arches paper. This watercolor shows the shore at Baton Rouge. I painted it while I was on an assignment for Standard Oil Company. It illustrates some characteristics of colors reflected in muddy, still water. I painted the river with a strong-colored wash, shading to a lighter value in the area between the pier and the near shore where men were washing accumulated silt back into the river. I made all the reflections in the still water the same color regardless of their local color.*

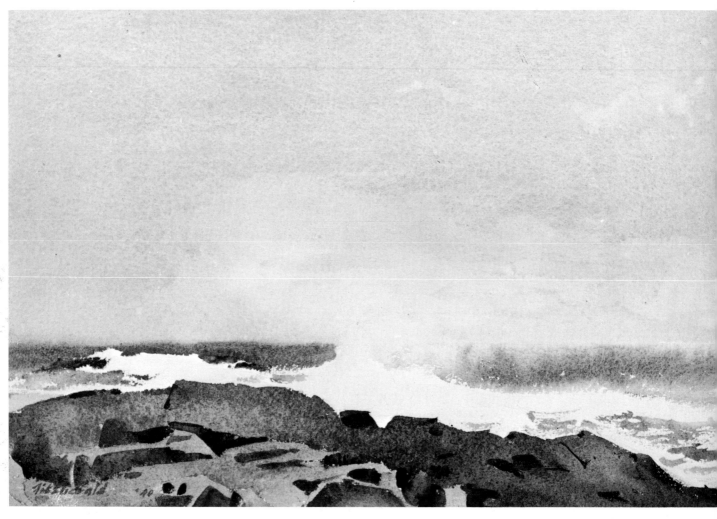

Spindrift *(Above), 11" x 15", Whatman board. This very simple painting was done more than 30 years ago, and I find it hard to recall the exact procedure I used. It is a good representation of spindrift. I painted it quickly (in about an hour) on a stormy day on the coast of Alaska. I can recall the chill and mood of violence but not the order of washes. I believe I painted the gray sky and distant water in a single wash, fused at the horizon. The white water is mostly white paper. I do not really remember how I achieved the effect of spray blown off the top of the near breaker. Robert Browning was once asked what he meant by a certain line. He pondered a bit and said, "When that line was written, God and Browning knew what it meant — now only God knows."*

Granite Shore *(Right), 11" x 15", 300 lb. rough Arches paper. This watercolor illustrates waves "creaming over the rocks." The effect is rendered by simply leaving white paper to show the rivulets of foam running off the dark rock formation just after a wave has broken over it. Each wave lasted only seconds, but the process was repeated over and over again for my observation. There was no sunlight; in fact, it rained a little, from time to time while I painted, so I constructed a temporary shelter out of some boards I found among the rocks. The diffused light and damp weather brought out fascinating colors in the rock formation.*

11

More about white water

White water is created by churning foam on a stream tumbling over boulders, whitecaps on an expanse of water on a windy day, or great combers piling up on an ocean shore. These have been sources of fascination for artists of all times and places. The bright tone of these elements creates endless patterns of design, and their action expresses energy and power.

Painting White Water

White, to the watercolorist, starts with the whiteness of his paper. Opaque white pigments are available, but the essential character of watercolor is transparency, particularly in the lighter colors. Watercolors have an inner glow, caused by the paper gleaming through the thin veils of color, that sets it apart from other media. Sometimes I leave white paper untouched for the dramatic whites, but most often I apply delicate washes, even for the brightest areas like the sky, snow, and white water. Careful examination of original watercolors by some of the most spontaneous practitioners, like Homer and Sargent, reveals that they have filled with the appropriate color tiny "skips" and pinholes left in washes. Even accidental specks of white paper are part of the painting structure; they should be so considered and filled up if necessary. (See *East Wind* in *Demonstrations* section.)

Since white paper is your whitest white, remember that use of it in your painting represents the ultimate in your light values. Reserve white paper for special purposes and instead, paint most of your light areas with lightly tinted washes.

Color of White Water

White water, seen under certain circumstances of lighting, is far from white in value. Direct sunlight bathes it in a warm glow, showing delicate tints of yellow and red, while a cresting wave seen against a low sun appears to have a rather dark gray whitecap. White water on a muddy stream or in surf that has churned up quantities of sand is, of course, colored by the material in solution. A foaming breaker in such water looks, for all the world, like a pile of soiled snow thrown up at the side of the road by a snowplow.

Since white water is wet, it also has considerable reflective capacity and even brightly sunlit parts of it pick up gleams of coolness at places where blue sky is in the angle of incidence. As you can see, white water is likely to be singularly colorful.

Shadows on White Water

White water has form and therefore light and shadow almost like solid substances. In spite of the reflective capacity, its light and shadow components can be in strong contrast to each other very much like snow or clouds.

White water, tumbling down the face of a wave, is formed into a series of plunging white hills and valleys that show a definite pattern of light and shade. The lights are a warm white. The general color of the shadow remains quite cool, but warm reflected light illuminates the shadows, and warm accents are apparent at the base of each small hill of foam.

Shadows on white water, because the form is turned away from the source of light, are similar to shadows on any white form, except that the wetness increases the reflective capacity of these areas. This means that the shadow is more subject to secondary, reflected illumination than it would be on a dry, white form. The shadow may reflect sky in places, making it very cool, but it may also pick up warm reflected light from nearby sunlit white areas.

Patterns of Foam

Most of the white foam of aerated water is short-lived and soon dissolves, except where there is

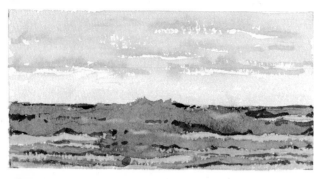

White Water Against the Dawn or Evening Sky. *When seen against the dawn or evening sky, the white foam of breakers is quite dark in value. The overall color tends toward blue-gray, but upper surfaces of foam are cooler, having more blue or green, and lighter in value. Lower surfaces of foam may be darker and warmer, and yellow or orange in color.*

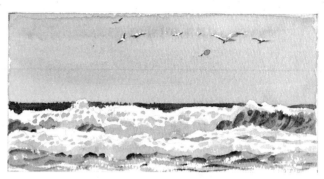

White Water Partly in Shadow. *When white water is partly illuminated with sunlight and partly in shadow, it has light and shadow components similar to snow. Like snow, white water is every color but white! The lights tend to be warm, yellow and pink, but with some cool variations. The shadows are cool, blue, but with warm variations.*

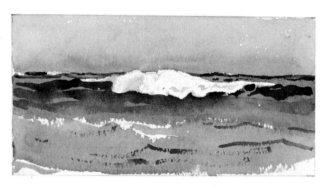

White Water Illuminated by Strong Light. *When strong light is coming from behind you, it floods white water areas with so much light that everything else — sky included — appears darker by contrast. Few shadows are present in the white water. If the sun is low in the sky, the illumination on white water is likely to be very warm in color.*

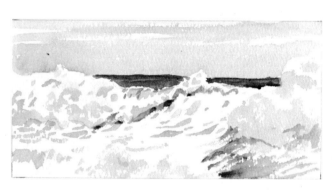

Foam Caused by a Breaking Wave. *When a wave breaks, it leaves a wake behind it of foam-laden water which is often lifted into a new wave before the foam has time to disperse. Shadows cast on the foamy surface by the slant of light are very apparent, as on any light surface.*

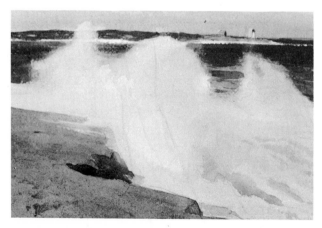

Painting Foam. *Detail of Breezy Day, Rockport, p. 102. In painting foam, soft edges are important. You can paint foam wet-in-wet, by wiping out, or with carefully controlled drybrush strokes surrounding the white areas.*

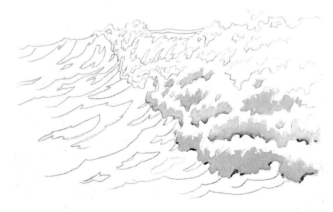

White Water Tumbling Down a Wave Face. *White water goes galloping down the face of a breaking wave like a lot of wild, white horses.*

constant action breaking the surface tension, as at the crest or in the wake immediately following a cresting wave. The thin sheet of water in the wake of a spent wave on a sandy beach and the shallow water between breakers near shore carry a lacy pattern of foam in the process of dissolving. The darker, dissolving areas between the white "lace" often are roughly circular in shape, like coins of different sizes strewn over a white cloth. These shapes usually have a semiopaque look and tend toward green in color. This green color is produced by the presence of dissolving bubbles of aerated water. Such coloring appears in the wake of a cresting wave or moving boat. (See *Surf*, p. 46.)

A denser kind of foam sometimes forms at the base of waterfalls or in clefts on a rocky shore, where water action is violent and constant. This foam remains intact and is slow in dissolving, being tossed about on the surface or held in place by an eddy. It is usually darker in color than the rest of the foam and sometimes you will see it undulating over more than one wave, like a blanket over a restless sleeper. (See *Bald Cliff* in *Demonstrations* section.)

Spume and Spindrift

Spume is just another word for foam. It refers specifically to sea foam and has such a salty, nautical sound that I find it irresistible. It is a poet's word for the froth upon the sea and evokes the lonely cry of gulls and the wind's song in the rigging. Masefield used it to create an image of the sea, "And the blown spume and the flung spray and the sea gulls crying."

Spindrift (or spoondrift) is another poetic word. It refers to the streamers and clouds of spray blown from the tops of breaking waves under a driving wind. When a strong wind is blowing parallel to the beach, you will see streamers of spindrift blown from the crest of each breaker. Such semi-transparent shapes are not easy to paint, but water-color is certainly the most suitable medium for realizing such effects.

Creaming over Rocks

A great breaker thundering over a rocky ledge keeps its foaming, aerated character for several seconds as it charges over the ledge, seeking channels down the sides. The interaction between the rushing water and the rock prolongs the aeration, so the white water drapes over the ledge like frosting on a cake. High places on the ledge remain above the foam and you can paint them as strong, dark accents. You must draw the dark and light patterns carefully to be convincing. (See *Lobsterman's Morning* in *Demonstrations* section.)

As aeration fades and the bubbles dissolve, the white foam changes to a number of miniature waterfalls and rivulets draining off the ledge. These display the reflective and refractive qualities discussed in Chapter 9. While the white water remains in cracks and crevices of the ledge, it may have strong shadows cast upon it, depending on the strength and direction of light. Draw and paint the patterns of these shadows with the firm definition described in "Shadows on White Water" p. 91.

The Dying Wave

Under "Patterns of Foam," I described the roughly circular shapes between the lacy areas of white water. The coloring and opaque appearance of these foam patterns varies as the bubbles dissolve and disperse. The clear, reflective characteristic of water increases as the dispersal of aeration takes place. This process describes the spent energy that created the initial climax of the breaking wave and the plume of dazzling white. As aeration subsides, the lovely jade color fades. Clarity returns to the water as it readies for the next surge of power in the boundless profligacy of nature.

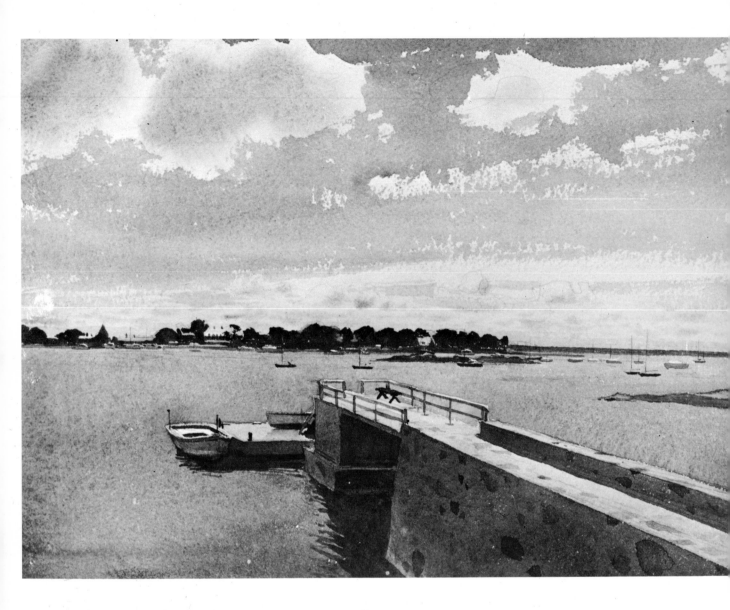

Cedar Island Boatlanding (Above), 11" x 15", 300 lb. rough Arches paper. This view across Larchmont harbor was painted from a friend's terrace. I used two washes for this sky, the first a wet-blend. That is, I covered the entire sky with clear water and put into this a pale tint for the light on the clouds with spots of warm gray for the shadowy underside of the fleecy summer clouds. When that was dry, I applied a second wash for the clear sky area. I thinned this with water and added viridian in the lower sky. The feeling of perspective in this sky is largely created by the drawing of the cloud shapes growing ever smaller in the distance. The masonry in the foreground is also important. I first applied broad washes in the appropriate value for the mortar. Superimposed over this are varicolored spots to read as the large stones visible in the construction.

Gloucester Harbor (Right), 11" x 15", 300 lb. rough Arches paper. The sky in this watercolor is painted in light values but has, nevertheless, a good deal of depth and substance. The lower sky is quite warm and makes a strong contrast with the water and silhouetted boats. A few touches were superimposed.

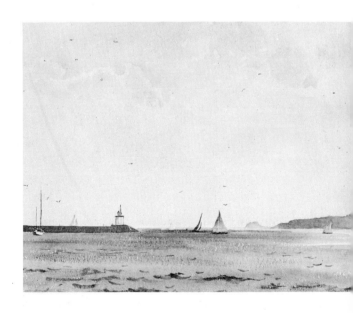

12

Canopy of the sky

Watercolor is without equal as a medium for expressing the sky. Transparency and clarity of color, speed of execution, and the very nature of the wash technique make watercolor the supreme means for rendering luminous skies.

The long tradition of British watercolor painting reveals the recognition its masters have of the affinity of their medium for capturing the fleeting effects of the incomparable English skies. Many of the watercolors by Girtin, De Wint, Cotman, and their contemporaries are three-fourths sky. More recently, Gerald Ackermann and William Russell Flint have kept this great tradition alive. (See *Beach at Arch Cape*, p. 43.)

Our own Winslow Homer and contemporary masters like Ogden Pleissner, Andrew Wyeth, and a few others can paint a magnificent sky, but my impression is that many contemporary painters have turned their attention to more earthy subject matter. In recent years there has been a great increase in interest in watercolor, and some marvelous work is being done, but it is a matter of regret to me that the sky has assumed a less dominant role in composition.

Transient Sky Effects

The sky is a restless model. Waves will not "sit" patiently to be painted either, but at least they tend to repeat themselves for our observation. The sky, however, is a place of constant change. A cloudless sky will "hold its pose" fairly well, as will a solid gray overcast, but these are not always the most interesting skies, and they are not necessarily easy to paint.

Color of the Sky

Colors and values in the sky are deceptive. The sky usually is not as blue as it looks, and clouds are not always as white as they seem. Contrasts in the sky often look very strong, but if you attempt to paint them so, you may exhaust your means of producing intense and delicate values and leave an insufficient range of values on your palette for other contrasts.

Apparently some artists rely on formulas for painting skies. They try to repeat in one painting a sky that worked well in a previous painting. This method produces a manneristic result. I recall the late Gordon Grant pointing out the dangers of this approach. He said that it carried an artist away from a search for the truth and gave only a repetitious, "safe" look to his work.

The sky is the source of light, but it often appears as a strong, dark contrast to illuminated, light-toned surfaces — whitecaps, for instance. (See *Manor Park, Winter*, p. 79, and *East Wind* in *Demonstrations* section.) Various parts of the sky, even when cloudless, are different in color and value. The zenith of a clear sky is usually the darkest in value, while the lower part of the sky is usually lighter than the zenith and also tends to be warmer in color. The color of the lower sky varies considerably, but it is most often a warm, pearly gray tending toward pink or yellow. In clear weather it may have a greenish cast. A hint of green often appears in the sky somewhat above the horizon, while near the horizon a warmer haze is present. (See *Schaefer House*, p. 122.) The darker zenith is usually the bluest part of the sky, though I find it best even for the upper sky, to modify the blues on my palette. (I often use cobalt or ultramarine with a touch of red or ochre.)

The varied colors in the sky are brought about by light being diffused and otherwise acted upon by air and the infinite variety of particles drifting in the air. As the density and variety of particles of dust, smoke, and moisture varies, so does the color of the sky. (See *Art Class at Nubble*, p. 123.)

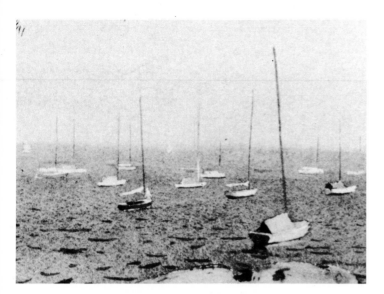

Soft Transition at the Horizon. *Detail of Small Boat Moorage, Larchmont, p. 29. I used the wet-blending technique to create this soft transition from sea to sky.*

Sky in Successive Washes. *This figure illustrates the beginning of the painting, Cape Newenham p. 101. First I covered the sky with a wash of pale gray, except for the white areas on the clouds. A second wash of the same gray strengthened the cloud form near the center of the sky. When the gray washes dried, I superimposed a wash of cobalt blue over parts of the upper sky to read as areas of blue sky between clouds.*

Light Reflected from the Earth

Light reflected from the earth to the sky produces a marked difference in color to the sky above. A great deal of warm color is reflected into the sky over broad expanses of sand, while in the Arctic a phenomenon called "ice-blink" is a cool, yellow glow in the sky caused by sunlight bouncing off an expanse of ice.

Influence of Large Shapes

Another, less obvious, but equally important influence on the color of the sky is the color of large shapes seen against the sky. My observation convinces me that a harmony exists between the colors of such shapes and the sky immediately beyond. Some of the color of each seems to be absorbed into the other. Even when conditions of strong contrast are present, autumn leaves against a blue sky, for instance, warmth is infused into the blue; and the leaves near the point of contact lose a little of their yellowness and tend to become silhouettes, with a hint of coolness in their color.

Under conditions of moderate contrast of values, the color harmony between the sky and shapes seen against it is conspicuously evident in great art — and in nature — which, as Whistler put it, always imitates Great Art!

The Sky Reflected

The infinite variety of colors in the sky are often reflected from the water and wet surfaces below, as previously discussed. (See *Puget Sound Storm*, p. 24, and *Wyngersheek Beach*, p. 74.) Dry surfaces also show this influence in accordance with the way their planes lie in relation to your eye, their reflective capacity, and areas of the sky in the angle of incidence. When strong sunlight bathes upturned planes, the light from the sky is reflected in proportion to the reflective capacity of the plane. In other words, dry surfaces having low reflective ability show little sky color influence when in strong sunlight. However, when these same planes fall into shadow, sky reflection asserts itself more strongly in their coloring. This helps to account for the coolness of shadows on a sunny day; blue sky is being reflected. If other than blue sky is in the angle of incidence, the influence on the color of the planes described will be affected accordingly. Dry, polished surfaces reflect similarly to wet surfaces.

Light Paths on the Water

In Chapter 10 the effect of the glitter of sunlight on the sea was discussed. Paths of reflected light from

a less intense point of light like a dimmed sun at sunset, the moon, or harbor lights at evening, behave in the same way, causing a glitter to appear on the water, except that their lesser intensity reduces the reflected path to a line, no wider than the light source. (See *Lobsterman's Morning* in *Demonstrations* section.) The intensity of the light source and the stillness of the mirror of water determine the length of the path. On the rare occasions of perfectly still water, a weak light does not produce a path at all but is reflected as a spot of light immediately below its source, the same distance that the light is above the surface of the water. In short, it is reflected in the same way that any other object would be reflected.

A large, brightly lighted cloud, low in the sky, also constitutes a light source that can produce a path which will be the width of the lighted part of the cloud, much like any other light source reflected on moderately calm water. (See *Skiffs on a Wharf*, p. 126.)

Watercolor Technique for the Sky

Although watercolor is especially well-suited to expressing sky effects, there are plenty of problems not present with more pedestrian media. The speed of watercolor for capturing fleeting effects like moving clouds is fine! A major difficulty is keeping control of edges. A variety of edges — hard and soft, blended and sharp — are necessary for expressing clouds, or nearly anything for that matter. The techniques of wet-blending and fusing are both useful in rendering skies.

I find that a primary wash laid over an entire sky and aimed at achieving the light color value of the clouds is often a good way to start painting the sky. Sometimes I work shadow components on clouds, if present, into this wash while it is being laid on the paper. Wet-blending or fusing may be involved in this first wash. When the first wash dries, I apply the blue sky as a second wash, using a quick "drybrush" movement at places on cloud edges to obtain a soft look to some of the edges. Darker accents, in some of the shadow areas of the clouds, may be added as final touches.

Cloud Types

Meteorologists have names for various types of clouds, cumulus, cirrus, nimbus, etc., to classify and distinguish them. These classifications are of only passing interest to the outdoor sketcher. In sketching you are most concerned with the *appearance* of things, particularly with the way light plays over forms. Clouds, and all other forms for that matter, vary much more in accordance with the circum-

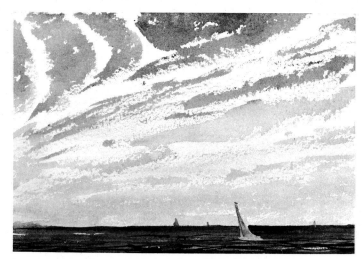

Mare's-Tails. *High, thin wisps of cloud, called cirrus by meteorologists, are sometimes blown into fantastic streamers in the upper air. They are said to be five or six miles high. These are mare's-tails, and to sailors they portend a weather change. In this sketch I painted the mare's-tails in two washes. The first, a pale, warm gray, started at the horizon and washed upward, gradually getting lighter and warmer in the upper sky. When the first wash was dry, I brushed on the second wash of cobalt blue in a pattern which left the first wash exposed in certain places as the cloud streamers.*

Clouds Shaped by Wind. *Detail of* Low Tide, Turbot's Creek, *p. 114. The long horizontal shapes of these clouds indicate the direction of the wind, and in fact, they are shaped by the wind.*

Clouds Painted on Dry Paper. *Detail of* Footbridge at Wells, p. 119. *I defined the overall shapes of the clouds by the surrounding dark washes, which were painted on dry paper with a hint of drybrush to soften the edges.*

Clouds Painted on Wet Paper. *Detail of* Lock at Troy, p. 119. *These dark clouds were painted on wet paper and allowed to soften and spread, though the shapes were carefully controlled by the brush.*

Storm Clouds. *Detail of* Convoy, p. 40. *These dark clouds were painted on rough paper. I allowed the color to settle into the texture of the painting.*

stances of light in which they appear than with their type classifications. A cumulus cloud, for example, may be a bright shape in the sky or a dark shape, or it may have both light and dark values, depending on light conditions. Your primary concern is with shapes and color values.

Painting Clouds

Clouds have many different shapes, and they are found at different altitudes in the sky. They appear in a variety of values and colors depending on their density, their position in the sky, and on the light conditions present at the time.

"Mare's-tails" and other high, thin clouds often appear as ghostly wisps that you can sometimes render as a variation in the blue sky wash. Other cloud forms have shapes as definite as solid objects, and you must render them in similar manner. Drawing, value, and color — in that order — are the keys to the solution. A scattering of clouds may appear to have rather flat bases, as though they all rested on the same invisible ceiling (which indeed they do). This invisible ceiling, parallel to the surface of the earth, has the same perspective solution as the ceiling of a huge room with you inside. Sometimes the invisible ceiling is less sharply defined, as though it sagged here and there, allowing lumps of its cloud burden to droop below the general level in places. Often more than one level is evident. My point is that you should handle the drawing of clouds as systematically as the drawing of a fence or a scattering of trees. (See *Shower Over Cape Porpoise*, p. 42.)

Use of Cloud Photographs

I have likened the drawing of clouds to the drawing of waves; the constant movement gives the draughtsman a hard time. Why not use photography to hold the movement so you can give it a little study? This is frequently done, but the results are usually disappointing and all too often "obvious." It is a curious paradox that where photography should seemingly be most helpful to the draughtsman, as in stopping rapid motion, it fails most conspicuously. The results are acceptable in an inverse ratio to the artist's dependence on the help. If the draughtsman relies *heavily* upon the photograph, it shows up in his work like the crutch it is.

Aerial Perspective

Aerial perspective in the sky, as on earth, effects the values and color according to distance. Dark areas become lighter as they recede into the distance, and lights become less bright. By the same

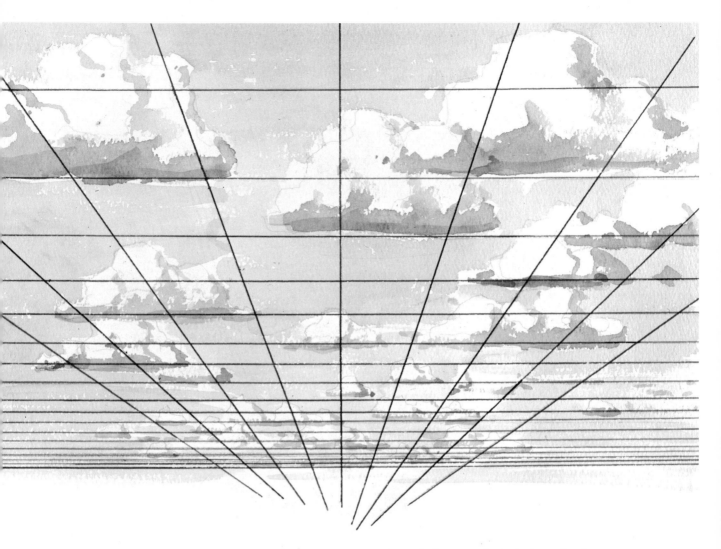

Cloud Ceiling. *If you imagine a ceiling of glass on which drifting clouds are resting, you can visualize perspective in the sky.*

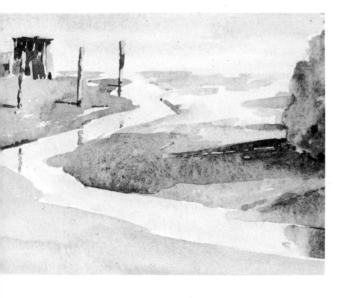

Directing the Viewer's Eye. *Detail of* Low Tide, Muckleteo, *p. 173. The shape of the water flowing from the foreground into the middle distance carries the viewer's eye into the picture.*

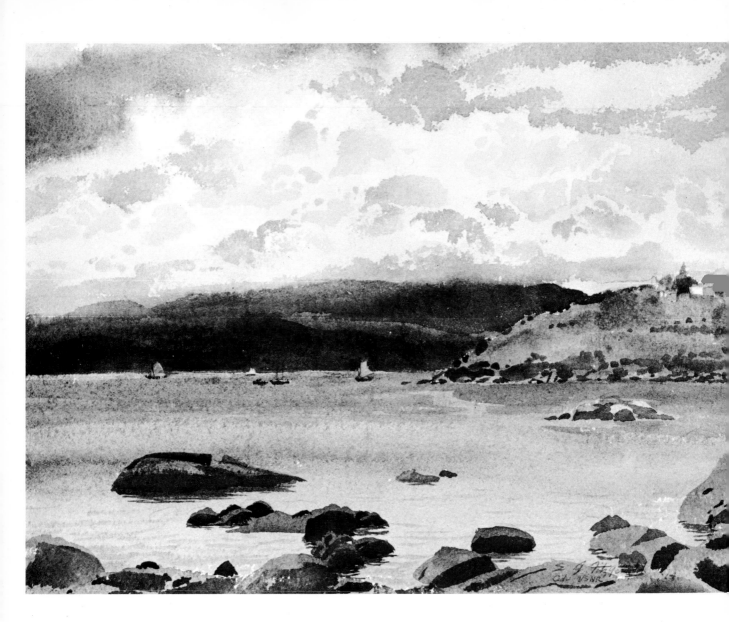

Harbor Entrance, Danang, *11" x 15", 300 lb. rough Arches paper. I found a shady place near a ruined shrine to paint this watercolor on a steamy August afternoon. I was particularly interested in the monsoon clouds, which I had quickly penciled in, sweeping the hills on the north side of the harbor. I brushed a wash across the upper left corner of the paper. Then I added water and carried the resulting lighter wash across the upper sky. Patches of this gray tone were spotted onto the white paper in the lower sky to describe the shadowy parts of the lumpy cumulus clouds. I also used a continuous stroke of this tone to mark the lower margin of the cloud mass. Before this stroke was dry, so the cloud and hills could be fused together, I continued with the very dark color of the cloud shadow covering the distant hills. I avoided the spots I had penciled in for the sails seen against the dark hills. These were later filled in with a warm tone. I also went back to the sky and superimposed some spots of pure color to read as patches of clear sky above the cloud mass.*

process, warm colors become cooler. But in the case of lights on clouds, the more distant clouds near the horizon are usually warmed a little in color by the warm haze that exists in the sky toward the horizon. The value relationship between darks and lights on distant clouds is in far less contrast than on clouds that are nearer. In short, all contrasts in distant parts of the sky near the horizon are slight, except when you are looking toward the setting or rising sun; then clouds appear as strong darks seen against the light.

Shafts of Light

Shafts of light from the rising or setting sun come through warm-colored haze near the bottom. They are affected by the greater quantity of atmosphere through which they must travel and often tint clouds in all parts of the sky with warm lights. The color of the blue part of the sky, and the shadowed parts of clouds are also affected in subtle ways at this lovely but transitory time of day. You must handle colors with great precision to successfully paint such effects. Turner, Boudin, Bonington, and a few others could manage it, but the list is not long.

Cloud Shadows

Clouds that are dense enough to have shadows on those parts that are hidden from the light can, like solid objects, also cast shadows which may fall upon other clouds or on the earth below. These shadows, like all shadows that are on upturned surfaces which would normally receive light, do in fact show some light reflected from the blue sky. Such shadows are cooler in color than shadows on surfaces that are turned away from the source of direct light. The shadows on the underbelly of clouds, for example, are warmer than shadows cast on the upper parts of the same cloud by other clouds.

Cloud shadows sweeping over broad areas of landscape or water provide marvelous compositional elements for the design of your paintings. You can dramatize details in bright illumination in the foreground by having the background of the picture under cloud shadow. You can also show an entire foreground thrown into shadow by a passing cloud, thereby directing attention into the distance in your painting.

Cloud shadows, like the clouds that cast them, are difficult to sketch because of their constant movement. Close observation in "open-and-shut" weather, good visual memory, and the ability to reconstruct something from a fragment, like an anthropologist with a bit of bone, are the best tools for handling this problem.

Cape Newenham, *11" x 14", 140 lb. cold-pressed, stretched Whatman paper. This low-horizon watercolor, painted on the Bering Sea coast, illustrates perspective in the sky and cloud shadow on the foreground. I superimposed a blue wash in the upper sky over the pale gray tones describing the cloud shapes and the mist in the lower sky. Lights on the clouds are white paper. I indicated some bushes and the sandbar with warm colors in the sunlit area beyond the figure. The entire foreground is in cool shades of green, indicating cloud shadow.*

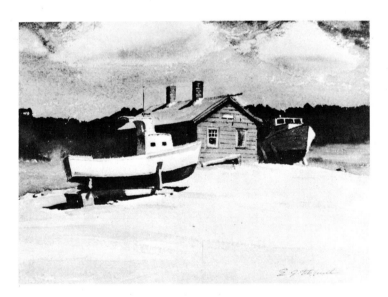

Lobsterman's House, Cape Neddick, *11" x 15", 300 lb. rough Arches paper. In this watercolor, cloud shadows racing over the distant landscape heighten the effect of sunlight on the foreground. This effect was transitory, so I had to observe it intently to be able to remember. I painted the sky in two washes: first I fused the warm lights on the clouds and gray shadows at their point of meeting, then I superimposed a strong mix of color for the blue sky. I used an intense (practically opaque) mixture to paint the shadowy distance. The building, boats, and foreground were painted with more time to observe colors and values. In all, this painting took me about two hours to do.*

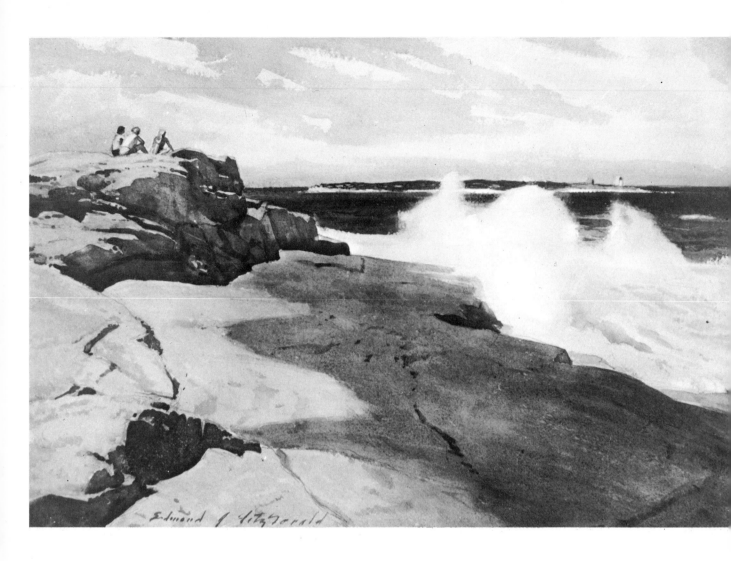

Breezy Day, Rockport (Above), 20" x 29", 300 lb. rough Arches paper. Straitsmouth Island appeals, as small islands always do, to fishermen, picnickers, lovers, and painters. The massive rock formation at Paradise Point makes a good foreground for a view of the island. I made the rocks warm in color, except where they were drenched with spray (right foreground). The wetness gave them a cool gleam because of the sky color reflected by the wetness. This painting won the Herb Olsen Prize, A.W.S. Annual, 1961.

Rock-strewn Beach (Right), 10" x 15", 90 lb. cold-pressed Whatman paper. Tidal pools, rocks, and sand provided an interesting foreground for this view of the Olympic mountains, across Puget Sound from Seattle. I did this painting in 1934. It contains a lot of cerulean blue, a color I have not used in years. The overall color effect is a silvery coolness that I rather like. (I think I must try some cerulean again.) In looking at the painting I can recall the day: there was a thin, overcast sky on a mild, summer afternoon — all-in-all a silvery kind of day. I painted the sky in a single wash with variations and left a few white areas unpainted. The mountains were superimposed on the sky. A few of the foreground colors were slightly warm, all the rest cool.

13

The shoreline

Perhaps the most interesting aspect of the waters that wash the world is the shoreline. Streams, lakes, and oceans all have shorelines, and their variety is boundless. They are the home, feeding ground, and playground for countless creatures — including people — yet they often seem places of vast solitude. Gregarious man has his Coney Island or Cannes, where there is scarcely room to kick sand into your neighbor's face; yet there are many places on the Mediterranean coast, on Long Island, or in California where you can walk for miles with no other companions but sky and sea and a sandpiper or two. If you look closely, you might see among the rocks or sedge at the top of the beach an artist with his easel.

Beaches

A sand beach, trimmed on one edge with breakers and a lace of surf and on the other with dunes wearing a topknot of sedge, is a fine symbol of freedom and space. The enormous sky and the rhythmic music of the sea expand the spirit and refresh mind and body. Under such stimuli you are at your best.

When you draw and paint this simple theme though — watch out! Simplicity is a cornerstone of art, but it is not easy to achieve. Subjects that contain the fewest "things" usually demand the most precision in drawing. Free and spontaneous handling of paint sometimes offsets weak drawing in compositions that are filled with objects, but to achieve the look of ease and freedom implicit in an expanse of sky, sea, and open beach, you must carefully execute the underlying drawing and base it on precise observation.

The slant of perspective lines of breakers; the edge of the beach; tidal pools; and objects like driftwood, footprints, high tide indications, clouds, and figures must all be drawn with careful regard for scale, as well as distance above or below the horizon. The fact that the beach slopes, that the water is level, and that there is depth in the sky are all primarily matters of linear perspective. Aerial perspective, involving values and color, functions well only if the linear drawing is sound. If it is not, the result is like stuffing a pillow into a paper bag. Fine color values and treatment go to waste in a shaky drawing.

Typical Errors

Here are some typical errors I have noticed in drawing this type of subject matter:

1. Too much perspective slant to long lines of breakers and shoreline.

2. Attempting too wide a range of vision to right and left. This exaggerated panorama tends to shrink horizontal distances and at the same time increase vertical distances.

3. Exaggerated vertical distances, especially near the horizon.

4. Failure to relate the size of objects — boats, people, birds — to their placement in the drawing.

Relationship of Large Areas

The relationship of values of large areas like beach, water, and sky to one another is of equal importance to linear relationships. Pissaro said that the chief problem of the landscape painter was to "set the accord between the earth and the sky." I think he was talking mainly about values in this statement. A broad, open subject like beach, sea, and sky compellingly points up the need for nicely related values. (See *Arch Cape at Evening* in *Demonstrations* section.)

There are plus factors in this kind of composition. You can use a single vertical, such as a figure or a beach umbrella, to "correct" the long

Distant Shoreline. *Detail of* Harbor, New Rochelle, *p. 114. To establish a sense of remoteness, the distant shoreline is painted as a flat shape.*

Pattern of Waves on Shore. *Detail of* Jockey Cap Rock, *p. 70. The low waves on a sandy beach should be studied for the rhythmic pattern they create.*

horizontal planes of all the rest. Such a vertical shape holds the attention of the viewer in a striking way; not present in all types of landscape composition.

Dunes

Sand dunes are shaped more by wind than by any other force. They range all the way from small ridges or hummocks to rather impressive hills. Their forms can create splendid light and shadow patterns, particularly when the sun is low. They are usually topped with grass or other ground cover that makes still other patterns for your shore composition. Driftwood, sand fences, decaying boat wreckage, and figures in fascinating poses are typical details found among dunes. (See *Showers over Cape Porpoise,* p. 42.)

Headlands

"The headlands marching out to sea" is a phrase of Joseph Conrad's, that great prose-poet of the sea. It encapsules the romance of the sea and shore that fetches so many of us away from land-locked towns with swimming togs or sketchbooks. (See *Jack's Cove, Morning,* p. 21.)

In drawing headlands, like all features of the shore, pay careful attention to perspective and scale, and locate them properly with respect to other land forms and the plane of the sea. The line at the base of the headland must be in a correct position, relative to the horizon, to establish its distance. If you are near the shoreline, a headland whose base appears to coincide with the horizon is about two and a half or three miles away. A rule of thumb for those who are mathematically inclined is that the visible sea horizon is, in nautical miles, approximately equal to the square root of your height in feet above the level of the sea.

If the headland is farther away, the horizon appears to be in front of it. Nearer headlands have their bases lower than the line of the horizon, but bear in mind that placing them a small distance below the horizon moves the headlands much closer to you. The size of the headland and the details of its appearance relate closely to the placement of its base with respect to the horizon in your drawing. This particular drawing problem seems to give beginners in sketching the shore considerable trouble. (See *Beach at Arch Cape,* p. 43.)

In addition to distance, light and atmospheric conditions play a large part in the appearance of a headland. Even a distant headland, if bathed in sunlight, may appear light in value and cause the

sea and perhaps the sky to appear much darker by contrast. Most often, though, distant headlands appear as cool silhouettes, darker shapes against the sky. Near headlands may also assume a simplified shape in mist or diminished light, giving them a lofty and mysterious aspect.

Islands

Most of what I have said about headlands also applies to islands. If your drawing reveals only one end of an island, it is, pictorially, a headland. When you are working out the perspective problem of relating the baseline to the horizon, remember to consider the distance you want to establish in your painting between yourself and the island. A group of small islands, like a scattering of moored boats, should be related to one another with respect to their vertical distance from the horizon and in keeping with their size and amount of visible detail.

Influence of Moods and Emotions

When the subject matter in your painting is an island, special thoughts and concepts inevitably find their way into your work. Moods and feelings flow from your brush into your paintings, often subconsciously. It is well-known that artists are at times astonished by conceptual notions read into their paintings by others. Who knows? Critics have been known to be correct!

It is quite possible that thoughts and emotions do get into our paintings unconsciously and can be detected later, perhaps even by ourselves. I am reminded of the story of the gold prospector who went to heaven, only to be told that the special place for prospectors was full, no vacancies! The old prospector thought awhile and made the suggestion that one of the angels whisper the word around that there was a big gold strike just made down in hell. In a little while, out came the prospectors through the pearly gates in a purposeful stream; picks and shovels, pack mules, and all. He recognized many of his old pals in the resolute column. As the last one trudged off down the trail, the old prospector could not resist. He swung his pack on his back and took out after them. "Might be something to it," he said.

Shoals

The sand bars or rising pieces of ground that make shoals are not always visible, but they often have a visual effect on the water over them. The nature and color of the bottom determine the effect as does the movement of the water over the shoal.

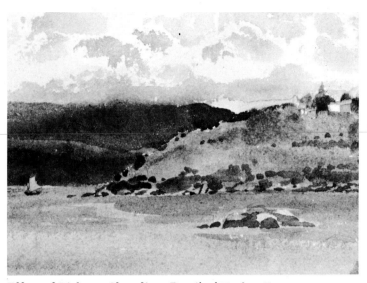

Effect of Light on Shoreline. *Detail of Harbor Entrance, Danang, p. 100. In the erratic light of this turbulent sky, the near shoreline is in light and the distant shore is in shadow.*

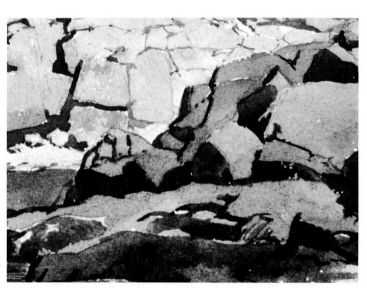

Painting Rocks. *Detail of Nubble Light, p. 120. The geometric shapes should be carefully analyzed and rendered in simplified form. Here, the light and shadow planes are clearly defined by flat washes.*

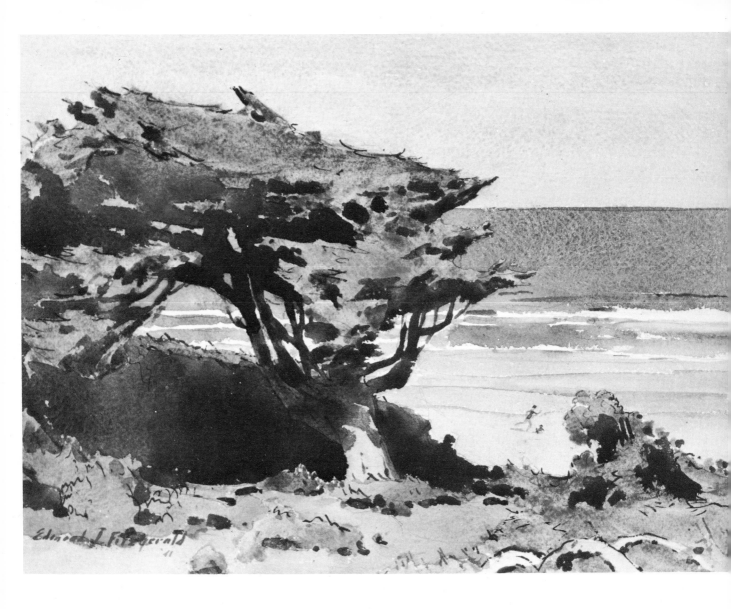

Pacific Beach (Above), 11" x 15", 90 lb. rough, stretched Whatman paper. A wind-sculptured tree overlooking an ocean beach is typical of beaches in many parts of the world, and a beach, almost any beach, is a symbol of the finest this planet has to offer its long-suffering inhabitants. This two-hour watercolor was drawn and painted with a direct, "one wash per area" approach. I applied a few calligraphic lines with a small brush and added dark color to strengthen the foreground.

Channel to Perkins' Cove (Right), 11" x 15", rough J. Green paper. This glaciated granite ledge marks the entrance to Perkins' Cove, Maine. It makes a solid foundation for a couple of houses and a fine subject for a watercolor. I carefully drew the larger shadow areas in the rock formation, architecture, and shrubbery and painted them first. The requirement in this procedure is to make sure the color values are full strength. The light on the rocks was filled in after the shadows were dry. I superimposed a few of the small shadows texturing the rocks and architecture. The warm rock colors were reflected in the water near the shore. The white house also produced a dimmed reflection in the water in mid-channel, although the water was agitated by ripples and current. My drawing had shown a tree to the left of the large house, but I omitted it in the painting.

A light-colored sand bottom, such as that found in shallows around tropical islands, imparts a limpid turquoise color to the water surface, much like that in a tiled swimming pool or Winslow Homer's Bahama watercolors. Alternate light-colored shoals and nearby deep channels produce some fascinating color patterns in tropical waters. The deeps are ultramarine, next to cerulean shallows.

Shallows in a stream affect the flow and can be "read" on the surface by one accustomed to navigating such waters. The practiced artist too can detect the slight difference in appearance where the water flowing over the shoal alters its reflective quality. Its surface ripples slightly, something like a cat's-paw on calm water.

Waves pile up into impressive breakers where they sweep over shoal water. Coral shoals off tropical beaches produce towering breakers even in relatively calm weather.

Rock Formations

Geologists have a complex nomenclature for rock formations and their characteristics. Such scientific information is of interest to a serious art student, but only isolated bits of the information have much direct bearing on drawing and painting problems. I have listed some sources under the *Bibliography* section in the back of this book if you wish to explore the subject; it can't hurt!

The artist is mainly concerned with drawing, color value, and color temperature; and it is not necessary for him to know that a rock is sedimentary or igneous in origin. If you get the drawing, value, and color right though, a geologist should be able to tell what kind of rock it is by looking at your painting.

Rock-ribbed coasts do not look the same everywhere. The rocky Maine coast is very different from the rocky California shore, and the limestone cliffs of the English Channel are unlike either.

The form and color variety in rocks is endless. The added attraction of lichen and moss clinging to them and the reflective qualities imparted by wetness and other factors such as light, shadow, and texture give the artist plenty to cope with. (See *Rocks at Ecola*, p. 127.)

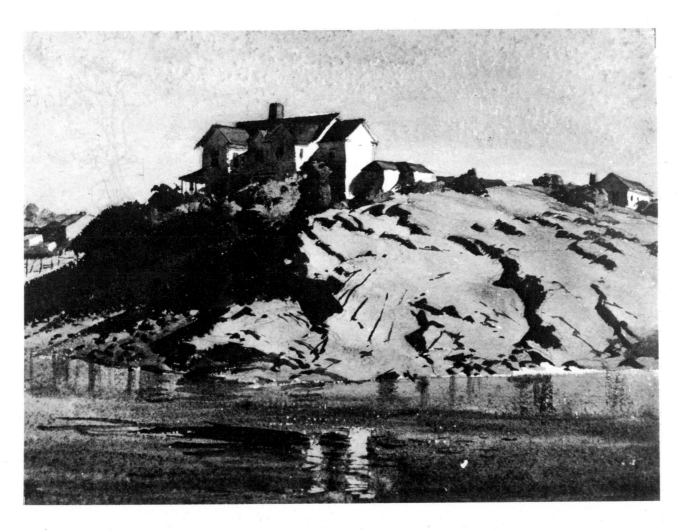

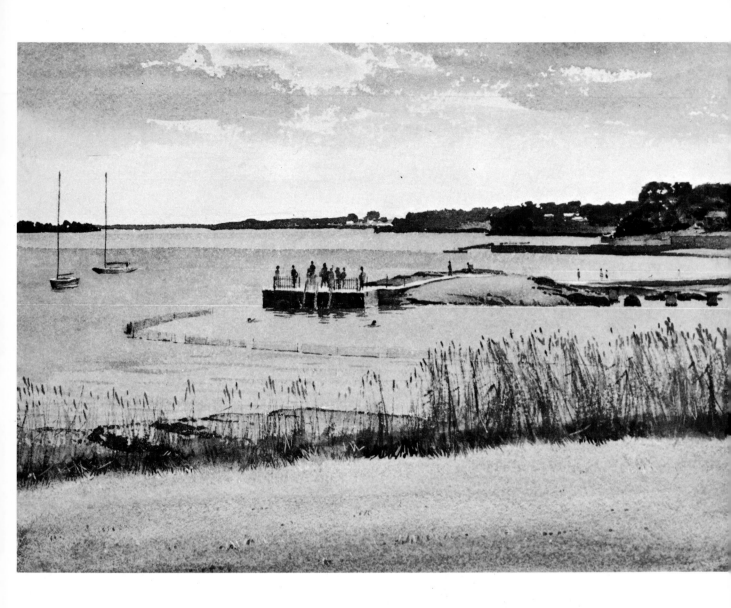

Floating Fence, Larchmont (Above), 11'' x 15'', 300 lb. rough Arches paper. The fencelike structure, floating on the water at the entrance to Horseshoe Harbor, makes an interesting curve in the composition, but the detail that captured my attention was the fringe of coarse grass at the edge of the bank. The grainlike stalks and heads were painted over the blue-gray water with a small brush and warm color.

Still Life with Lobster (Right), 20'' x 26'', 300 lb. rough Arches paper. My wife had culinary plans for this boiled lobster, but I was too slow with the watercolor, and she had to throw it out. (Needless to say, it cost me dinner at a restaurant to square things up.) Much of the time was spent in arranging the still life and doing the large, dark areas. I used strong touches of pure color on the lobster to contrast with the blue-gray shadows and warm lights on the newspaper. The broad washes were slow to dry, and their depth of value could only be achieved by superimposing one wash over another.

14

Flora and fauna of the shore

The vegetation and creatures of the shore and waterways are all part of the inventory of marine painting. In preceding chapters I have mentioned that in several areas the painter leans toward scientific discipline in search for answers to his questions. Fundamentally, art and science have the common goals of the pursuit of knowledge and truth. Procedures, of course, are different and acquisition of scientific information is so demanding that none of our brethren, except perhaps Leonardo da Vinci, could possibly delve fully into all the fields of inquiry to which painting leads us.

As compared to Leonardo's day, it is now relatively easy to skim what we need off the top of the great store of available scientific knowledge. Numerous periodicals and inexpensive books offer abundant information about vegetation, birds, and similar data that outdoor sketchers might be curious about. Field trips lead you into many situations that pique your curiosity. You are confronted with flowers you have never before noticed, birds of unfamiliar shape and plumage, and on the margins of the sea, strange and wonderful creatures that seem to be both plant and animal.

It certainly is not necessary to "know all about" the wonders of nature in order to paint it. In fact, I think you must sometimes guard against letting specialized knowledge get in the way of the painting process. It can be a mistake to try to tell *all* you know about things in your painting. For one thing it is apt to bore your viewer, and besides it is likely to put some things out of context with other parts of your painting. A "finished" painting is a delicate balance of parts related to a whole. A highly detailed painting is not necessarily more *finished* than a broad and freely rendered one.

Use of Vegetation in the Foreground

The most difficult part of a painting is likely to be the foreground where grasses and other vegetation play such an important part in marine paintings. The late John Carlsen, N.A., suggested that it was advisable to start your foreground at least twenty paces away from you in order to induce unity into your painting and avoid the compulsion to paint the complexity of detail visible close at hand. Like many dogmatic rules, other painters have broken this one with notable results. An almost still-life approach of rendering detailed, individual items instead of a nebulous collection of shapes seems to be called for in certain painting situations, even when distant sea and sky occupy an important part of your composition.

In such a situation, if overlapping and interlacing of grasses and clusters of leaves and blossoms are involved, observe them as carefully as large areas of land, water, or sky farther off. It is not necessary to have a botanical knowledge of ground cover to paint it convincingly. However, such knowledge *can* be an asset, unless it causes you to over-emphasize some details at the expense of others.

Masking, wiping out, scraping, and opaque touches, all the tricks in your bag may be called upon in rendering a small patch of foreground in a painting where all the rest has gone off with masterful ease. The great difficulty is that the innocent tangle of grass and twigs nearby must *look* as easy as the rest.

A particularly interesting kind of marine foreground is an area where grasses are present in shallow water and are partly submerged, as in a rice paddy. Waving blades of grass reflected in the water, singly and in clusters, makes fine watercolor material. (See *Schaefer House*, p. 122.)

Lily Pads

The broad floating leaves of water lilies are special aquatic subject matter. A flotilla of them makes charming patterns of design to work with in your composition. Their flatness on the water surface

Shoreline Growth. *Detail of Cape Newenham, p. 101. The scrubby growth on the shoreline is indicated with quick strokes. The flecks of light are actually scratched into the surface of the paper with a razor blade.*

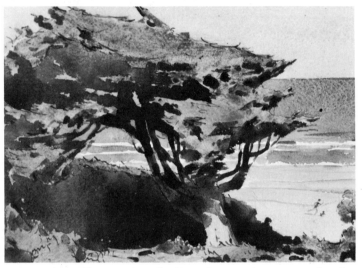

Tree Shapes. *Detail of Pacific Beach, p. 106. The distorted shapes of shoreline trees are often molded by the wind.*

Painting Trees. *Detail of Manor Beach, Larchmont, p. 68. One way to render the softness of distant foliage is to paint wet-in-wet.*

establishes the plane of the water, and blossoms resting on their raftlike surfaces produce grace notes in your value and color scheme. Edges of the leaves curl to the breeze and cause the pads to sail into each other, like the sailboats called "day sailers" rounding the marker in a Saturday afternoon race.

One of the delightful stories of recent art history concerns the final years of Claude Monet's life in which he painted the water lilies in his garden over and over in a magnificent artistic documentation. He made it seem that the entire world of color, light, action, and vitality was contained in that simple theme. These paintings, when seen as a group — as I saw them at a splendid exhibition at New York's Museum of Modern Art — make you feel that a pond with a few lilies is the only subject worth painting.

Waterfowl

Birds of all kinds have an impressive tradition as subject matter for the watercolorist. (See *Rocks at Ecola*, p. 127.) They are hard to sketch with accuracy without a good deal of special knowledge because they are so active and shy. Many sources of information in books and prints are available if you wish to seek it out. Bird identification is a time consuming and demanding study even as a hobby, and again, an artist cannot possibly find time for everything, but a cursory study of the common types of aquatic birds can help you use them as realistic details in paintings. However, you must be careful in the use of illustrations or photographs of birds; if they are copied too literally or in too much detail, they look foreign to the rest of the painting.

Also, for the sake of accuracy, be sure of the identification of bird types and ranges in your research. There are a number of different kinds of gulls, for example, with different markings to be found in various parts of the country. To avoid criticism from meticulous observers, make sure the birds you put in your painting are inhabitants of the region. This applies to migratory birds as well. Make sure the season depicted and birds or other creatures shown are consistent or, granting full artistic license, not out of context unintentionally!

Birds on the wing, unless close up, usually do not present much of a problem of identification in the picture. The accurate observer, however, should note such characteristics as flight patterns and similar bird habits that might be revealed even in the distance in your paintings. When birds in flight are painted close at hand, they are most convincing if they are painted so that their wings seem to be in motion, a little blurred, not stiff and frozen like a fast-lens snapshot.

Bronx Marshland, *10" x 14", 140 lb. rough, stretched Arches paper. The scene of this painting, circa 1950, would now reveal towering apartment houses. However, at that time it was only vegetation and wild life of the shore. The foreground shows marsh grass and other vegetation close at hand. Careful observation of colors and values is necessary in this type of foreground. Masking is sometimes helpful, although I did not use it in this painting. I did some wiping out and gentle scraping in damp areas with a dull point. I also used second and third overlaying strokes. I superimposed the flying ducks with a small brush. Care was exercised to avoid hard edges, especially on wings in rapid motion — soft edges express the movement of flying.*

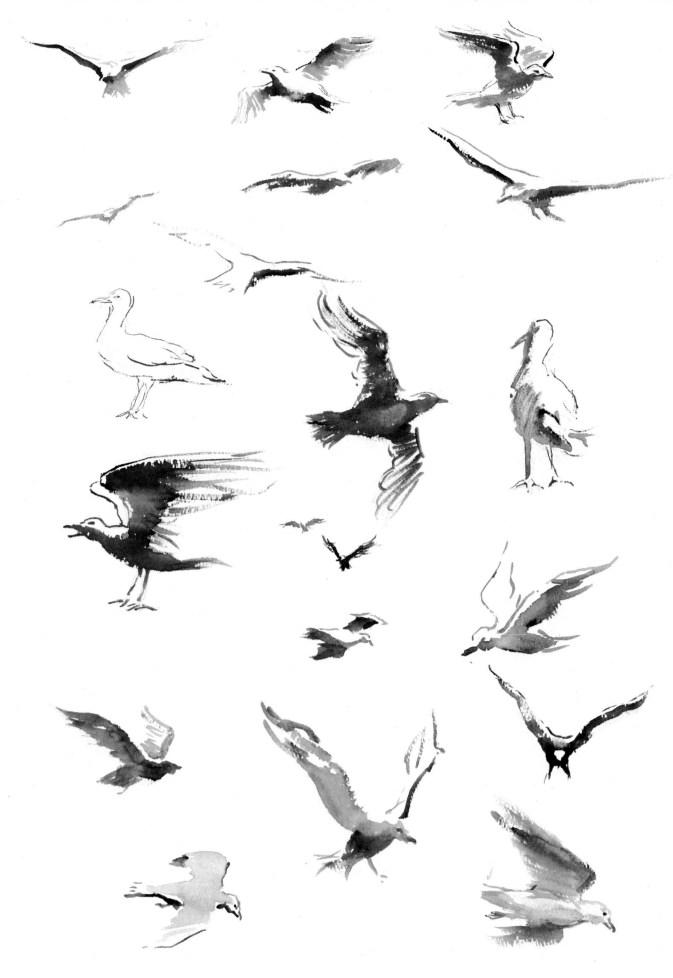

Fish and Animals

Fish and animals of the sea and shore are among the most impressive inhabitants of the globe. They make excellent still-life material and also fine live subjects for depiction in their natural environment. Great paintings by Winslow Homer come to mind: *The Herring Net, The Fox Hunt,* and *Trout Breaking* to name a few.

Homer is said to have had a lot of trouble with *The Fox Hunt,* which depicts crows attacking a fox in deep snow. He got a hunter to provide him with a dead fox and crows which he arranged in position in the snow outside his studio window with sticks and string where they froze stiff, but a sudden thaw created problems in that the crows went limp. He was not able to finish the painting to his satisfaction until spring, when he got a friend to lure some crows with corn so he could make some live sketches.

The abundance of excellent photographic recordings of fish and animals of all kinds makes the problem of introducing such subject matter into paintings much easier than in former times. Some ingenuity is necessary to make use of the photographs for painting purposes, as I have mentioned elsewhere in this book. Perhaps the best means of overcoming the tyranny of the photograph is some knowledge of the anatomy of the animal depicted. (See *Bibliography.*)

Water Lilies as Simplified Forms. *With apologies to Claude Monet, these are watercolor interpretations of two of the great impressionist's water lily series. I did them from prints of the original oil paintings. Notice how these forms are suggested by simply leaving the paper untouched.*

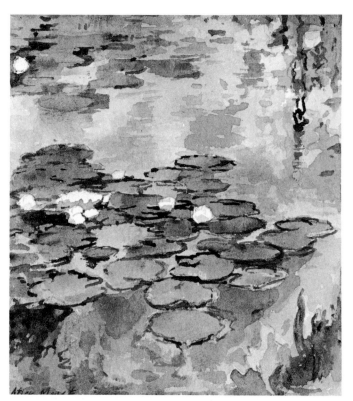

Water Lilies with Reflections. *Copying great work is good training. In this, the reflection on the water gives an indication of the background of trees.*

Gull Sketches *(Left). Photographs and published material are plentiful for the study of the birds you plan to include in your paintings, but it is better to go directly to nature for such study, as I did with these brush drawings. The training of hand and eye from nature is unsurpassed, although it is obviously difficult to do with birds and other wild life. Gulls are probably more accommodating as models than most. If additional detail is desired, you can always do research.*

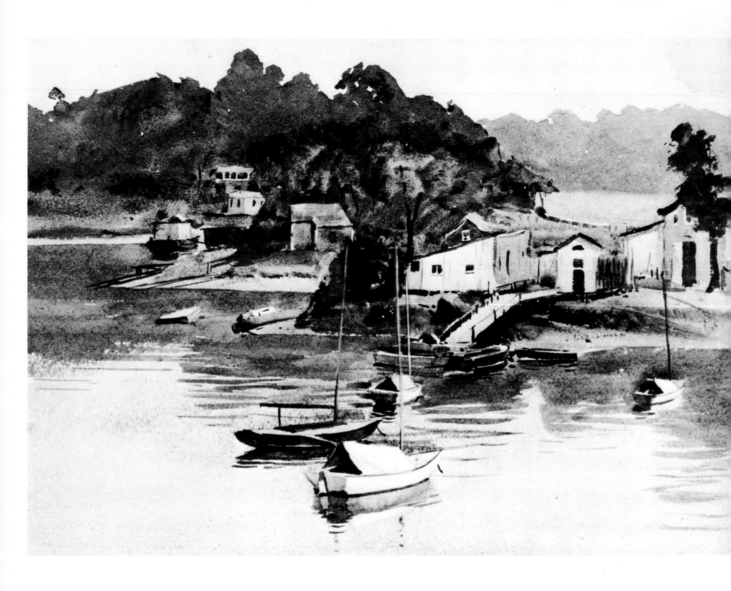

The Harbor, New Rochelle *(Above), 10'' x 15'', 90 lb. stretched Whatman paper. This painting illustrates small wharves and other shore structures. I painted it from high ground in a little park by the shore. It was an overcast morning without strong light and shadow, resulting in full effectiveness of local colors on boats and buildings. The calm water offered interesting patterns of reflections which I superimposed over the basic wash for the sky reflecting in the water. No white paper was left; even the boat cover in the foreground has a wash.*

Low Tide, Turbot's Creek *(Right), 14'' x 21'', 140 lb. rough, stretched Arches paper. This watercolor was a demonstration for a group of students. My purpose was to show how I proceed with field work. The model was an 11'' x 15'' watercolor I had done on location. I covered the entire foreground area up to the boats with a cool wash. When it was dry, I superimposed a second wash to read as mud. However, I left the cool underwash exposed to appear as puddles reflecting the sky. The result was an instant, glistening mud flat!*

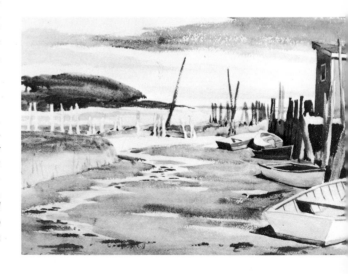

15

Structures of the shore

Some scientists speculate that all living things evolved from the sea. Then for countless eons they stayed in the primordial ooze of the shore before creeping onto drier ground to develop avial and pedestrian equipment — recently cars, jets, and rockets.

An urge more primitive than the magnetism of a bonfire on the beach draws some of us toward this original environment. With the hair of an animal fastened to the end of a stick, and dipped into colored water, we attempt to record on paper our responses to the traces of evolved progression. Therefore, it is not surprising that the wormy piling of an old pier or the green slime on the remains of a boat are more alluring to a painter than new concrete or fresh paint.

Shore drives and bridges in our coastal cities are constructed with exasperating bulwarks along their sides. They function like blinders on a dray horse to constrain us from rubbernecking while driving to avoid accidents. Humans seem to have a powerful compulsion to gaze upon the shore and its structures.

Docks and Piers

Water in a dock, lapping upon the piling of a pier or the venerable stones of a quay, is charming to the eye. Perhaps the random irregularity of repeated details is part of the charm, like ancient masonry that is crumbled, stained, and settled out of alignment and which combines rhythm with variety. A pier or wharf constructed of piling and planks has similar qualities, after a little ageing and use. (See *Doryman*, p. 75.) The supporting piles might have been placed as regularly as marching soldiers, but the strain of weather, wear, and random repair soon disorganizes the ranks a little and pleases the eye more.

You can use the dense gloom under the pier to provide contrast and emphasize the bleached pil-ing along the edge of the pier. Tidal stains, marine growth, and decay add irregular patterns of color. A lost and found appearance in the supports in the darkness under the pier resembles the trees in a gloomy forest. Patches of light break through the "forest" in random shapes and places.

The bull-rails, stringers, and planking of the pier's upper surface also record wear and tear to break the heart of the harbormaster and delight the artist.

Wharves

I think of a small pier, for the use of small vessels, as a wharf. It is sure to bear all the marks of rough use seen in its larger brother, usually with more delightful decrepitude. Lighter burdens and less strain do not demand as much upkeep, and initial construction is likely to be less strong.

A wharf always seems to snuggle into its surrounding landscape in a comfortable way. The floats, catwalks, skiffs, and other boats gather themselves around a wharf like a family, and the color and patterns are ready-made for your painting.

Shacks

The buildings on piers and wharves and on the adjacent shore are as varied as rugged individuality can make them, but they still have a lot in common. Visible evidence of wind and weather, a slight instability of underpinning, and the adornment of nautical paraphernalia gives them a rakish and jaunty air.

You will often find faded lettering, signifying former use, or a rich texture of tattered posters on the walls of such buildings. The regular courses of shingles or planking on the buildings are apt to show irregularities here and there, giving them a blasé look of studied negligence.

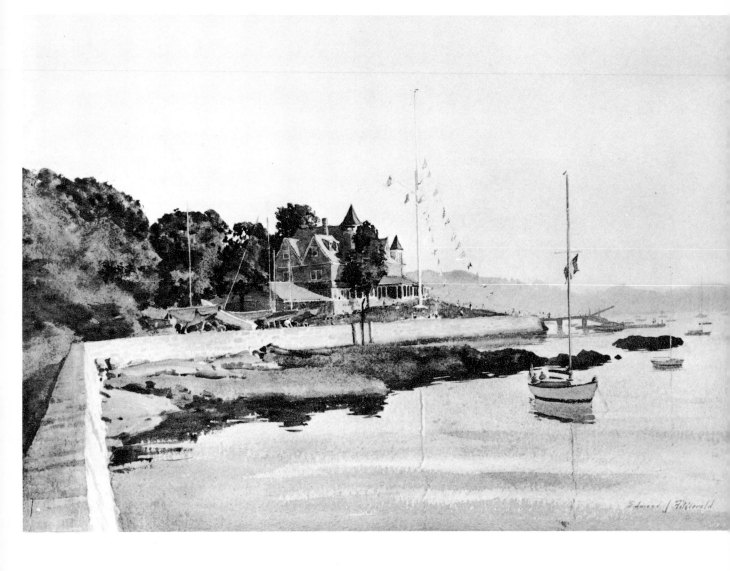

Larchmont Yacht Club *(Above), 21" x 30", 300 lb. rough Arches paper. This watercolor was painted in the studio from an 11" x 15" done at 6:30 in the morning, when the sun was bright and warm but not yet high enough to illuminate the top of the sea wall (left foreground). I added the boat in the foreground, the flag display, and the figures on the lawn in the studio version. I painted the light on the sea wall with a primary wash strengthened with cadmium orange. Over this I superimposed the varicolored stonework. I used masking for the light-colored masts, but their pale reflections were wiped out to achieve a soft effect.*

New Rochelle Shore *(Right), 11" x 15", 300 lb. rough Arches paper. A barge on the shore made a snug cottage for someone and a fine subject for a watercolor. The powerful contrast created by the mass of foliage and the blue-black darks under the barge gives dramatic effect to the composition. Touches of strong Indian red on the bottoms of the beached boats and the peeling paint of the barge also add effectiveness.*

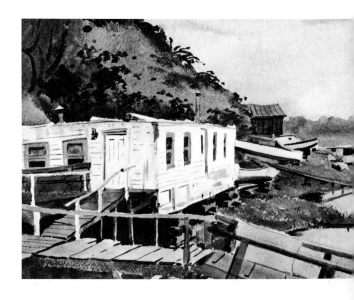

Shacks are paintable, not so much because they are small and humble, but because of their weathered look. The tracings of life are visible. You can find the qualities in major edifices that have gained a certain degree of old age; however, such subjects are not commonly found at the shore.

Other Buildings

Buildings on the waterfront are not all shacks. Some are warehouses; some may be respectable dwellings, ship chandleries, or public houses. Town waterfronts the world over have a special, salty flavor that is eminently paintable. For that matter, even waterfronts in suburban areas with better class homes, lawns, boat landings, and so on are generally more attractive to the painter than inland suburbia.

Paintable Places

The imagination is stirred by a glimpse of blue water down a street which ends at the shore. A window on the world, beckoning flights of fancy, is opened to you. A curious truism I have noticed is that in paintable places the reception is most congenial to the painter. It is as though the inhabitants and frequenters of such places, sensing the color of their surroundings, are sympathetic to your mission. All, in some mysterious way, are fellow painters, whether or not they have ever touched a brush. In the more affluent, well-manicured areas, you might feel the hostility of suspicion to your activities, but, by and large, your paintbox and easel are a universal badge of entrance, particularly in the most paintworthy places. Your greatest hazard is your attractiveness to well-meaning but curious onlookers, but you soon learn to live with this. It goes without saying that an absolute prerequisite is respect for the property rights of all.

Boatyards

Boat storage and repair yards are the jewels of the shore for the painter. Permission to sketch in them is usually obtainable if you keep out of the way of their bustling activity, particularly in springtime. It is well to investigate the functions of their hoists, marine railways, and other machines in order to keep clear and to understand them for painting purposes. The confusion of gear and general clutter may appall you at first, but as I have pointed out elsewhere, such subjects often produce better *results* than the apparently "simpler" subjects. (See *Boatyard* in *Demonstrations* section.) The prolife-ration of patterns and color often helps rather than hinders your efforts. If you concentrate on large areas of color value and do not let yourself get too involved in a literal rendering of complex details, good luck may come your way. You need luck in everything in this life, especially painting watercolors.

Boats hauled out in the yard reveal all their lines like a disrobed model. It is a fine place to study boat construction. Boats, like icebergs, are largely concealed most of the time. However, a boat reveals much of its character and capability when you can see it all, and the lines of the underbody are apt to be the most beautiful of all.

Nevertheless, in boatyard paintings, you must not allow yourself to become too involved in the intricate and subtle lines of naval architecture or you will never get on with the painting. Color contrasts, large shapes in abstract patterns, and varied textures present a dazzling kaleidoscope something like a carnival or circus. Let yourself become absorbed in these elements rather than laborious details, and you will produce a more spirited painting.

Sea Walls

I have touched upon the masonry of quays already in this chapter. Such constructions have always intrigued me as watercolor material. Often I sweep in the tone value of the mortar as an overall wash and later superimpose the random patterns and colors of the stone work. You can add cracks and juttings as accents, along with the stains of lichen and marine growth. If the wall has crumbled and fallen in here and there, so much the better (except for the property owner)!

I am particularly fond of mortared stone work that appears in places where natural rock outcroppings are also present. A natural formation in conjunction with a man-made wall has special appeal because of the contrast of textures seen in juxtaposition.

Brick or concrete sea walls are not common except along sheltered waterways where wear and tear is not so great. Where heavy weather or powerful currents occur, the walls are often sloping rather than vertical and may be buttressed with piles of heavy stone.

Man-Made Bodies of Water

Recently formed artificial lakes or waterways created by man instead of nature have an unnatural appearance to their shores. As a result they are not very paintable, at least when new. After enough time they mellow with age and decay, and

Masonry: Step 1. *First render the light and shadow components in the color values of the mortar between the stones. You can incorporate color changes caused by tidal stains in these initial washes.*

Masonry: Step 2. *Individual stones, often of varying color, can be superimposed over the dried washes of the mortar between them. The perspective of these stones helps describe the construction of the wall. Reflections in the water relate to the value pattern of the wall.*

their attractiveness to the artist's eye increases. Old towpaths, dikes, or structures like locks become interesting as nature's tenacious effort to reclaim its own becomes more obvious. By some perverse instinct I find such evidence more compelling to the brush than new construction or even a remote shore where no trace of man is apparent. The tattered remnant of past effort to wrest livelihood from the earth makes a better subject than gleaming manifestations of current success.

Bridges

Who can resist a bridge as subject material? Old bridges are probably best, and particularly smaller bridges, but nearly any bridge will do. The late master painter, Frank Brangwyn, R.A., painted so many bridges that two books were written about them, containing numerous reproductions of handsome watercolors. Brangwyn was partial to ancient bridges. I recall one of his great watercolors was *The Bridge, Espalion,* an arched stone structure said to date from the eighth century.

Most of Brangwyn's bridges are European. There are still plenty of them in that part of the world, and contemporary painters continue to seek them out, but the more modern wooden bridges and iron and steel bridges are not to be scorned. Some of the drawbridges built for the railroads around the turn of the century have been in existence long enough to have a quaint appearance, and their gaunt silhouettes provide excellent material for the watercolor brush.

The famous covered bridges of New England are fast disappearing, but there are a few left, for the most part in a charming state of decay. You can find little moss-grown wooden bridges everywhere, though, and they are sure-fire subjects.

Modern super-bridges that span some of our harbors and rivers are majestic structures and are exceptions to the requirement of decrepitude since they form effective subjects, particularly in a haze of diminished light.

Advantage of Partial Obscurity

Any large mass in a painting — bridge, ship, building, mountain — is enhanced by having a wisp of smoke or cloud obscure its outline at some point. It leads the eye through the painting and prevents the viewer from feeling trapped. (See *East River Bridges,* p. 121.)

Lighthouses

If bridges are alluring as subject matter, what about lighthouses! They are the ultimate in shore-

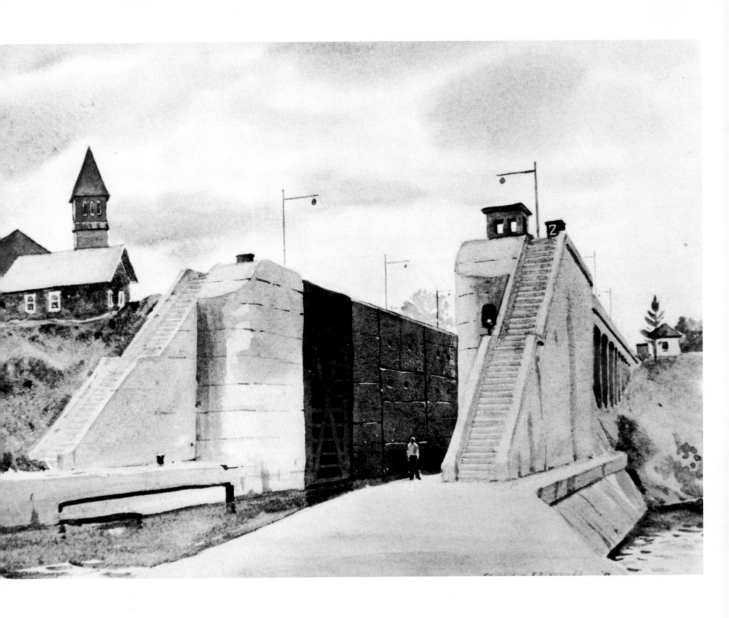

Lock at Troy *(Above), 11" x 15", Whatman board. An overcast sky caused the light on this autumn day to remain fairly constant. I painted the sky with clear water down to the light roof and concrete structures. I added gray tones into the wet area to create clouds. The figure was included to establish scale. I stained the masonry inside the lock (behind the figure) dark gray. The top lights on the wet blocks of masonry were carefully avoided in the intial wash, and I later tinted them in with pale viridian to simulate the dankness.*

Footbridge at Wells *(Right), 10" x 15", 300 lb. rough Arches paper. This footbridge over a tidal channel leads to the sand dunes and ocean beach on the Maine coast. The warm tones on the underside of the low clouds were partly reflected from the broad expanse of brilliant sand. The sand, topped with patches of green sedge, made a strong contrast for the silhouette of the bridge structure.*

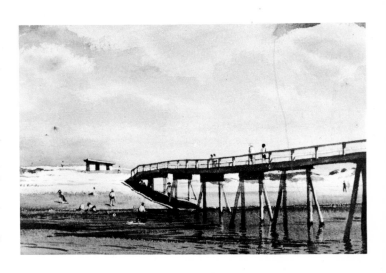

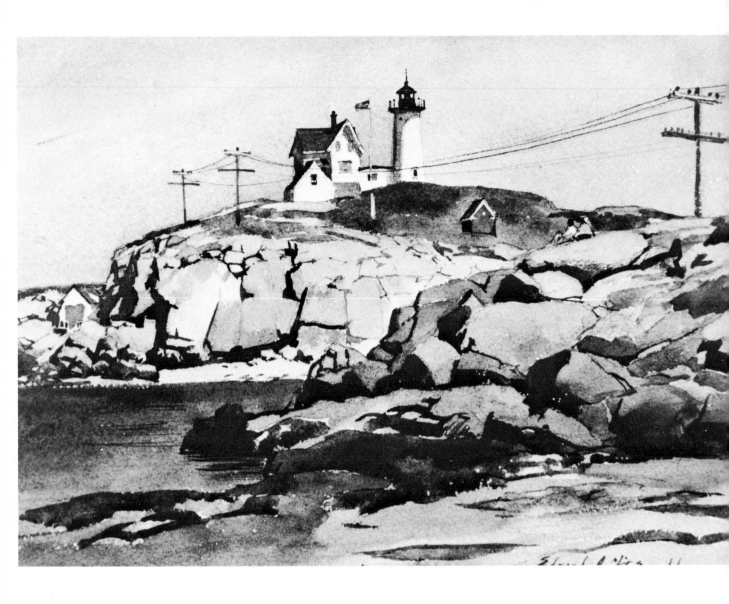

Nubble Light, *10" x 13", 140 lb. rough, stretched Arches paper. This lighthouse sits on a granite island a few yards off the end of a long point of land at York, Maine. It is a popular tourist attraction. Many photograph it, some just stare at it, and a few paint it. On the sunlit round tower I used the procedure called "fusing" to achieve a blended but distinct line of demarcation between the light and shadow. After a careful (but rapid) pencil drawing, I did most of the painting in a "one wash per area" approach. The rock formations were painted by establishing the main shadow areas first. I worked as fast as possible (my total painting time was two and a half hours) but even so, the light and shadow patterns had changed scandalously before I was through.*

side structures that capture the imagination. True, they have been done to death by artists, but it has not hurt them a bit. There is always the possibility of a fresh approach. Also, they are rapidly disappearing from the scene. Those handsome, round towers with light-keepers' homes at the base are being replaced by steel structures containing automatic equipment that needs no regular keeper. Electronic navigating systems may soon render most lighthouses obsolete. Nevertheless, while lighthouses remain on headlands and lonely islands, they cry out to be painted.

Lightships

The seaborne counterpart of lighthouses, lightships, are also disappearing. Lightships have characteristic, red-painted hulls with white superstructures, and their names are printed in large white letters along each side. They remain at anchor to guide mariners to channel entrances, using their light, foghorn, and radio beacon. They are usually well off shore, and it requires something of a cruise to get near them. After they are relieved by a lightship named *Relief* on a regular schedule, they proceed to their home port for upkeep. When at dock they are just as colorful and romantic subjects as at sea.

Buoys

Buoys being repaired are usually in evidence near docked lightships. They are handsome shapes to test your draughtsmanship and compositional ingenuity. Buoys that look frail and small on the vast sea turn out to be impressive in size when you find them on land because the underbody of buoys, like that of boats, is concealed afloat.

There are a number of sizes and types of buoys. Their shapes, colors, and other characteristics are related to their functions as navigational aids. The non-boating artist may find such matters confusing, but the rudiments are spelled out in readily available publications. (See *Bibliography*.) If you include a navigational aid in a painting, it should be correct, unless there are compelling artistic reasons to the contrary.

Villages and Cities of the Shore

A cluster of buildings on the shore has great compositional possibilities. As with painting lighthouses, the idea is not original, but the subject is far from exhausted either. A view from a pier, a park, or a building is the most available. A view from the water presents problems even for a boat owner. You cannot always anchor where you wish

in order to sketch. Fairly distant views from islands or points of land are more accessible than views from close by. Magnification of scale, using binoculars if necessary, has possibilities.

You should also consider the panoramic view, sometimes shunned as too complex. Contrary to statements I have heard, I do not believe a panorama is slower or more difficult to paint than a closeup. In such a composition the sky and water may cover a large part of your painting. In watercolor, paint these areas quickly to establish dominant value relationships, Pissarro's "accord of sky and earth." I find that distance helps to simplify architectural details.

Sometimes the best way to manage a view from the water toward town is to fall back on a photograph taken from a boat. A photograph that is slightly blurred may be just as good as one that shows every window. If a veil of smog or mist obscures the buildings, consider it an advantage. Sketches to supplement the photograph are also helpful.

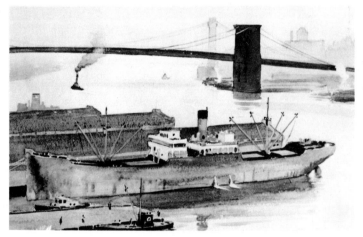

East River Bridges, *9" x 13", 90 lb. rough, stretched Whatman paper. This painting was done on a still, "smoggy" morning from the top of a building. Whites and strong colors, like the funnel and rusty hull of the freighter, stand out on such a day. All else was done in variations of gray. I was careful to let the wisps of drifting smoke break the long line of the Brooklyn Bridge.*

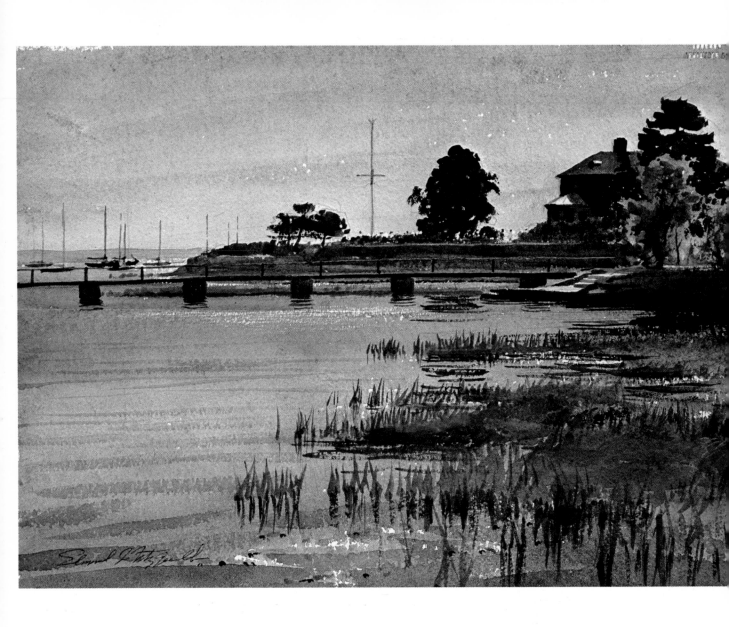

Schaefer House, *11" x 15", 300 lb. rough Arches paper. I did this painting in morning light on the well-kept Westchester shore near the Larchmont Yacht Club. I was looking toward the sun, which is just out of the picture space (above and to the right). This slant of light produced an odd, warm, greenish tint to the sky and some glitter on the water. I rendered the latter effect using skips of white paper and a little scraping. I was particularly interested in the sea grasses waving gently in the high tide and resembling an oriental rice paddy. The individual grasses nearby are reflected in the water.*

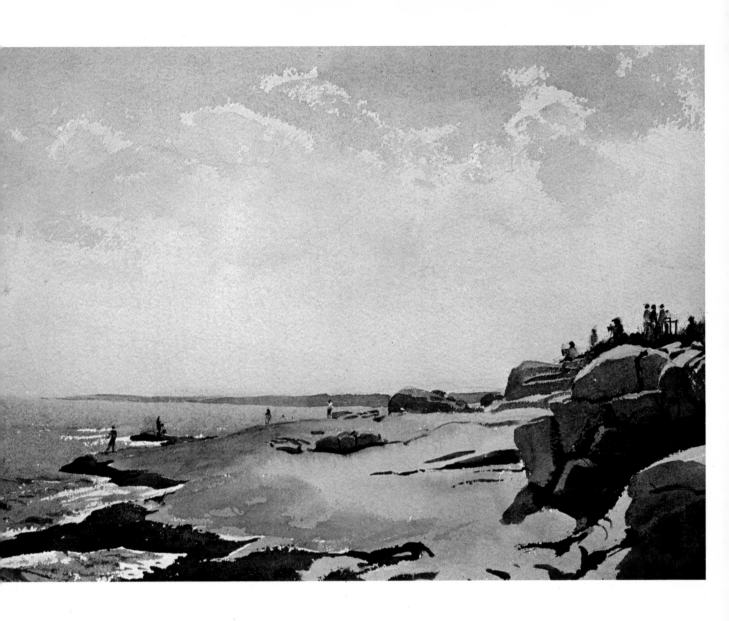

Art Class at Nubble, *11" x 15", 300 lb. rough Arches paper. An effect I am fond of painting, as many examples in this book show, is looking toward the light; "contre jour" is a descriptive French term for this type of light. I found the warm, delicate color in the sky and the warm glow on the glaciated granite particularly effective in this subject because of the light. These effects caused me to dip heavily into my favorite color, yellow ochre. The silhouettes of shadowy rocks, fishermen, sightseers, and fellow artists act as a foil for the flood of light.*

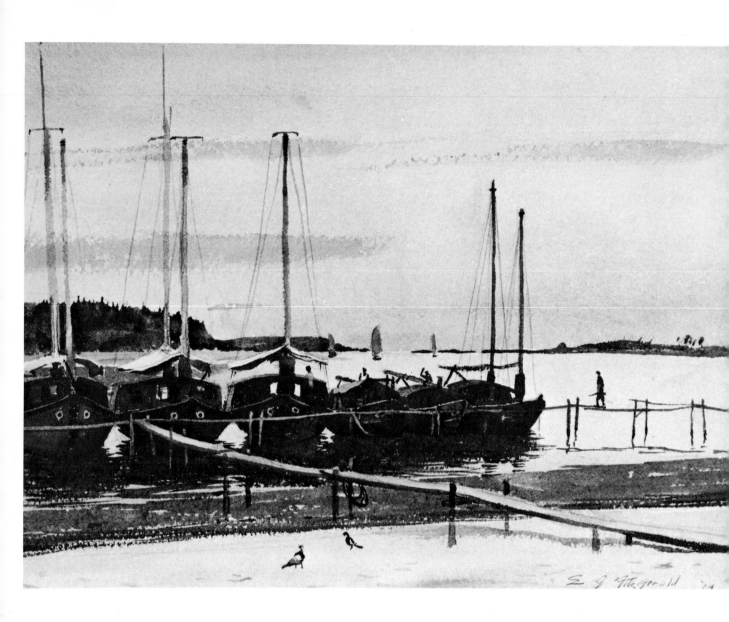

Vietnamese Navy Junks, *11" x 15", 300 lb. rough Arches paper. The text refers to Southeast Asian vessels with woven basket-type bottoms. The junks in this painting were not so constructed, but I saw some in this area (near Chu Lai) that were. A distinguishing feature of small vessels in this part of the world is the "eye" painted on each side of the bow. Subtle variations in the shape of the eyes indicates the precise coastal area from which the vessel comes. I used a little Maskoid on parts of the catwalk and the eyes. A group of Vietnamese who watched while I painted this watercolor seemed fascinated with the "magic" of its removal. I sat on an oil drum to start, but they brought a chair, table, and tea and took turns holding an umbrella over me and the watercolor. When I sketched in a figure or their pet pigeons on the shore, they all cheered.*

16

Boats

To some people ships are the same as boats, but for the sake of nautical correctness appropriate to marine painting, I will relay a definition I once heard from a salty old chief bos'n, "If you can hoist it aboard a ship, it's a boat." Even that is a little vague because some fairly large vessels have been carried on the decks of larger ships. Indeed, the distinction is not clear-cut even in the Navy, where submarines are traditionally called boats. To avoid getting too involved in semantics, consider all large vessels ships, Chapter 17.

Boats come in a great variety of shapes, and like many practical things designed to meet life-and-death demands, many have lines of exquisite beauty. It is not necessary for our purpose to become involved in complex terminology. Like other scientific matters, channels of study are open for those who have the inclination to dig deeper. (See *Bibliography*.)

Perspective of the Visible Hull

In order to establish a boat's perspective, consider the visible hull as a box and lightly sketch it as such. The dimensions of length, height, and breadth are thus fixed in position on your drawing. The perspective of this "box" must be carefully observed to maintain the plane of the water surface. The box-like shape can be sketched as though it were transparent in order to solve the problem of perspective. Then within the box sketch the lines of the boat using "X-ray vision" to locate lines that are hidden from view.

Small, open boats like skiffs and dories do not require as much x-ray type vision because the construction of the boat interior is partly visible. (See *Dorymen*, p. 75.)

Displacement Principle

If a boat were made of glass and if you could see through it, you would see a symmetrical shape at the waterline, where the boat "makes a hole in the water." It is well to indicate this shape or at least have it in mind so that your rendering will make the boat sit *in* the water. An empty, flat bottomed skiff might actually sit almost *on* the water like a raft while a loaded skiff or a "V" bottomed boat would float more deeply. The heavier the load, the deeper the boat rides. Remember Archimedes' principle: "A floating object displaces a quantity of liquid equal in weight to the weight of the object."

Superstructure

You can sketch in the superstructure of the boat, all the solid structures above the hull including the cabin and pilot house, in simplified cubelike shapes. Leave conspicuous details such as windows, portholes, fittings, rigging, and loose gear until after the major construction lines are established.

Since a boat must maintain balance, most of its superstructure is based on a center line. Exercise care in placing such items as masts and hatches in your drawing by keeping this center line from bow to stern well in mind.

The size of various parts of the boat and its gear must be carefully related in your sketching so that the parts are in consonance with the whole. If a mast is too thick, for example, the boat looks top heavy. The eye of your viewer, even the non-boatman, is remarkably sensitive to discrepancies of symmetry and equilibrium in boats.

Inconspicuous Details

If it is hard to make out what some small piece of gear actually is, simply paint it for what it appears to be, a blob of a certain size and color value. This method always works out better than over-emphasizing a detail.

I am convinced that a person who is a little near-sighted and fails to see inconspicuous detail has an

Skiffs on a Wharf, *11" x 15", 140 lb. rough Whatman paper. A misty cloud formation, low in the sky, provided a pale glow on the calm water for this subject, which I painted on a lazy Sunday afternoon. The water was so calm that even distant trees were faintly reflected. The earth-filled, wooden sea wall made a kind of wharf or quay from which the skiffs could be launched at high tide. A piece of tarpaulin thrown over one of the skiffs provided the strongest color note in the tranquil scene. I carefully filled in its color, cadmium orange, and the other warm colors last, in spaces I had drawn with pencil and previously painted around.*

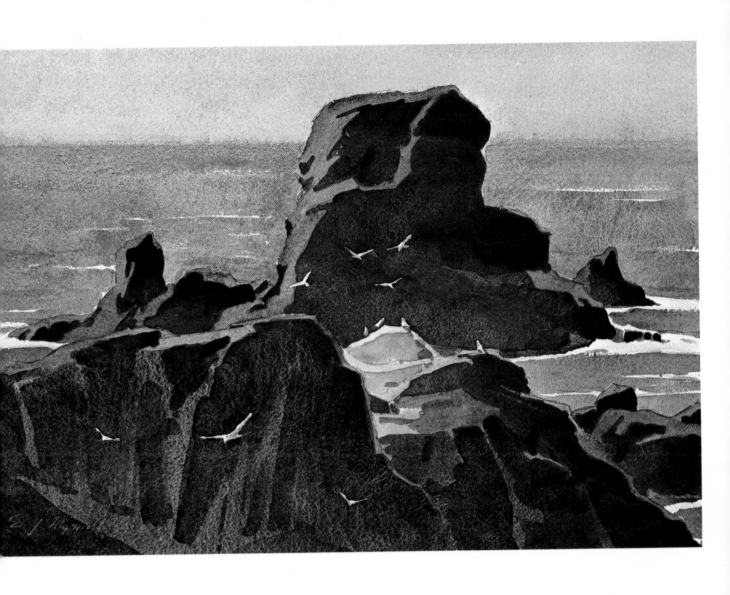

Rocks at Ecola, *14" x 20", 140 lb. rough J. Green paper. I
did this painting of the spectacular rock formations on
the Oregon coast from a 9" x 12" oil done on location. I
painted the water first, as a single wash, avoiding the
rocks and whitecaps. While it was wet, the sky (which
had been pre-mixed) was separately painted and fused
with the water at the horizon. I used Maskoid for the sea
gulls and painted the shadows on the rocks next. When
the shadows were dry, I filled in the lights. A few accents
were added to the shadows. Upon removal of the mask-
ing, the gulls were accented.*

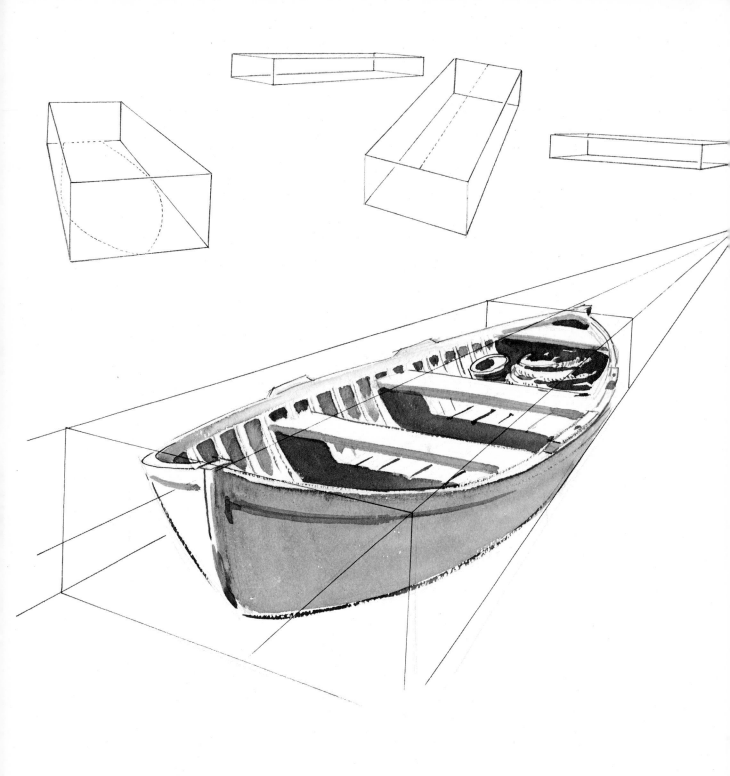

Drawing Boats. You can solve the problems of perspective involved with boats and other complex shapes by seeing them as simplified, boxlike shapes. To establish the perspective, I sketched this boat as though it were contained in a box. Also consider the shape of the "hole in the water" a boat would make. (This is shown by the dotted lines, upper left.) The center line from bow to stern is another important factor.

advantage when it comes to sketching complicated things. A person with 20/20 vision should impose a kind of myopic mask upon himself in order to "see" with the painter's eye, that is, in broad terms of relationship rather than focusing upon details.

Masts

Masts on boats for holding sails or cargo handling gear are highly purposeful constructions. However, a non-boatman, who is unfamiliar with their construction, can avoid glaring errors by drawing them with careful fidelity to his observation. Unfortunately, such care is not always exercised.

Rigging

The rigging around the mast of a boat presents a confusion of ropes and lines if you are unfamiliar with their function. It is better to leave such details out of your drawing rather than overstate them or place them falsely. A good rule for the non-sailor is to draw only those lines of rigging that are conspicuous to your eye. If such details are the least bit dim or hard to see, *leave them out*.

The fact that rigging aloft is so exposed and balanced in all its parts, like a spider's web, compels the need for correct emphasis. The commonest errors are overemphasizing the thickness of some lines of rigging or placing firmly drawn lines in impossible places. Simplification or understatement seems a very venial sin by comparison.

Details of Construction

I don't mean that you should *not* study details of construction. (See *Boatyard* in *Demonstrations* section.) In the last chapter I pointed out the advisability of studying boats at close hand in boatyards where their hulls are exposed. A partly constructed boat or a wrecked wooden boat ashore offers a good opportunity to study boat anatomy. Wooden boats with their characteristic ribs and planking are being replaced by metal or molded plastic boats which have much less concealed inner strengthening. This is a return to primitive construction such as carving a boat from a single log.

Thwarts

One detail of small boats is the seats called thwarts. They are as much a part of the construction as places to sit. If you made "boats" out of peapods as a child, you recall the need to use tiny sticks as thwarts to keep your boat from collapsing.

Simplifying Shapes. *Detail of Provincetown Pier, p. 89. Note how the forms of the hull, masts, sails, and rigging are simplified and rendered with a minimum of strokes.*

Boats in Fog. *Detail of Foggy Morning, Larchmont, p. 63. Painted on an overcast day, the scattered boats are rendered as flat silhouettes.*

Boat and Reflection. *Detail of Lake Union Shore, p. 69. Painted as a single, luminous wash, the side of the boat melts away, wet-in-wet, into its own reflection. Note the reflected light on the hull. The light is picked up from the water.*

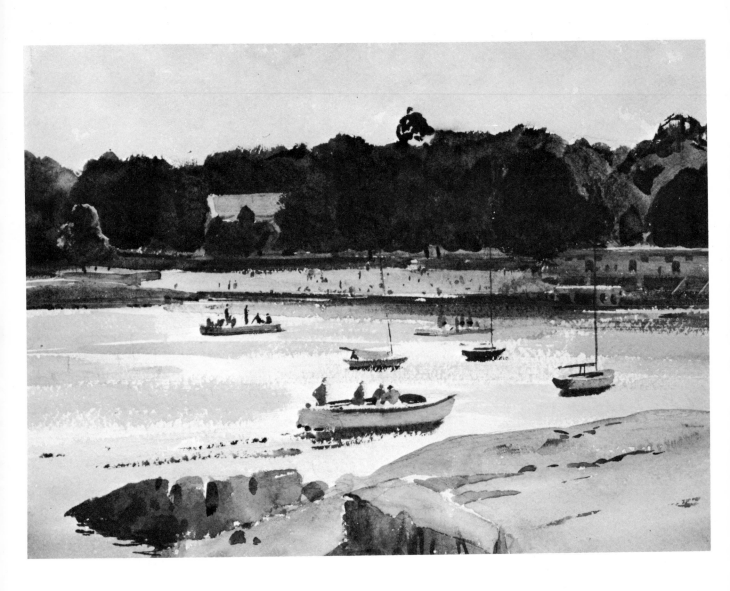

Horseshoe Harbor, Larchmont, *11" x 15", 300 lb. rough A.W.S. paper. This harbor painting illustrates the glitter on the water that is seen when you look toward the sun. A pale warm sky and the dark masses of the trees set the stage for the brightness of the water. I used light-colored washes surrounding patches of white paper to express the gleam on the water, but I quickly shaded the water to deeper tones near the far shore to express the reflected trees. I used warm tones for the beach and foreground's sunlit rocks. Cool tones expressed the boat silhouettes, and small, hot touches brought the figures into focus.*

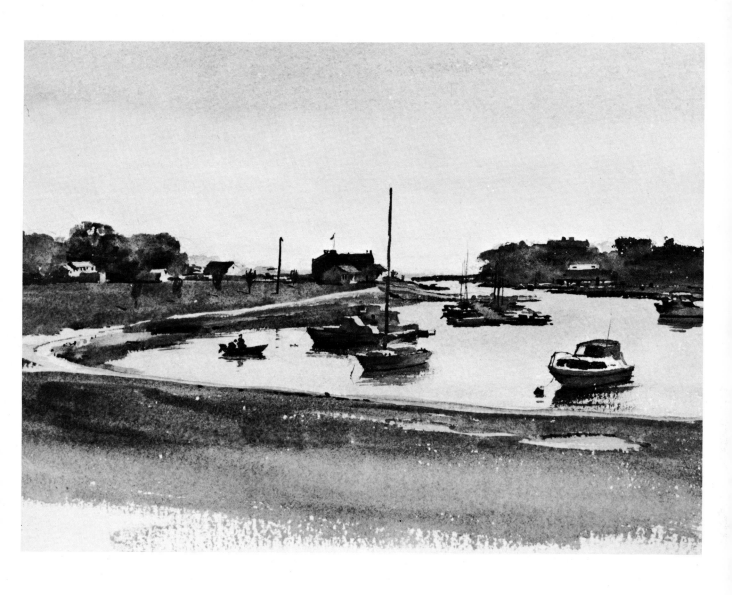

Mamaroneck Boat Basin, *11" x 15", 300 lb. rough Arches paper. The smooth water seen in the boat harbor and the even tone of the sky received similar treatments. However, the warmest part of the water was at the top while the lowest part of the sky had the warmest hues. The wash for the water avoided the light areas visible on parts of the boats.*

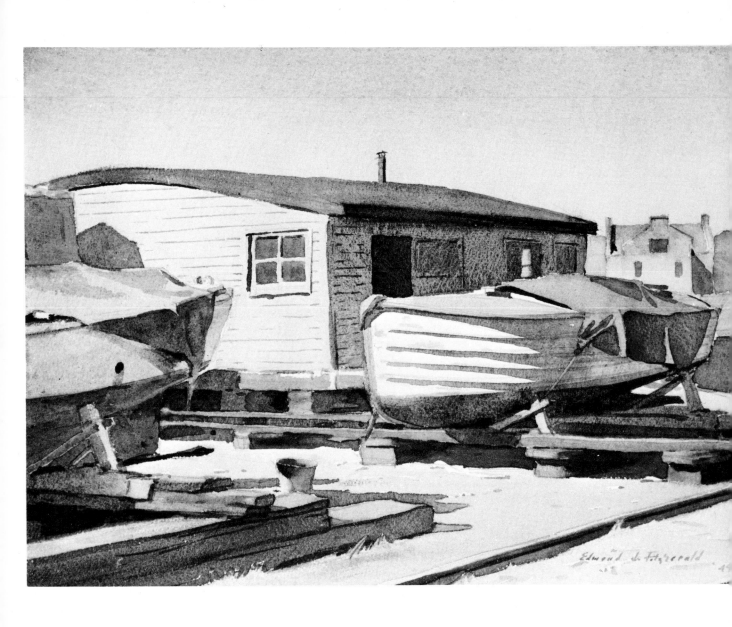

Nichols' Boatyard, Mamaroneck, *9" x 12", 72 lb. cold-pressed, stretched Whatman paper. The "lap-strake" construction on the dominant boat in this painting is no longer in general use. However, it makes an interesting texture to paint when seen in a strong slanting light. Perspective lines and value relationships are keys to the solution of this painting. The washes are straightforward, rather flat, and uncomplicated. I covered the paper, for the most part, with one wash per area. Only the light on the bow of the boat remains white paper. Color is important, but the impact of this painting loses little in the black and white reproduction.*

Watertightness

A covering secured to the thwarts provides a deck. If there were no openings for water to enter, a completely decked boat could turn over without sinking. Eskimos do close this opening when they sit in their kayaks, lacing their bodies into the boat, and they feel quite secure in their frail craft even though most of them never learn to swim.

Watertight compartments are built into some small boats to make them less sinkable, and the interiors of large vessels are subdivided for the same purpose. However, a heavy engine or cargo negates the added buoyancy to some degree.

Stability

Weight is needed in most vessels to give them stability. Sailboats often have lead secured to their keels to keep them upright, and oldtime sailing ships frequently carried a load of rock for this purpose. A dory, which has a flat bottom and floats rather high when light, is much more seaworthy when loaded.

Design of Water Craft

Three considerations have determined the design of water craft through the ages: cargo capacity, need to withstand rough weather, and need to move through the water with the least resistance. The priority of these considerations is governed by the kind of waters the vessel is expected to navigate and by its purpose. It would be impossible to design a vessel well-suited to all conditions. Consequently, at any given place or period in history, a "smorgasbord" of types of boats, barges, and ships are available as subject matter. This opens still another large area of research for you.

Anchorages and Moorings

Nearly every sheltered harbor offers moored and anchored small craft as material for your pencil and brush. In some cases, there is a whole bewildering fleet. (See *Northeast Harbor*, p. 78.) In northern states these harbors are empty in winter, become rapidly populated with boats in spring, and thin out in the fall.

To me, harbors are most interesting as subjects when they are not too crowded. Above all, when you draw harbors, do not sketch in too many of the boats at any one time. Your distribution of the boats in your painting can be a challenging game of composition. You can place the boats where you wish, like pieces on a chessboard. Just be sure to think about perspective!

When boats are anchored or moored to a buoy at the bow only, they swing with the tide or wind. Also, they may sail away during your sketching. These are frustrations, but they are not necessarily devastating. Your memory, a thumbnail sketch, or a Polaroid photograph provide possible solutions.

Rendering Actions

Activities, such as the appearance of figures or the sudden hoisting of a sail in the fleet you are sketching, can sometimes be spontaneously incorporated in your painting, but be careful not to allow such happenings to distract you too much from your basic plan. You can't tell everything in your painting; it is not a movie!

Harbor Traffic

The rules of the road for marine navigation are not a lot different from traffic regulations on land. They are based on common sense and courtesy. One point that all sailors arbitrarily accept is that, under most conditions, the man to the right has the right of way, as in auto traffic.

Things often happen more than once so that you get a second look at a detail that you may have sketched in quickly. It is helpful to remember that traffic in and out of a harbor follows a pattern. A sail, moving along the far shore, will probably be repeated. The handling of sails, fishing gear, and other marine equipment similarly involves repetitive actions, and as you do when painting surf, you often get a second pose from your "model."

Paintings that attempt to illustrate boat handling are not generally acceptable to the boating fraternity unless they reflect some understanding of the ways of the sea. You don't have to be a sailor to paint successful marines, but careful observation is paramount.

Wakes

With experience you can tell a good deal about the capability of a boat by observing its wake and bow wave as it moves through the water. Friction, cavitation, and other manifestations of resistance are revealed.

The wake of a fast-moving boat contains effects resembling boiling bubbles breaking to the surface. Patterns of aerated white water and semiaerated, milky green water occur. Waves, of sufficient force to break, continuously trail away on each side of the "boiling" area. Transverse waves also form in the wake and appear to follow the vessel at its speed. If the water is not calm, the wake clashes

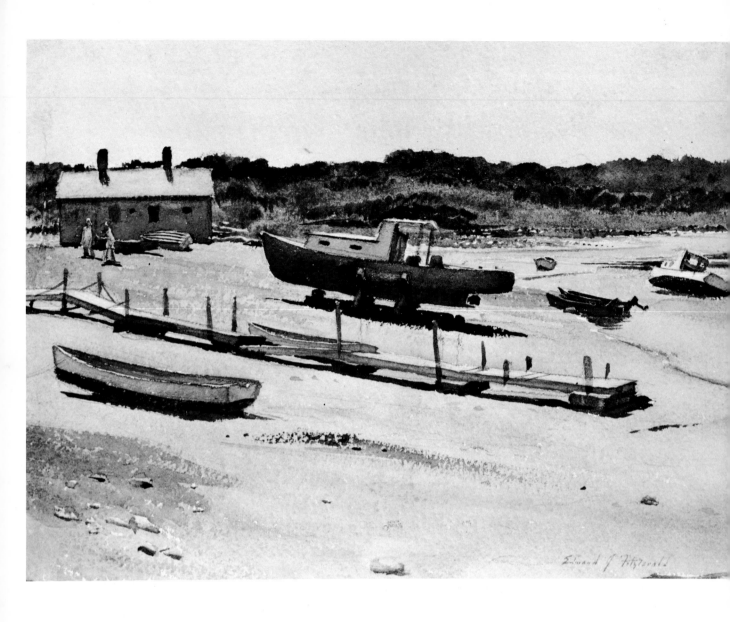

Low Tide, Cape Neddick (Above). 11" x 15", 300 lb. rough J. Green paper. By observing the shadows, you can see that I did this painting looking toward the sun. The French call this light effect "contre jour" (against the day) and photographers often refer to it as "back lighting." On a bright day, pursuing such an effect can be hard on the eyes, and it is sometimes devastating to color as value contrasts become so great that things appear in an extreme black and white relationship. Color content is overwhelmed by the intense light. In spite of the drawbacks, such effects often appeal to me. This illustration directs attention to the variety of boats sometimes encountered in one place.

Schooner near Edgartown (Right), 13" x 20", 140 lb. rough, stretched Arches paper. This watercolor of a boat under sail illustrates wakes and bow waves. It also uses another "against the light" effect. This back lighting produced a strong glow of warm color in the sails from sunlight shining through them. The shape of the sails caused a faint warm reflection in the silvery water. I gave the white wave curling away from the bow a light wash of cobalt blue because it was in shadow. The wake at the stern is white paper.

with other waves and produces occasional explosive puffs of white water. In calm water a wake may be visible for many ship lengths behind a fast-moving vessel. The wake tends to spread slightly.

Bow Waves

The wave formed at the bow of a moving vessel is sometimes called a "bone in the teeth." A blunt-nosed boat creates a large crest of white water at its bow that gives the impression the boat is moving faster than it actually is. A boat with a narrow, sharp bow, going at the same speed, has a smaller bow wave because it is pushing less water ahead of itself. A sharp bow causes the bow wave to curl away from the vessel's side and form a vortex as it breaks into a white crest, similar to a cresting breaker. The bow wave at a blunt bow more nearly resembles the leading edge of the "crescent" of a cresting wave as described in Chapter 9.

A bow wave sweeps away from a vessel's side in a graceful curve, breaking into white for perhaps half the boat's length, more in a fast-moving small boat. Several smaller waves follow the first, their number and size depending on the vessel's length, shape, and speed. The largest of these secondary waves usually originates where the tapering bow joins the full width of the vessel. The cresting of these waves is followed by a trailing wake of semiaerated water, as is true of any breaking wave.

Rolling or pitching of the boat produces a confusion of waves that intermingle and clash with the bow waves. If rough water and wind are involved, an additional confusion of clashing waves marks the progress of the boat through the water.

From a distance the bow waves and wake appear as a more or less continuous path of white, marking the vessel's track like the trail of a rocket.

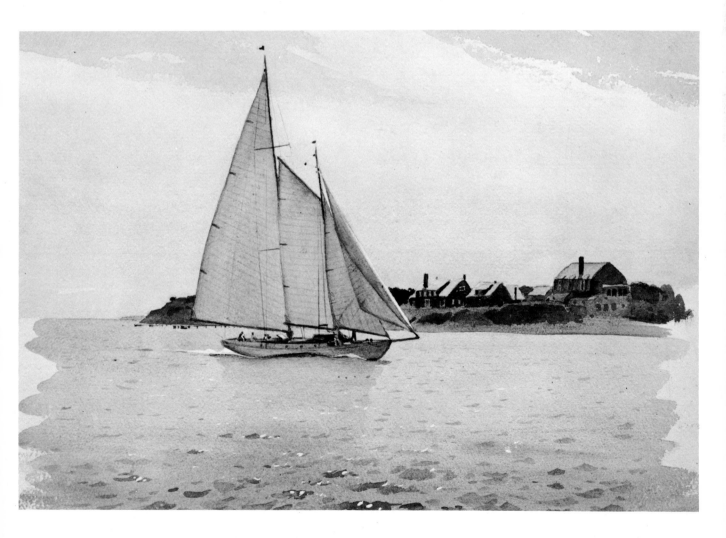

Ships at Dock, Seattle (Above), 9" x 12", 72 lb. cold-pressed, stretched Whatman paper. The shapes of the autos date this small watercolor, circa 1935. I recall being attracted by an odd lavendar color on the hull of the dominant ship. In contrast to the white superstructure and orange mast and funnel, the effect was striking. I did the rest of the painting in a variety of grays with warm brown touches on some of the figures. Drawing and painting took no more than an hour.

Readying for the Last Voyage (Right). 10" x 15", 90 lb. rough, stretched Whatman paper. I painted this water-color of a four-masted schooner on the Seattle waterfront before World War II, when a few such ships were still commercially active. The sunlight, somewhat dimmed by haze, was just strong enough to create a light and shadow pattern in the fresh paint on parts of the ship. The hull, except for the white upper part, is "Kelly" green while the rest of the painting is dominantly warm gray.

17

Ships

I must go down to the sea again,
To the lonely sea and the sky,
And all I ask is a tall ship,
And a star to steer her by.

These opening lines of John Masefield's *Sea Fever* eloquently sing the romance of the sea and ships. Men have restlessly followed the salt-darkened figureheads of ships over countless tracks on the sea. After the passing of sail, they roamed in rusty freighters and sleek liners. Their wanderings have stirred the envy of shore dwellers in every time and place. The romance remains and beckons to all, landlubber as well as the old salt who has perhaps "swallowed the anchor" and vowed never to leave dry land again.

Many sailors in all periods have been moved to try their hand at pencil and brush to capture the color and mood of life at sea. Some of our great marine painters have come from this fraternity, having followed the sea at least briefly perhaps in early youth. Charles R. Patterson sailed before the mast and, like Joseph Conrad, achieved officer rank before he left the sea to pursue his art. Anton Otto Fischer spent his youth at sea and has told the story in an absorbing book, *Fo'c's'le Days* (Scribner's, 1947), handsomely illustrated with his paintings.

All fine marine painters have not had such backgrounds, however. Homer, for example, went to sea only occasionally as a passenger. Frederick J. Waugh spent early years on the Channel Island of Sark and at St. Ives in Cornwall studying the sea from the shore. Gordon Grant's love of the sea stemmed from his childhood on the San Francisco waterfront and a trip by clipper ship around the Horn to England as a teenager. His knowledge of ships was augmented largely by making ship models — undoubtedly excellent training.

Ships are among the most majestic constructions of man. They are a dominant symbol of his rela-

tionship to the sea. The inside of a modern ship is like a small city; you can lose yourself in its mazes, but despite its size, a ship can become a mere speck on the broad bosom of the ocean. Whether you know your ships from the inside out or merely as shapes on the horizon, they are an integral part of the experience of marine painting.

The Appeal of Old and Modern Ships

Old things have a special appeal, and ships are no exception. Ancient ships are hard to come by as live models, although there are a few maritime museums like the ones at Mystic, Connecticut, San Francisco, and New York City's South Street, where old vessels are preserved. They provide invaluable material for your research but are few and far between. Books and prints are more accessible. If you want to paint a Carthaginian trireme or a Viking long ship, you can find the necessary information with a little digging.

Among contemporary ships, the signs of colorful wear and tear are plentiful. You can see the inexorable ravages of a rough life on a purse seiner on the Seattle waterfront or a dragger out of Gloucester. A tramp steamer records its voyages in rust and marine growth.

Recreating the Past

If your painting calls for a period piece, an East Indiaman or an eighteenth-century frigate, the problem is more difficult. Ships preserved in museums may look a little neglected, but neglect is not the same as use. To make your period ship look storm-battered and sea-weary takes some doing.

You may research your ship by studying plans, diagrams, and nicely scaled models down to the last buntline and cathead, but the authentic stains of sea and weather can only be added by a well-informed imagination.

Freighter. *Detail of East River Bridges, p. 121. The pattern of rust on the ship's side is rendered by allowing the liquid color to flow freely downward.*

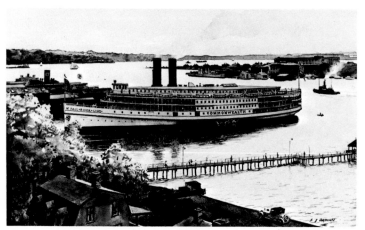

Commonwealth at Newport, *15" x 22", 140 lb. cold-pressed, stretched R.W.S. paper. Collection Professor Robert Farson. This watercolor was commissioned by my friend, Professor Farson of Pennsylvania State University, who recalled being a passenger on the Fall River Line ships. (They ceased operations in 1937.) The Commonwealth was elegantly appointed and had sleeping accommodations for 1,500 people. My research for the painting included old photographs and my familiarity with the area, having sailed those waters many times.*

Marine painters of the past provide us with the greatest wealth of information about ships of former times; however, study them critically to seek out the look of truth. Marine paintings are always scrutinized, for seafaring men are sharp-eyed and outspoken critics. Landsmen do not have the sailor's professional eye for accurate marine detail, but the feel of authenticity in maritime art does reveal itself. A smooth-talking person may make us believe he possesses more wisdom than he does, but a painter, that is, a representational painter, reveals his strengths and weaknesses in his work. Your study of marine art must be profound enough to evoke real understanding. A mere copying of effects also reveals itself.

Change in Ship Design

Ship design in all periods has gone through changes with remarkable speed. Evolutions in ships is as complete and devastating to former styles as those precipitated by fashions. Two principal motivations have produced the changes: commerce and its concomitant, warfare.

Certain special needs such as those present in the American colonies about the time of the Revolution generate changes. Commercial and military needs in the latter part of the eighteenth century brought about the design of fast schooners and more maneuverable frigates than the competition possessed. Steam propulsion of vessels and development of the submarine and ironclad warships are also part of American maritime heritage. Each new look in ships influenced world trade, economics, and politics and provided new models for the marine painter.

The mid-nineteenth century saw the flowering of one of the most nearly perfect of all marine achievements, the clipper ship. These beautiful, beautiful ships held the world enthralled for about a decade before passing from the scene.

The World Wars produced a veritable explosion of ship construction and maritime activity. With the advent of relative peace the great ships were no longer needed, and hundreds of them now sadly decay in quiet estuaries. Streaks of rust from their hawspipes resemble weeping. Perhaps they envy their noble fellows who, battered by sudden violence, took the final plunge.

Whole fleets of vessels, born of necessity, have come into being, plied their various trades, and succumbed to economic pressures. Coastal ships of surpassing elegance, like the *Commonwealth* and *Priscilla* of the Fall River Line and the *Yale* and *Harvard* of Pacific Coast fame, flourished for many years until other modes of transportation became

more popular. Great river packets, as ornamented as wedding cakes, once thrilled sightseers on the levees. Perhaps the huge liners too will all disappear from the oceans as well, but no doubt there will always be ships. They seem to be building them bigger than ever, but not necessarily more beautiful or paintable.

Homely Ships

Ships are not all handsome; many are homely as sin. Some are mongrels — part sail and part steam — but partaking of the charms of neither. Some ships are built for one purpose, then modified for another, generally resulting in a bastardized look. Such was the mail steamer *Star* I once took passage on in the Bering Sea. It was launched as a schooner and later had engines and a superstructure added. It was a stout little ship, but ugly and rough riding.

Nevertheless, even homely ships somehow manage to have character, and a dishevelled and unkempt appearance is not without charm for your watercolor. Evidence of stormy passages and the battered look of a hard life give a little tramp steamer a jaunty and defiant air, as though it is used to hard knocks and can take anything that comes along. A fishing vessel that wrests a tough living for its inhabitants from an unrelenting element also has color and life in all its stains and scratches. (See *Menhaden Fishermen*, p. 20, and *Schooners, Seattle* in *Demonstrations* section.)

Primitive Types

Evolution in ship design has submerged whole classes of vessels, but like other evolutionary processes, it has left behind primitive types that resist change. Fellucas and dhows similar to those of hundreds of years ago still sail the Mediterranean and Persian Gulf. The junks of Asia and the outrigger canoes of the Pacific Islands remain unchanged. Coracles, small boats made of wicker and hides, can still be found in Wales and Ireland, and sprits'l barges still ply the Thames. In Viet Nam I saw sampans and junks that are made of wood but have bottoms of basketry, woven with reeds and sealed with pitch. They are considered more durable than all-wood construction, which is attacked by wood-boring teredos. When the basketry wears thin, it is readily replaced.

Huge Ships

Two-hundred-thousand-ton tankers are becoming commonplace, and even more monstrous ships are on the way. These giants are certainly impressive but not particularly alluring to most painters. Perhaps when they have been around long enough, they will have more appeal. Brand new mechanical things have seldom appealed as subject matter for painters. When these colossal modern ships come to grips with their mortal enemies, violent winds and crushing seas, when they have been thoroughly baptized and tested, as was the *S. S. Manhattan* on her historic traverse of the Northwest Passage, then artists may take greater notice.

Ultra-Modern Ships

Such ultra-modern types as air-cushion and air-foil vessels will also have to be absorbed into general experience for quite a spell before they too attract most painters.

Warships

Warships of all times and types have special appeal as subjects for some painters. Historic types are well documented in paintings and prints. You can find more recent types in such books as *Jane's Fighting Ships* (Arco Publishing Co., New York). The Public Relations Officer, Navy Department, Washington, D.C., is usually very helpful with information about U.S. Navy ships of the recent past. A periodical found in most libraries, *U. S. Naval Institute Proceedings*, is another good source of information and pictures of ships, old, and new.

Drama of Marine Disasters

Marine disasters are singularly potent in their dramatic impact, and they appeal to many artists as subject matter. Our old friend, Winslow Homer, was drawn to this theme and painted various aspects of shipwrecks, sea rescues, and the like.

News photos and books dealing with maritime events and history provide information that can help you in developing such paintings. You can use sketches of ships in port or boats in boatyards as basic material for developing imaginative reconstructions of marine disasters.

When the wind howls and sleet is driven horizontally, it is not difficult to "Pity poor sailors on a night like this." Our minds evoke vivid images of the terrors of the sea and violent forces enveloping men and ships. Nevertheless, to respond to such imaginings and set them down in line and color is no easy matter. Some artists have greater capability than others in sustaining such images with sufficient clarity or over a sufficient period to fix the images in terms of painting.

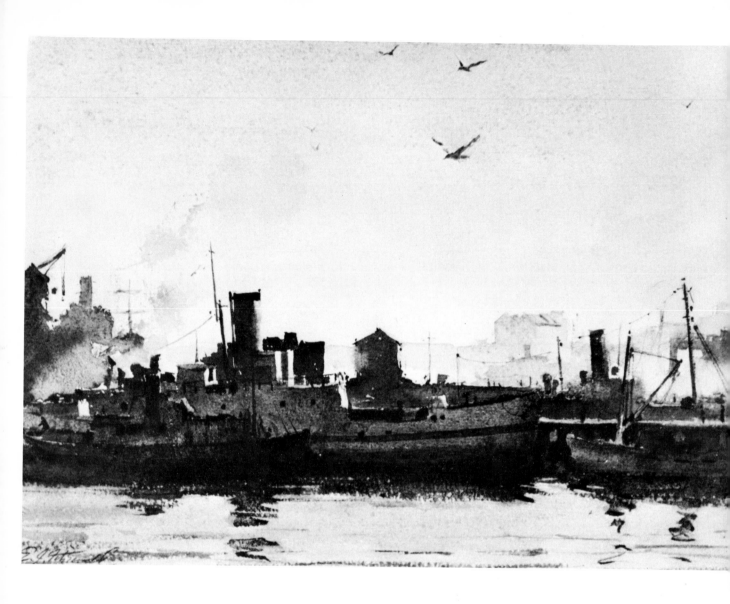

Winter Morning, Weymouth *(Above), 9″ x 12″, 72 lb. rough, stretched Whatman paper. This little watercolor was painted on a frosty morning in an English harbor. The painting is dominantly cool in color except for a pale light in the lower sky and a dull red glow near the waterline of the largest vessel. I filled in the few sunlit areas (superstructure of the ship, dock surface, etc.) last with pale, warm tints. Then I superimposed the reflections on the water and a few small, dark accents; the rest is done in a "one wash per area" style.*

The Last Anchorage *(Right), 11″ x 15″, 300 lb. rough A.W.S. paper. I have painted this decaying hulk in New Rochelle harbor several times. Its colors seem to be more intense on an overcast day as this painting shows. On such a day whites also stand out; note the small white house on the far shore. Because of the overcast, and therefore less changing light, more time was available for this painting (about three hours) so I took extra care in rendering the construction of the skeleton of the ship.*

Of the various media, watercolor with its fluid quality and speed of application enables you to seize the essentials of illusive, imaginary visualization. When you have the feeling that your imagination is in good working order, try such experiments. It is good fun, and you can't go to jail for failing. The worst dampener to such an exercise is fear of failure or the conviction that more technical data must first be researched. At that point you must remind yourself that some great paintings have been rather short on technical details and long on imagination. The force of imaginative power is far more convincing than recorded details. If you can evoke the spirit of an event, literal details are unnecessary. Stirring examples of Turner's great paintings, *Slave Ship* or *Rain, Steam, and Speed*, come to mind in this respect.

Derelict Vessels

The hulks of abandoned ships or wrecked boats left in shallows or high and dry are also evocative subjects. They are easier to find as models than occurring marine disasters. The shores of many a quiet backwater or ocean beach contains the remains of deceased boats and ships. Sometimes they are almost buried in sand or hidden by vines and grasses. They reveal details of construction and often display evidence of once handsome lines. They may display their mortal wounds and the ravages of passing time and neglect.

If you are an imaginative viewer of a derelict vessel, you can read many stories into the encrusted evidence. Tragedy and comedy are visible. Human aspiration and folly are etched in peeled paint and loosened fastenings. Achievement, failure, pleasure — the gamut of feelings are bared.

When the polished metal fittings are gone or corroded, the brightwork dulled; the trappings, adornments, and the very skin and flesh are bleached and fallen away; then the revealed likeness to living things in the ribbed carcass of a vessel strikes a note of horror, "As you are, I once was; as I am, you shall be."

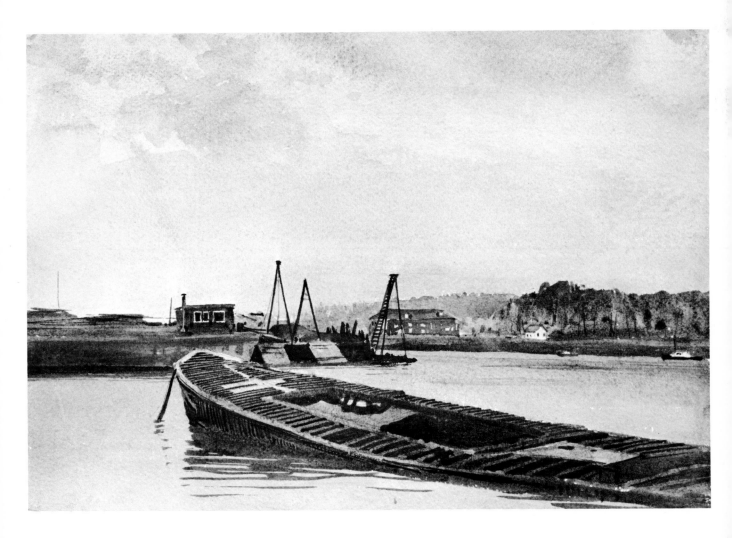

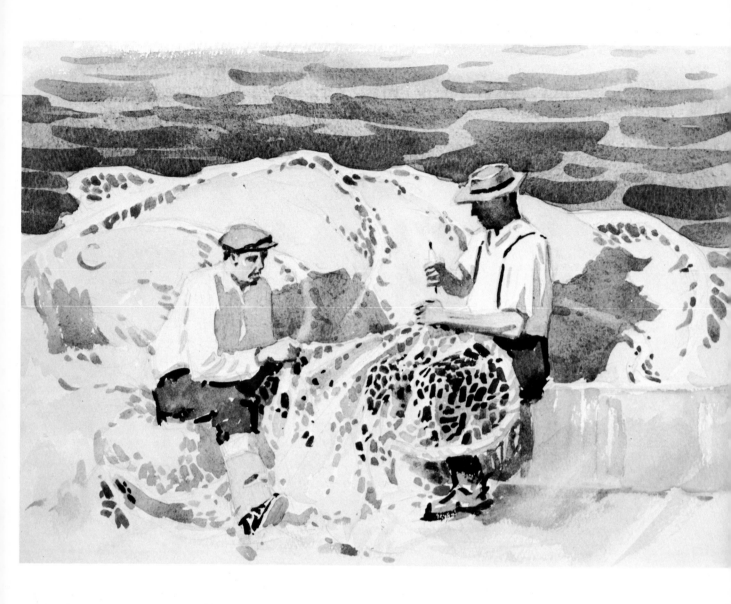

Net Menders (Above). 9'' x 13'', 140 lb. cold-pressed, stretched Whatman paper. Although this watercolor was painted in the studio from a pencil sketch I did on location, I made an effort to retain the same kind of simplicity of treatment that would be present in an unposed watercolor done in the field. The light on the shirts is white paper. After I established the light on the water with a basic wash, I superimposed strokes of color to create the wave pattern.

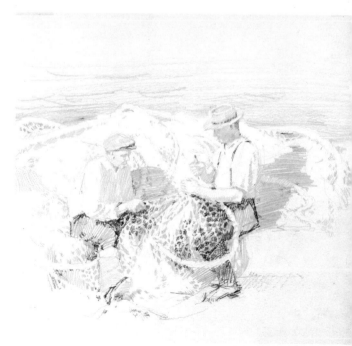

Pencil Study. This is a preliminary drawing I made for the picture Net Menders.

18

People of the sea and waterways

I feel moments of envy for the colorful people who dwell by the water and take their living from its bounty and commerce. They appear hardy and self-reliant and in tune with the vital element that brings us to the shore. Their costumes and speech are free and easy. They are generally friendly and hospitable to artists, and they are eminently paintable. (See *Menhaden Fishermen*, p. 20.)

Influences of the Sea

The sea has provided fame and wealth for a few and scanty bread for many, but it exacts a hard price for its yield. It can be whimsical and merciless, and long experience does not assure its mastery. It encourages strength, demands humility, but guarantees safe conduct to none. Its rigors, that tan the skin and harden the will, may spare the foolish and slay the brave. The sea dispenses no moral justice, but all who come within its orbit are etched more deeply and brushed in bolder colors. They are a race apart.

Charles W. Hawthorne, N.A., found in the fishermen of Provincetown and their families models that enabled him to paint a whole saga of the sea with scarcely any water or boats. And Homer's paintings of the fishermen and women of Tynemouth speak as eloquently of the sea as his great surf subjects.

Homes of the Seafarers

The homes of sailors are affected by the sea as are the sailors themselves. Long absences, letters describing distant places, and the souvenirs from foreign lands that decorate the home, all make the pattern of life different from that of others. Homes of sailors at ports like Salem or Edgartown are equipped with "widow's walks," balustrades on the roof for watching incoming ships. These are relics of another time when a return from sea was first made known by the sight of a familiar set of sails.

Some sailors who retire from the sea retreat as far from the water as possible. Their rolling gait is apt to remain with them, however, as well as the "salt" in their speech and the crinkle around the eyes from squinting toward the glitter of the sea.

An Alien Environment

James Russell Lowell said, "There is nothing so desperately monotonous as the sea, and I no longer wonder at the cruelty of pirates." Mr. Lowell had probably just returned from an unpleasant voyage. We all know that the sea is not the only harborer of cruelty, and pirates are not all waterborne.

Nevertheless, man *is* a land animal, and the sea is an alien environment, just as is the air to fliers and space to astronauts. One of the great seamen of all time, Lord Nelson, is said to have felt reluctance upon embarking on each of his many voyages because he was usually seasick for the first week or two. Yet some deep drive in men causes them to return again and again to search the unknown and unsafe in quest of an obscure dream.

Related Occupations

Many people who do not actually go to sea somehow "belong" to it. In addition to the wives, sweethearts, and children of seafaring men, there are stevedores, longshoremen, fishmongers, ship chandlers, and ship builders — a whole brotherhood with a touch of salt in their veins. As they belong to the sea, so do they come within the ken of the marine painter.

Recreation Seekers

As a marine painter, you have a still larger group of prospective models: those who are drawn to the

Old Salt, *11" x 15", 300 lb. rough Arches paper. Touches of strong color were required to express the flesh tones in the face of this old timer. I painted it from life in about an hour. In several places I used pure pigment, and in the light-struck areas on the face, there is a wide variety of colors.*

water for fun and games. (See *Parson's Beach*, p. 159.) Sunbathers, waders, and swimmers are all available and call upon your training in that fundamental of art education — the nude (or essentially nude) figure. Fishermen, clamdiggers, or people just walking or sitting on the shore are equally part of a marine painter's domain.

Action Figures

Sketching unposed models, particularly those in action, is difficult but feasible. Most life classes conduct drills in action sketching to train you for just such problems. Don't attempt to set down more than the general swing and attitude of the pose in a short (1 to 5 minute) sketch. Apply the same approach to sketching figures in the open. If the figures are small in size in your composition, as they usually are in a painting that is mostly landscape, two or three small brushstrokes may be all that is necessary to express them.

Size and Color of the Figure

You must maintain control of the size of the figures. You can accomplish this by relating their size to other objects in their vicinity in the sketch. Their color and value are important too. Since the color spots in the figures are small, my tendency is to exaggerate the observed color a little, thus avoiding the fault of making them appear as colorless dots and slashes. In other words, I would suggest the silhouette of a bather seen some distance away on the beach with a rather hot color, like burnt sienna. If a bit of color like blue or red is observed in a costume, I would use a small touch of a rather pure color, perhaps cobalt blue or cadmium red, instead of a modification of such colors, which I would probably use if the figures were larger in scale. Intense color in a small spot holds its place, where a larger spot might not, even in the same composition. (See *Wyngersheek Beach*, p. 74.)

If the details of a costume are light against something dark in a painting, a rocky headland, for example, the *value* of the color can be successfully heightened, that is, it can be left white or nearly so. On the opposite end of the value scale, in the case of a figure that appears dark against a light background like the sky, restrain the darkness a little and infuse color, being careful not to disturb the silhouette effect.

Figures may be resolved as mere blobs in the painting, but take care to express their action and to plant them firmly in place in their surroundings. Remember to include any shadows the figures cast.

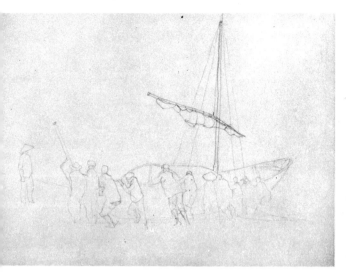

Sketchbook Notations. *These sketches from my sketchbook are brief — often taking only a minute or two to draw — notations of figures, boats, and fleeting effects recorded with pencil, watercolor, or anything else that is handy.*

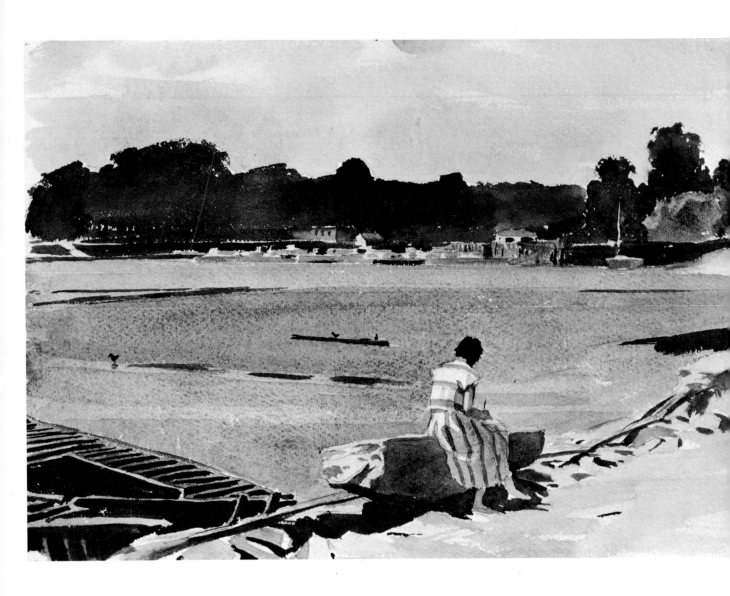

Aquarellist, New Rochelle (Above), 11" x 15", 300 lb. rough Arches paper. Among the people of the sea and shore that make good subject matter are your fellow artists! This watercolorist was sitting on a damaged sea wall near the decaying remains of a small ship, which was resting on the shimmering mud at low tide. She made an attractive foil for her surroundings. I did the drawing quickly and the painting was finished in a little over an hour. I created the effect of mud by means of a second wash of gray over a cool base wash that I had used to establish the color of the water in the harbor. Except for that and the stripes on the dress, I used a minimum of superimposing.

Mecong River Patrol (Right), 10" x 14", 120 lb. stretched David Cox paper. I painted this watercolor at dawn on a Vietnamese Navy patrol boat heading down the Mecong not far from Cambodia. A U.S. Naval officer and two Vietnamese are on the "bridge." I used warm colors in sky and water with a band of light along the horizon. Some of the light areas in the sky are the warm tone of unpainted David Cox paper. The silhouetted figures are reflected in the cool, damp gleam on the turret and cabin top. I had just finished the drawing for this when a bullet, fired from shore, "zinged" by. I instinctively ducked, and my glasses hopped out of my breast pocket and into the Mecong. I needed them for the pencil drawing, particularly in the dim early morning light, but I like to paint without them as I see the overall color relationships better.

Sketchbook

I often set aside my watercolor for a few minutes in order to sketch passing figures or boats or other moving things in a small sketchbook. I do them in line or with a brush and a few blobs of color.

Figure Groups

Groups of figures around a picnic spread or under a beach umbrella suggest enticing compositional groupings, even when small in scale in your painting. Such groups can seldom be composed directly in your watercolor, so try them first in your sketchbook. Then you can organize the arrangement of contrasting values and colors. It usually is not necessary to draw each figure in the group literally; just indicate a spotting of darks and lights to *suggest* a figure group. Admittedly, this is easier said than done, but you have the best luck if you do not try too hard. (See *Art Class at Nubble*, p. 123.)

Developing Action Figures in the Studio

Back in the studio, you can develop figures observed while working in the field whose actions were too rapid to adequately sketch. Searching your sketchbooks or "scrap" file for the right pose is a possibility, though often frustratingly time consuming. Posing a model in the correct attitude and lighting is perhaps the best solution. The use of an adjustable manikin in place of a model is a fairly good substitute. The small-scale, wooden manikins are almost as useful as the lifesize version, except that you cannot clothe them, and this is unnecessary for most beach activity anyway. Besides, a good, lifesize, adjustable manikin is so expensive you might as well marry a model!

Many artists use photography to assist in capturing the actions of figures to be included in landscapes. Usually this is part of a studio project, and is not used in outdoor sketching. Photographs can be used either to further develop an outdoor sketch or to repaint a sketch, perhaps in larger size, back in the studio. It is essential to use the information provided by the photograph in such a way that it does not appear inconsistent with the rest of the painting. Placing the photograph some distance away from you while you study it can be helpful, so you can avoid getting involved in nonessential details "seen" by the camera.

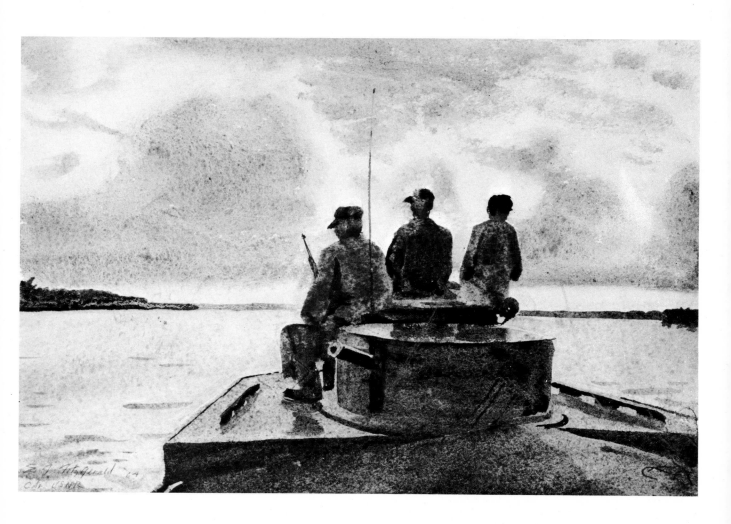

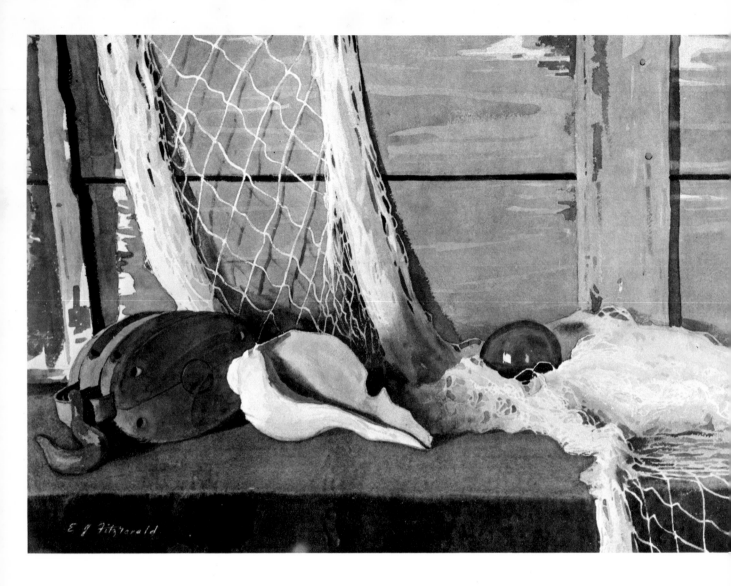

Beach Combings *(Above), 22" x 30", 300 lb. rough Arches paper. This painting won an award in the 1970 American Watercolor Society Annual. One of the prizes that beach-combers seek is the spherical glass float used for fish-nets, particularly in Japan. They occasionally float in, presumably all the way across the Pacific. A small one is in this painting on the right. Some are more than a foot in diameter. I arranged this still life in the studio and painted it in natural light.*

Beached Derelict *(Lower Right), 10" x 14", 90 lb. rough, stretched Whatman paper. Studying wrecked or aban-doned and decaying boats is an interesting way to observe their construction; somewhat as you might study skeletons and cadavers to learn anatomy. The utilitarian and often beautiful lines of a boat are apparent up to the final stages of decay. In addition to being able to study the ribs and planking of this once sturdy boat, I was fascinated by the compositional setting. The deep blue water, the bleached driftwood, and the faded colors on the derelict all seen against the pure, limpid sky, had a poetic impact I can still remember.*

19

Still life

Still life is where many artists start and often end up. Beginners are frequently set to work drawing or painting simple arrangements of crockery and lemons. They sometimes get bored stiff and long to try their talents on more "worthy" subjects, such as figure compositions, sweeping landscapes, or marines that make you feel the spray in your face. As often as not, at some more mature period in their career, they return to the *vive mort*.

Some of the most noted painters are remembered more for still life compositions than for their more "ambitious" works. The gallery of painting for the last 200 years would be mighty empty if all the still lifes were removed: Picasso, Matisse, Braque, Van Gogh, Cézanne, Fantin-Latour, and Chardin are just a few of those who have created an inspiring heritage in this fundamental art form.

In any case, still life painting is a good diversion from landscape, portrait, or marine painting or as an occasional rainy day project. The beauty of still life is that you can do so much composing with the actual objects before you get into the drawing and painting. In a way this too is painting — or perhaps more akin to sculpture — because you are dealing with form and color in a three-dimensional context. You can also exercise a great deal of control over light, that supreme *source* in the realm of visual art.

One of our greatest contemporary painters, Andrew Wyeth, N.A., A.W.S., has a way of using "found" still life most effectively — a bucket hanging on a fence post, an empty chair, slippers by an unmade bed. The spontaneous quality of a chance encounter that is evoked by such compositions gives them a special appeal. They do not have the contrived look that a "regular" still life often has. Obviously such compositions could in fact be contrived, or perhaps partly so. Part of the art is to make them *appear* uncontrived.

Driftwood

The beachcomber instinct is strong in most of us, particularly those who go down to the sea to paint!

If you have ever walked along a beach, you know the charm of the happenstance sculpturing of driftwood. The variety of forms is endless and the texturing and finish make an amateur of the cleverest frame-maker.

Some of the wood forms have been violently altered from their original shape by the action of wind, wave, sun, and sand. Some places on a form will be scoured with a deep, corrosive effect, while other places are polished with the tenderest touch. Sometimes, in an oddly shaped piece of driftwood, you can recognize a man-made article, but it may be so altered that identifying it is difficult. Perhaps it is a piece of nautical equipment, now obsolete, from a sunken ship of a former time — a dead-eye for example, from the shrouds of a sailing ship. A lathe-turned shape might be a stanchion from the taffrail of a frigate. Of course, it might also be the leg of a kitchen table!

Pieces of the root of a tree can be converted into fanastic and sometimes handsome shapes by weathering. The density of root wood is capable of taking a lot of punishment. A strange shape picked up on a beach may have travelled thousands of miles, to be shaped on numberless shores before resuming its journey. Some people make frames or articles of furniture from driftwood or display pieces of driftwood as sculpture.

Nautical Gear

A piece of driftwood establishes a nautical feeling in a still life, but you can also use other bits of maritime paraphernalia. These can be oddments picked up on a beach-combing expedition or such things as navigational equipment, pulley blocks, or marine gear of any kind.

Nautical gear lends itself admirably to the found still life. A glance around the deck of a fishing vessel, a wharf, or sail loft reveals many possibilities. In fact, if you respond at all to the romance of the sea you will find it hard *not* to see pictures wherever you look in such surroundings. A coil of

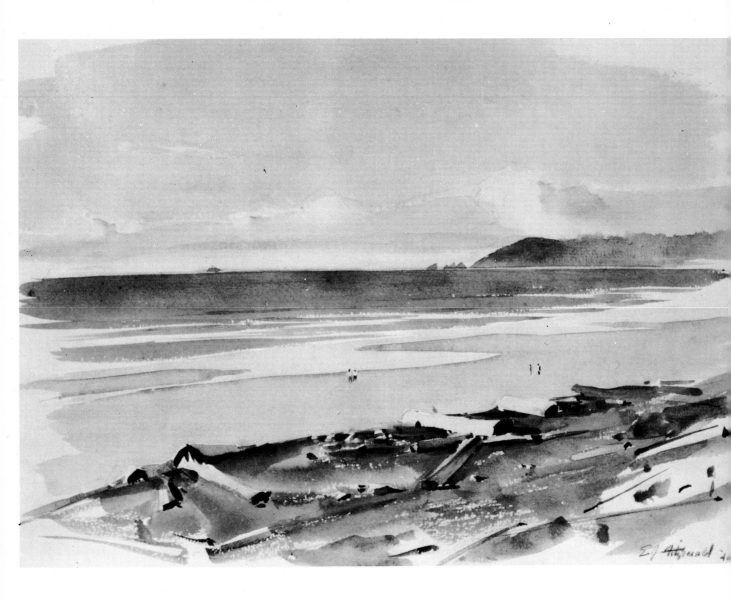

Tillamook Light, Oregon (Above), 10" x 14", 72 lb. cold-pressed, stretched Whatman paper. This watercolor gets its title from a famous lighthouse on a lonely rock just south of the mouth of the Columbia River. Its subject is beachcombers and driftwood. Beachcombers prize driftwood "sculpture." Some pieces are made into frames or furniture while less interesting pieces make great fireplace fuel. Driftwood gives off a salty fragrance while burning. I did this watercolor from the upper edge of the beach, where the driftwood had been concentrated by storm tides. I spent about an hour in the late afternoon drawing and laying in the direct, simple washes.

South China Sea (Right), 15" x 22", 300 lb. rough Arches paper. The title of this painting refers to the area of the chart revealed in the foreground. The chart provides some interesting pale colors for this still life. The circular filter on the sextant is bright green, and its color is intensified by the light chart shining through it and by the somber colors of the surroundings. Note that the shine on the parallel rulers and the varnished sextant box and pipe become reflective surfaces, like wet rocks.

rope, an old anchor, a pile of fish net with its cork floats, lobster markers hanging on the wall of a shed — there is no end to the variety of shapes and colors offered. The big problem is to fix upon a motive and set to work. The view finder, discussed in Chapter 3, can help you with this problem.

Fish and Shellfish Subjects

The gleam on the body of a fish or the marvel of construction of a crab or lobster has caught the eye of many painters. An urgent prerequisite for painting such subjects is speed. They fade faster than cut flowers, and they have a way of letting you know that it is time to let your model go!

My old friend, the painter Jacob Elshin, who is an inveterate fisherman, says that he has an ideal life. He goes out at dawn, catches a fish, brings it to his studio, and paints it as a still life. Then he has it for dinner. The cycle is completed when his dealer sells the painting. His only problem is trying to decide which is the best part of the process.

Importance of Design

Of course, there is nothing wrong with including non-marine objects in your still life, even if you wish to retain a nautical mood. You can glean a marvelous variety of shapes and textures from beachcombing, but never let the *theme* of a still life take precedence over the problems of design. To do so invites a trite and stilted result. As Sargent said, "There is nothing as dull as an obvious symbol."

Sometimes you light upon a possible subject but have a nagging feeling that this or that object should be moved a little or eliminated or that something should be added. If it is possible to physically move objects, you are in the process of still life arranging — which is fine. With imagination, skill, and experience you can do the necessary rearranging in your drawing. I would like to be able to suggest a suitable formula or two for resolving this kind of problem, but I don't know any. The best advice I can offer is this: if your urge is strong, by all means follow it, it may be the creative muse whispering to you.

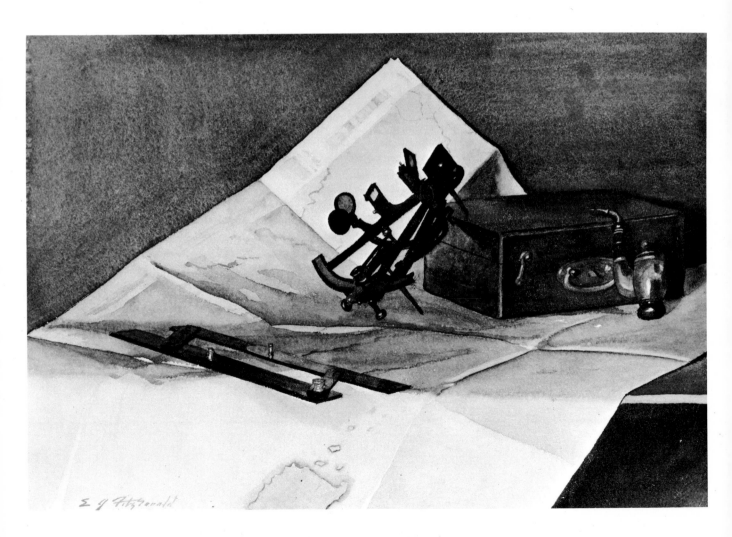

Demonstrations

Although the paintings on the following pages were originally done some time ago, I repainted them for this book. The various steps were photographed in color as they were done in order to detail the step-by-step progression of the paintings.

The steps were repeated as much as possible as they had been done originally. Discrepancies between the repaintings and the originals are due partly to the lapse of time between the original painting and the current work and changed working conditions between the two. The elusive quality of watercolor makes precise repainting almost impossible and the vagaries of color photography also added problems, but I hope these demonstrations will be helpful to you in spite of any discrepancies of color or form.

Strange emotions arise when you repaint a watercolor. I found myself reliving the moments of the original, even when a number of years had transpired between the two paintings. Response to weather and other long forgotten circumstances of the situation return with fascinating clarity. The psychic intensity of reaction to the rapid action of the watercolor medium as it occurred the first time around also returns. However, the clock is only symbolically set back, and the new painting is influenced by numerous subtle factors that preclude its being exactly like the original.

Lobsterman's Morning: Step 1. *I placed the horizon high in the picture, letting the upper edge of the composition come just below the sun, rising through morning mist. Alternate warm and cool colors were rapidly brushed in horizontal strokes for the sky; I used cadmium yellow pale, cadmium orange, cobalt blue, and Indian red.*

Lobsterman's Morning: Step 2. *Effects are transitory at this hour so I hurried along to render the water, working from the bottom upward so I could push ahead while the sky was drying. Shadows in the smother of foam are mostly cobalt blue, with white paper left for the sunlit areas.*

Lobsterman's Morning: Step 3. *I sketched in a lobster boat rounding the point and a lone sea gull perched on the point like a sentry. Next I washed in some of the dark rock shapes with ultramarine blue and Indian red with infusions of burnt umber. Sunlit spots were by-passed, to be filled in later.*

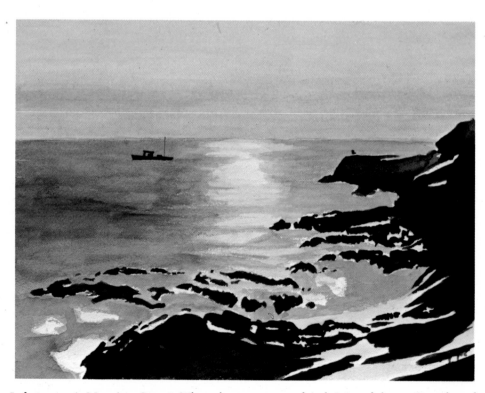

Lobsterman's Morning: Step 4. *When the water area dried, I tinted the sun's path and the light patches on the foam with cadmium orange. Sunlit spots on the wet rocks were tinted with stronger cadmium orange.*

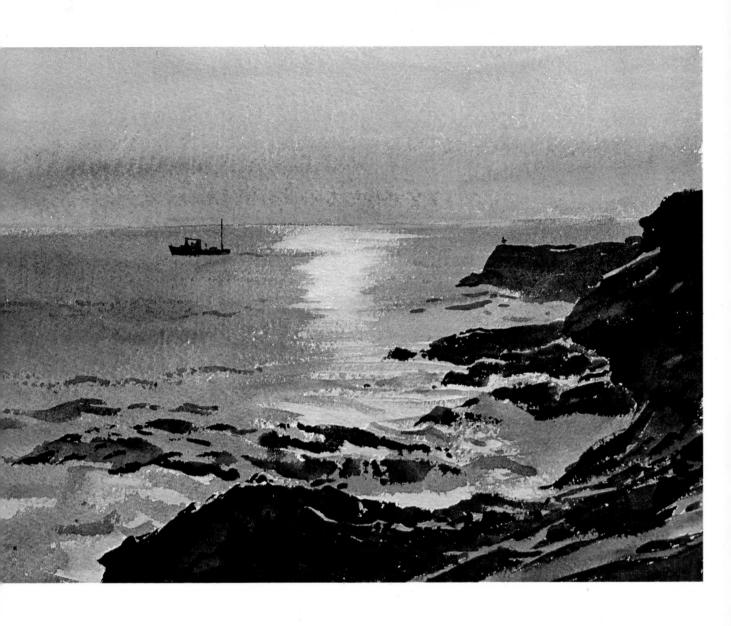

Lobsterman's Morning: Step 5. *11" x 15", 300 lb. rough Arches paper. Sunlit areas on the rocks nearby (lower right) were tinted with warm but less brilliant colors than those gleams seen nearer the eye level. I added some green accents to the moving water and superimposed very dark accents on the rock shapes.*

Schooners, Seattle: Step 1. *This watercolor was painted before World War II, during the latter days of the Alaska Packer Fleet. I did the drawing rapidly as in all outdoor work, but with due care. Details were simplified into "value" shapes rather than ignored. With the first washes I established some of the large color areas.*

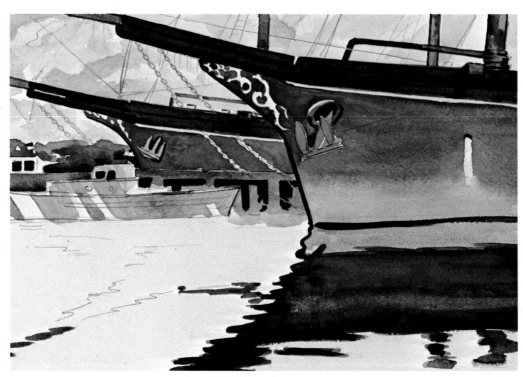

Schooners, Seattle: Step 2. *I started the pattern of the sky with a pale wash of cobalt blue and a little viridian. Drifting cloud shapes were by-passed, and then I blocked in their shadowed parts with touches of gray, composed of cobalt blue, Indian red, and yellow ochre. Cast shadows cover most of the white boat.*

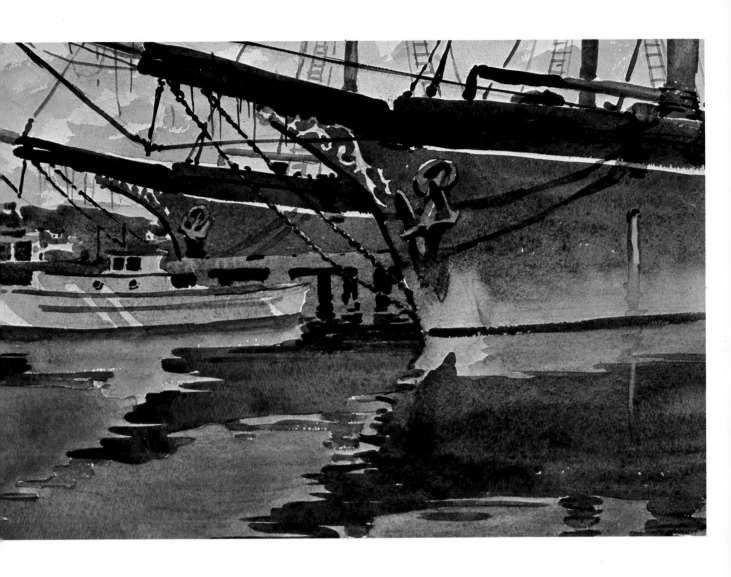

Schooners, Seattle: Step 3. *9" x 13", 90 lb. rough, stretched Whatman paper. The reflection of the white boat was painted as a continuous wash with the dark, warm stripe made at the water line in order to create a soft edge. Note that I ignore the reflections of the sunlit, slanting bands of light on the white boat as being too fussy. Sky reflections in the water were painted a good deal darker than the sky itself. I added dark accents here and there as final touches to describe shadows and detail anchors, ropes, and other nautical paraphernalia. Some of the whites that had been left were carefully tinted with pale colors as finishing strokes.*

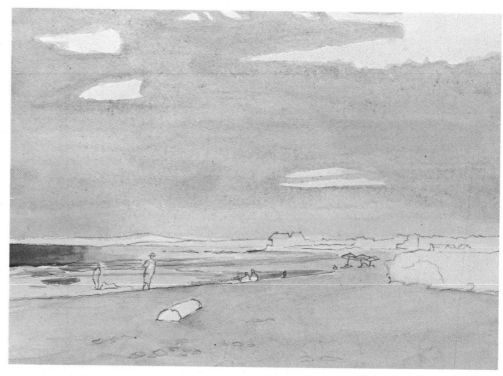

Parson's Beach: Step 1. *I washed yellow ochre over the upper sky and added cobalt blue and Indian red near the horizon. The same colors — but more intense — create the hot sand. I used cobalt blue, shading to alizarin crimson and yellow ochre and then to white paper, to express the glitter on the sea.*

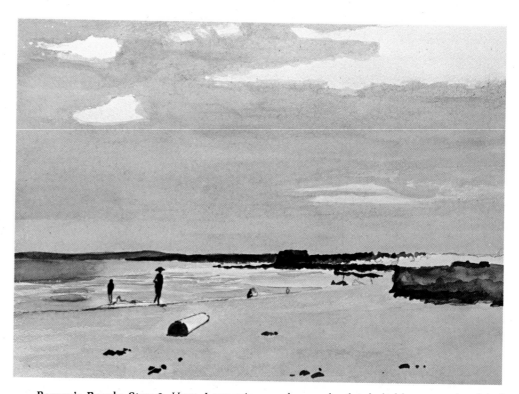

Parson's Beach: Step 2. *Here I superimposed a wash of cobalt blue over the dried yellow ochre base wash on the sky, avoiding the cloud shapes. Cobalt blue, intensified with Indian red, described the distant landscape. I used a dense wash of ultramarine blue and Indian red to silhouette the house on the rocky point.*

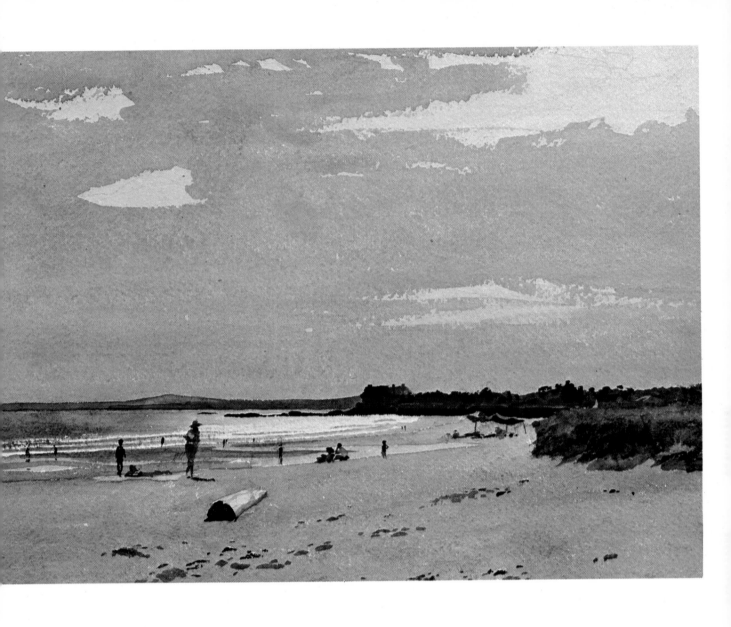

Parson's Beach: Step 3. *11" x 15", 300 lb. rough Arches paper. Since the "subject" of this type of painting is the light itself, I kept all of the landscape details, such as the grass and trees, fairly dark. Rough spots in the foreground sand, for instance, create small shadows that provide useful effects for adding texture and contrast to the flood of light.*

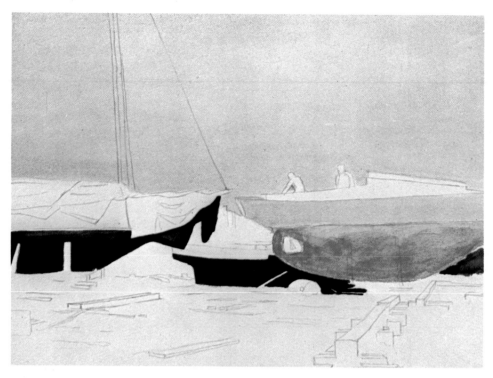

Boatyard: Step 1. *First I quickly but carefully penciled in the composition. Tiny pencil sketches for the figures were made on the brown paper tape margins of my paper. I used a single wash for the hazy sky of yellow ochre, cobalt blue, and Indian red. I made variations in the wash, since the sky was not flat. Next, strong, warm tones were washed in on the underbody of the boats.*

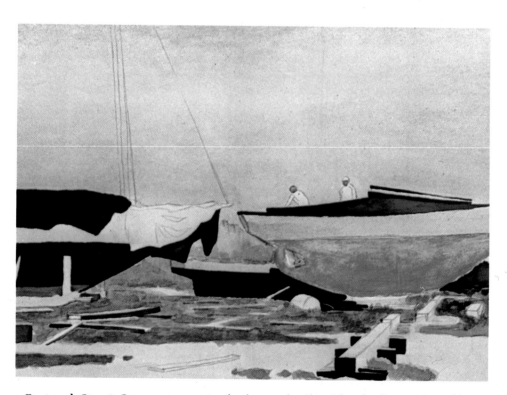

Boatyard: Step 2. *Some warm spots of color set the "key" for the figures. I used burnt sienna for the varnished cabin of the boat on the right. The warm gray tarpaulin on the boat on the left was brushed in, followed by the warm green of the grass (viridian and yellow ochre). I spotted in a few, almost black, accents on the foreground timbers to establish the complete value range from dark to light.*

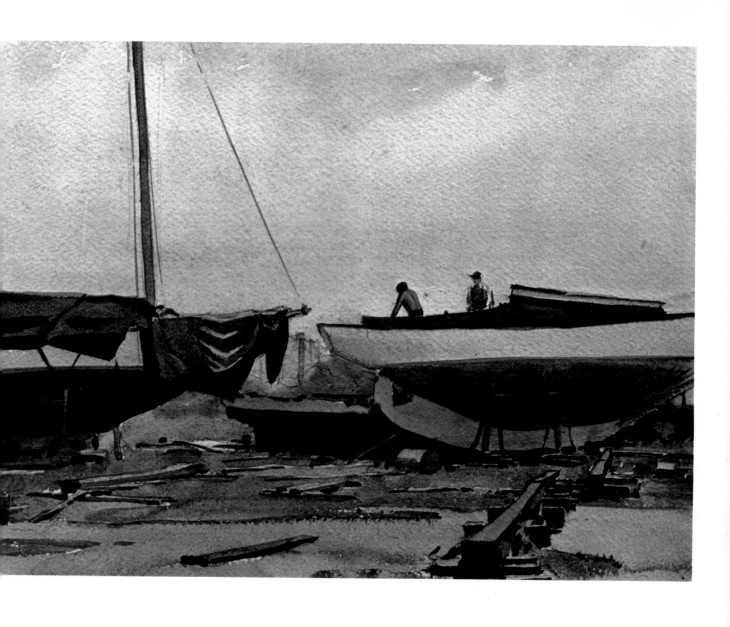

Boatyard: Step 3. *10" x 14", 140 lb. stretched Arches paper. Lastly I filled the color areas in, using a single wash wherever possible. Note the blue tint on the grease-smeared top surface of the heavy foreground timbers. I superimposed accents where necessary; for example, a large area of Indian red was needed to model the bottom of the boat on the right. I simplified construction and rigging details, placing emphasis on those things that create strong, fairly obvious, value contrasts.*

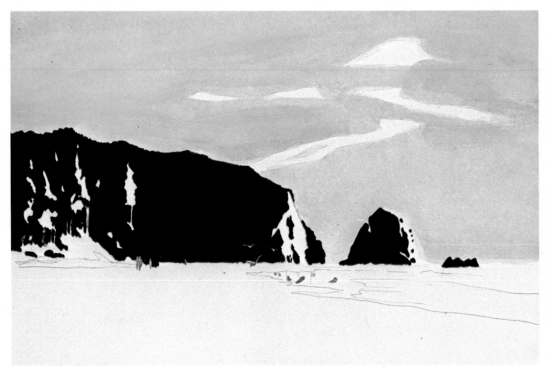

Arch Cape at Evening: Step 1. *I used Maskoid for the figures and gulls and for the trunks of the tall spruce trees. First I washed in the sky, shading the color mixture from yellow ochre at the top to warm gray by the addition of cobalt blue and alizarin crimson and avoiding the light patches which I later tinted with pale yellow.*

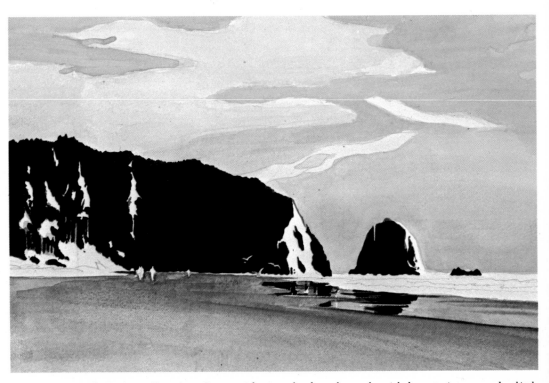

Arch Cape at Evening: Step 2. *I began the beach wash with burnt sienna and a little blue, adding yellow ochre as I carried the wash toward the foreground. I superimposed a second wash of cobalt blue and a little viridian on the sky.*

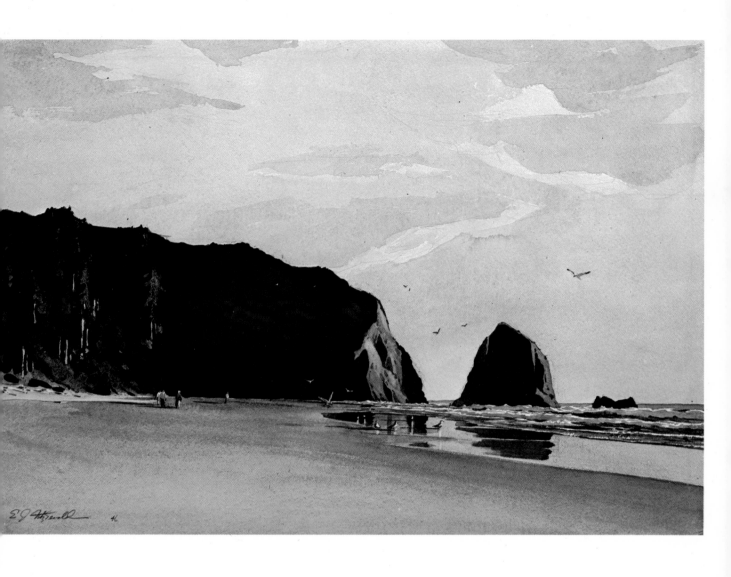

Arch Cape at Evening: Step 3. *14" x 20", 140 lb. cold-pressed, stretched Whatman paper. A warm light created by Indian red was painted in on the headland and tree trunks. I filled in the light areas on the foliage with a mix of viridian, yellow ochre, and cobalt blue. The figures are touched in with bright, pure colors. I painted the surf with cobalt blue shadows on the breakers, leaving white paper for the top lights. Deep greens and blues accent the spaces between the breakers. I took great care to retain control of the perspective drawing of the breakers.*

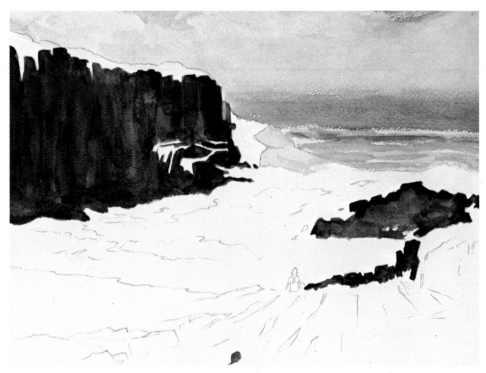

Bald Cliff: Step 1. *I started a wash of yellow ochre at the upper margin, adding color changes as the wash progressed downward across the sea, right to the top of the cresting breakers. (Alizarin crimson and cobalt blue were added in the lower sky; a lot more blue and yellow ochre were added at the horizon.) Then I painted the rocks with ultramarine blue, Indian red, and burnt sienna.*

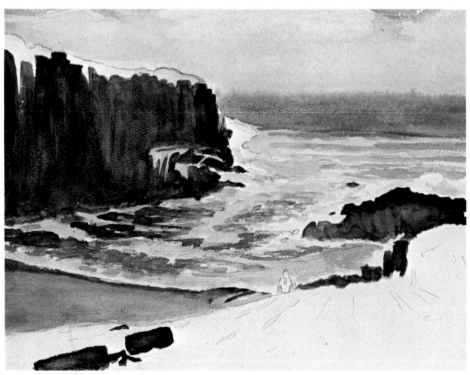

Bald Cliff: Step 2 *The churning water seen in the cove was painted with a basic wash of cobalt blue and alizarin crimson, the darkest tone being in the shadowy area at the foot of the cliff. Near the center of the cove I added yellow ochre. When it was dry, I superimposed dark green and blue accents.*

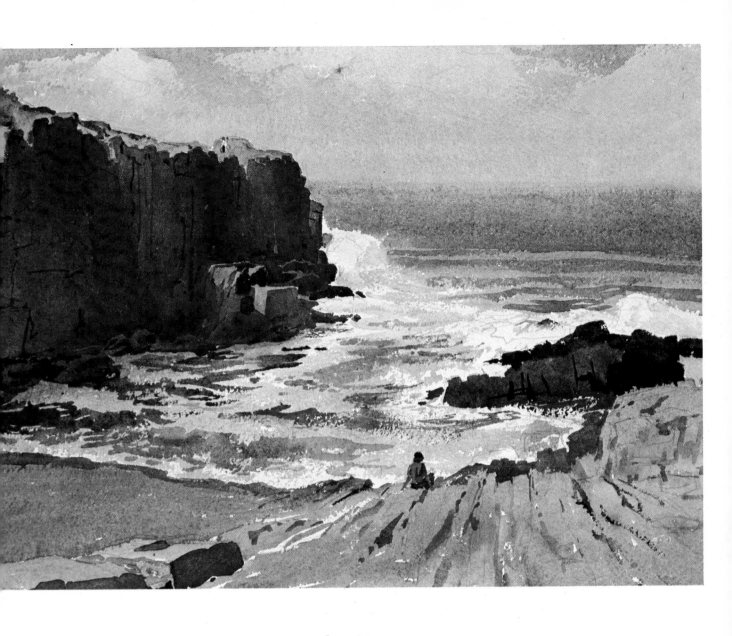

Bald Cliff: Step 3 *11" x 15", 300 lb. rough Arches paper.
To provide some scale I painted in a girl who had been
sitting on the rocks for a few moments. The foreground
rocks and a little sand beach to the left pull the com-
position together.*

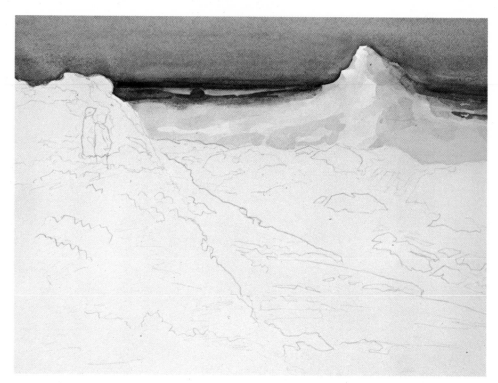

East Wind: Step 1. *I started a wash of cobalt blue, Indian red, and yellow ochre at the top margin. I added water and yellow ochre rapidly as the wash came to the dominant breaker, stopping it at the trees and rocks. When the first wash dried, I went over it with an intensified mix of the same colors. I infused more blue at the horizon, avoiding the distant breaker and stopping the wash at the foam, but with clear water, I carried the wash over the crashing breaker.*

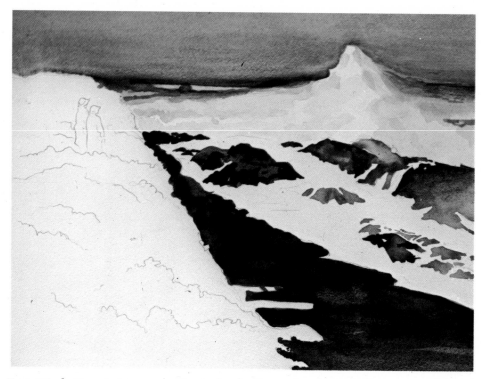

East Wind: Step 2. *I ran a basic wash of ultramarine blue, Indian red, and burnt sienna over the rock ledges. I varied the mix from quite warm near the burst of foam to very cool near the center of the paper, where a cool top light reflects from the wet rock ledge. I warmed up the mix again in the immediate foreground. A pale version of the wash is used to describe some of the ledge, still partly awash.*

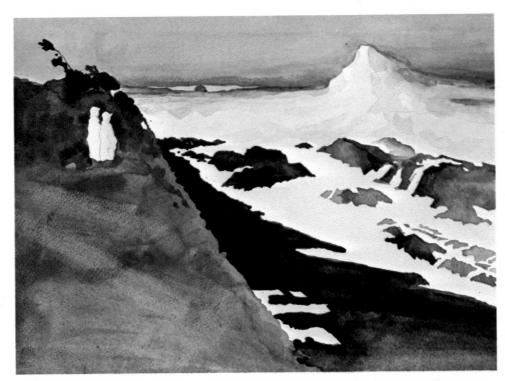

East Wind: Step 3. *I laid a large basic wash of ultramarine blue and yellow ochre over the area of foliage on the bluff. A little viridian is added to this wash just below the figures, and some burnt sienna is added in the foreground. I painted around the figures. A few accents were added to the distant water at this stage.*

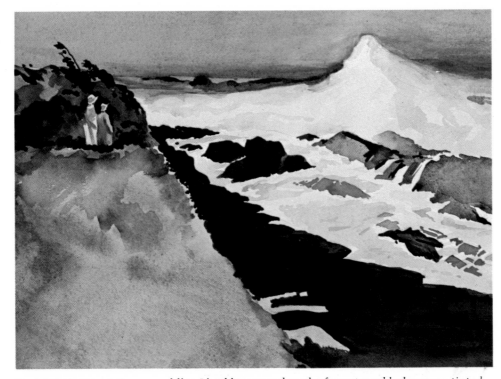

East Wind: Step 4. *Some puddles I had by-passed on the foreground ledge were tinted blue-gray to reflect the sky. I painted the figures with strong reds and yellows and started texturing the foliage with superimposed, dark washes. A pale mix of cobalt blue, Indian red, and yellow ochre gives structure to the foam from the preceding wave which is running back off the ledge to meet the oncoming breaker.*

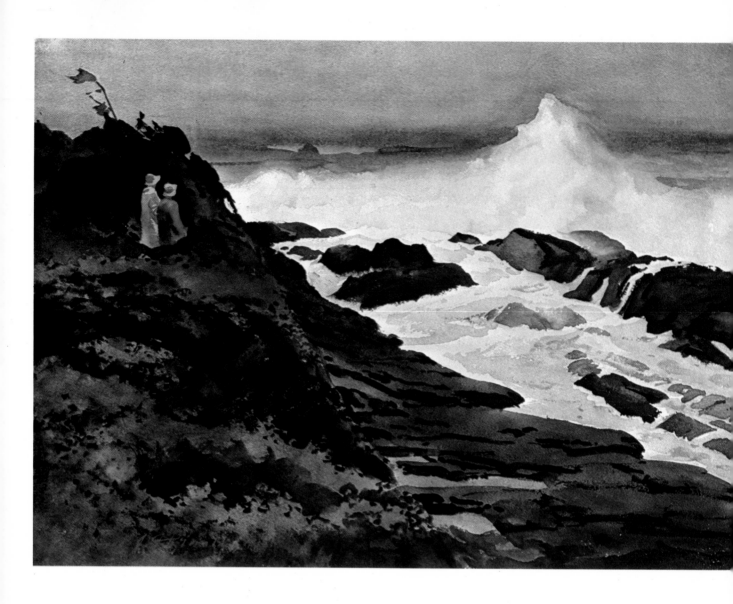

East Wind: Step 5. *22" x 30", 300 lb. rough Arches paper. This painting won the Famous Artists School Award in the 1969 A.W.S. Annual. The white areas left on the receding foam were carefully filled with a tint of yellow ochre, and a few touches of pale blue-green is used to texture the foam. I completed the texturing of the rocks with strong accents of ultramarine blue and Indian red and superimposed dark washes of ultramarine blue, yellow ochre, and burnt sienna on the ground cover. The white water is emphasized by the low tone of everything else in the diminished light. Observe that the "white" water bursting into foam and creaming over the rocks is not very white but contains considerable color.*

20

The finished watercolor

The final brushstroke does not mean the end of the painting. After you clean your brushes and put away the other paraphernalia, what happens to the finished watercolor? Now you must decide how to present it. How will you mat it? What kind of glass will you use? How will you frame it? Exhibitions, sales, and the originality of conception that any kind of success depends upon are all vital areas of interest to the painter.

Durability and Restoration of Watercolors

The most fragile part of a painting, and this includes oil as well as watercolor, is its support, the surface on which it is painted. Because excellent paper is more lasting than cloth, watercolors painted with permanent colors on top quality paper of good weight are probably more durable than oils on linen. Furthermore, the adhesive quality and stability of the thin films of watercolor are less subject to problems resulting from misapplication and internal tensions than oil films.

Conservation techniques are more practicable for oil paintings than watercolors, however. If necessary, the support can be separated from an oil painting and replaced. This is not possible with most watercolors. The surface of most oils can also be cleaned more strenuously than most watercolors. Moisture is the enemy of both, but it can be more devastating and its harm less reversible with watercolors than with oils.

Mildew and other fungus growths that attack paper in humid places, as well as various stains, can sometimes be removed from watercolors by expert restorers, but the methods used usually involve bleaches and other strong chemicals or fumes and often require the use of water. Obviously, the application of such chemicals to watercolors is very risky. Techniques that may be safely used on old prints and even pastels may cause radical changes to some watercolors.

You can usually safely remove surface dust from watercolors with a soft kneaded eraser, but it should be apparent that, while watercolors are durable, they should be protected from dirt, stains and moisture. Also, do not expose them to strong sunlight for long periods.

Storage and Display

You can store watercolor paintings in portfolios or any dry, dust-free place, and because of their thinness, large numbers of them require small space. They should be displayed under glass or a plastic glass substitute.

Non-Reflecting Glass

Non-reflecting glass is preferred by some people because it obviates the mirror effect that glass on paintings produces in some hanging situations. This mirror effect can be distracting, particularly on paintings of dark tone. Most watercolors reflect so much light themselves that the mirror effect of their glass covering is not a serious drawback. In any case, I much prefer the clear glass to the non-reflecting type. For me, clear glass gives a "wet" look to watercolors that I find attractive. It creates a unifying quality similar to the final varnish on an oil painting.

Plastic Glass

Plastic glass (Lucite, Plexiglas, Acrylite, etc.) gives the same optical effect as ordinary clear glass. It is much lighter in weight than glass and practically unbreakable. It is therefore advantageous for exhibitions, particularly where shipping is involved. It has some drawbacks though. It costs more than glass and is subject to scratching. It also has an annoying electrostatic tendency to attract particles of dust. Dusting off or any kind of rubbing increas-

es the electrostatic quality temporarily, but this gradually subsides. Nevertheless, cleaning is best accomplished by a light rubbing with a soft cloth or tissue dampened with alcohol or a special preparation made for this purpose.

The plastic type of glass comes in various thicknesses. 1/8" plastic glass has similar rigidity to regular glass and is suitable for framing large watercolors of imperial size (22" x 30") or larger. 1/16" thickness is also fairly rigid and can be used in smaller frames. You can use clear plastic in nonrigid, thinner sheets to cover unframed watercolors. It may cover just the painting or both the painting and mat. Although it may acquire distracting waviness, it affords protection and something of the wet look mentioned above. It is sometimes used in exhibitions of matted but unframed watercolors or graphics.

Mats

A mat on a watercolor can be considered as its basic frame. Placing a mat on a watercolor at intervals during the painting helps you to visualize succeeding steps because a mat gives a contained and finished look to the final stage. Some painters use an adjustable mat, made in two L—shaped sections, as a trial mat so the opening can be varied to test composition.

A white cardboard mat measuring 3" or 4" is fairly universal, but many variations are possible. Very thick mats which reveal a deep bevel at the opening are favored by some artists. A double mat, perhaps a narrow, white inner mat surrounded by a wider mat of a contrasting tone, looks well on some paintings. Mats covered with linen or other fabrics have an enriching effect. Some mats, called French mats, are decorated with lines or narrow bands of gold or washes of color near the opening.

Frames

Often the frame around a mat is quite narrow and inconspicuous, serving mainly to hold the glass in place. Here, too, you will find many variations for enhancing the painting and expressing your individual taste. Heavy, elaborate frames seem appropriate to certain paintings and some people. Occasionally you may want to reduce the mat to a narrow band or eliminate it altogether, so the framing resembles that traditionally used on oil paintings.

Varnishing

Some water-media paintings are not protected with glass, but may be varnished. These are hard to distinguish from oils. Such paintings are usually considered more appropriately hung with oil paintings in group exhibitions and are generally so handled by juries of acceptance and hanging committees.

Exhibitions

Most young artists seek recognition by entering their works in competitive exhibitions. It is a rough road, the competition is keen, and acceptance by the juries of selection, and even the winning of awards does not bring wreaths of glory showering down or hordes of purchasers to your studio. Rejection is a painful experience, and there are undoubtedly plenty of times when bad judgment is exercised, mediocre work accepted, and good things turned down; but this is more a matter of human foible than intention. People disappointed by the action of juries of acceptance or award sometimes harbor suspicions that favoritism and "politics" have been at work to deprive them of impartial consideration. It may appear that the "same old crowd" seems to win acceptance and awards from friends on the juries. My observation, over the years, has led me to quite a different conclusion. People on juries who are familiar with your work are apt to be harder on you than others! They are inclined to make you compete, not only with the others exhibiting, but with your own previous work as well — a sort of double jeopardy. "Pull" has little effect in art.

Jurying is a difficult and not very pleasant chore. If you gain acceptance in exhibitions and win awards, sooner or later you too may be elected to the onerous job of serving on juries!

There are rewards, however. In my opinion, the fraternity of artists is the salt of the earth. If any group of people has an edge on the virtues of imagination, intelligence, courage, and gentleness, it is the artists. It is the highest of privileges just to mingle with them. They are human, of course; and as in all things, there is bitter with the sweet.

The exhibition road, with all its pot-holes and detours, is a going concern, and it is likely to continue for a long time to come. In spite of the weaknesses and injustices that occur, I believe it is as fine an emblazoning of the democratic process as any that exists or can conceivably exist in this wicked, foolish world.

One-Man Shows

The one-man show is another avenue to recognition, in addition to the group competitions. However, you should be wary of unscrupulous galleries

that offer one-man shows based on your ability to pay a fancy rent rather than the quality of your work or your readiness to have a solo exhibition. But if you can afford such an arrangement, I see nothing wrong as long as you are not too disappointed with the results.

Recognition

Some say that an artist must die before he is fully recognized. The "fully" part is probably true in the case of the great, but I believe that talent is recognized more often than not and frequently beyond its just dessert. The tragic stories of people like Van Gogh are, I believe, exceptions rather than the rule. Yet in ten short years Van Gogh created a vast wealth and enormous influence. What statesman, tycoon, or entertainer has a better track record?

Recognition by the public will come to the signs of talent. I believe that your best place to seek the first glimmerings of recognition is from your fellow artists. My old teacher Eustace Ziegler used to say, "Just try to paint a better picture. Don't try for fame, and don't try for money — and you might make both." I would like him to know — may he rest in peace — that I am still on the first part!

Marine Subjects

Marine subjects have always been well-received by artists as well as the public. A qualifying thought should be emphasized, however. The fact that marines have been popular has generated a great volume of second-rate seascapes and portraits of ships. So much so that even first-class work in this area must be capable of shining through a cloud of prejudice. Originality of theme is given high priority among the art show juries, and any hint of imitation, obvious commercialism, or excess of sentimentality in art is handicapped. Juries of non-artists, such as critics and curators, are even more rigid. They seem timid about acclaiming any but avant garde fashions.

Nevertheless, the marine theme is big enough to embrace all esthetic styles, and you need not limit yourself to imitation of past or present fashions.

Interrelationship of the Arts

All the arts are related, and *general* artistic ideas and methods can be applied to specific problems.

Architecture, for example, is rather remote from marine painting, yet its visual esthetic lessons can be directly instructive. The unity of mass, the rhythm of repeated motives, and the harmonious relationship of details to their surroundings, all have application to the composition of marine or any painting. Similarly, sculptural tension and balance, the relation of parts to the whole, and textural expression of materials and surfaces are considerations that indicate common ground for all artistic endeavors in many esthetic disciplines.

Sources of Inspiration

Studying the paintings of others is a source of inspiration and a stimulus to competition. I have mentioned a number of my favorite painters of marines in this book, but there are many more: Edward Moran, Montague Dawson, John Whorf, James Sessions, Andrew Winter, and the list could go on and on.

The literature of the sea has also been a great source of enthusiasm for all things maritime to me, especially the poets: Byron, Coleridge, and Kipling. The great prose sea storytellers as well. I can "see" more subjects reading Conrad than I could possibly paint in several lifetimes. The same goes for Melville, Dana, McFee, and many others.

The music of the sea also evokes a tang of salt and wind shipping the halyards, from the simple chanties of sailors to the great tone poems and symphonies of the master composers. Who can hear *Fingal's Cave* by Mendelssohn or the stirring *Oceanides* by Sibelius without wishing to paint the sea? In fact, I seem to hear the rhythm and variation of the sea and murmur of rippling water in many musical compositions, whether their titles indicate that such considerations entered into their conception or not.

Sources of inspiration are all around us. Libraries and museums are full to bursting with accumulated treasure that can be had with the expenditure of moderate effort.

The most bountiful source of all though is with us every moment: the changing sky, the rhythm of the seasons, the infinite variety of weather and mood, the flow of water — now gentle, now violent — finding its way to the eternal sea; the external world freely gives each of us the same gifts that were spread before all the masters. Each of us also has his own inner voice of response and longing. We have only to listen and to see.

Some closing thoughts

This book has tried to cover the specific field of watercolor painting intimately related to its parent element *water* and within my own experience.

Within this framework, a great many problems have been exposed, and while no aspect has been consciously neglected, numerous side paths have been opened that remain to be explored. Water derives much of its characteristic appearance from its ability to reflect. Since it can reflect all things, all things theoretically come within the scope of its study. Each phase of water which this book has considered reveals others.

My experience has been fairly wide, and I count it a rare privilege to share it with you, but its breadth is that of one wave on the face of the ocean compared to the possibilities that have been uncovered in the preceding pages and the collective knowledge of the giants on whose shoulders we stand. Like the element water, watercolor painting has endless ramifications. I sincerely hope that you will not regard the exposition of my methods and approach as an attempt to define limits for this medium, or even to define the medium. The *idea* of watercolor is based on a deep and broad tradition, but there are as many breakthroughs into new areas possible as there are young talents.

Low Tide, Muckleteo, *10" x 14", 90 lb. cold-pressed, stretched Whatman paper*

Bibliography

Birds

Geroudet, Paul, *Water-Birds With Webbed Feet.* London, Blandford Press, 1965.

Pettingill, Olin S., Jr., *A Guide to Bird Finding East of the Mississippi.* Fair Lawn, N.J., Oxford University Press, 1951.

Pettingill, Olin S., *A Guide to Bird Finding West of the Mississippi.* Fair Lawn, N.J., Oxford University Press, 1953.

Mountbatten, Prince Philip, *Seabirds in Southern Waters.* New York, Harper & Row, 1962.

General

Brown, Lewis Stacy, *An Atlas of Animal Anatomy.* New York, Dover Publications, 1949.

Bush, Eric Wheeler, *Flowers of the Sea: An Anthology of Quotations, Poems, & Prose.* Annapolis, Md., U.S. Naval Institute, 1962.

Cutler, Carl C., *Greyhounds of the Sea; Queens of the Western Ocean,* rev. ed. Annapolis, Md., U.S. Naval Institute, 1961.

Fischer, Anton Otto, *Fo'c's'le Days.* New York, Charles Scribner's Sons, 1947.

Gillmer, Thomas C., *Modern Ship Design.* Annapolis, Md., U.S. Naval Institute, 1970.

Hutchinson, William, *A Treatise on Naval Architecture.* Annapolis, Md., U.S. Naval Institute, 1969.

Landstrom, Bjorn, *The Ship.* New York, Doubleday & Company, 1967.

Mayer, Ralph, *The Artist's Handbook of Materials and Techniques,* 3rd ed. New York, Viking Press, Inc., 1970.

Norling, Ernest, *Perspective Made Easy.* New York, Macmillan Company, 1939.

Peck, Stephen R., *Atlas of Human Anatomy For the Artist.* Fair Lawn, N.J., Oxford University Press, 1951.

Geology

Fraser, Ronald G., *The Habitable Earth.* New York, Basic Books, 1965.

Lake, Philip, *Physical Geography.* New York, Cambridge University Press, 1958.

Pearl, Richard M., *1001 Questions Answered About Earth Science,* rev. ed. New York, Dodd, Mead, 1966.

Marine Life

Dawson, Elmer Y., *Marine Botany: An Introduction.* New York, Holt, Rinehart, and Winston, 1966.

Hardy, Sir Alister C., *The Open Sea.* Boston, Houghton Mifflin, 1964.

Klots, Elsie B., *New Field Book of Freshwater Life.* New York, G.P. Putnam's Sons, 1966.

Maxwell, Gavin, *Ring of Bright Water.* New York, E.P. Dutton, 1961.

Teal, John, and Mildred Teal, *Life and Death of the Salt Marsh.* Boston, Little, Brown, 1969.

Marine Painting

Ballinger, Harry, *Painting Sea and Shore.* New York, Watson-Guptill Publications, 1966.

Smart, Borlase, *Seascape Painting, Step-by-Step.* New York, Watson-Guptill Publications, 1969.

The Sea

Carson, Rachel, *The Sea Around Us.* Fair Lawn, N.J., Oxford University Press, 1951.

Kovalik, Vladimir, and Nada Kovalik, *The Ocean World.* New York, Holiday House, 1966.

Maury, Matthew F., *The Physical Geography of the Sea and Its Meteorology.* Cambridge, Mass., Belknap Press. Imprint of Harvard University Press, 1963.

Watercolor

Binyon, Laurence, *English Water-Colours,* 2nd ed. New York, Schocken, 1969.

Bury, Adrian, *Two Centuries of British Watercolor Painting.* London, George Newnes, Ltd., 1950.

Butlin, Martin, *Turner Watercolours.* New York, Watson-Guptill, 1969.

Hoopes, Donelson F., *Sargent Watercolors.* New York, Watson-Guptill, 1969.

———*Winslow Homer Watercolors.* New York, Watson-Guptill, 1970.

Kautzky, Ted, *Ways With Water Color,* 2nd ed. New York, Van Nostrand-Reinhold, 1963.

Pellew, John C., *Painting in Watercolor.* New York, Watson-Guptill, 1970.

Pike, John, *Watercolor.* New York, Watson-Guptill, 1966.

Index

Edited by Adelia Rabine
Designed by James Craig and Robert Fillie
Set in 10 point Melior by Wellington-Attas Computer Composition, Inc.
Printed and bound in Singapore by Toppan Printing Company, Inc.